LAKE ERIE

LAKE ONTARIO

LAKE MICHIGAN

LAKE SUPERIOR

TORONTO

KITCHENER (Berlin)

Muskosh R.

Moon R.

GO HOME

BALA

PENETANG

GEORGIAN BAY

BROCKVILLE

MANOTICK

HEMMINGFOR

OTTAWA

SWEETSBURG

MONTREAL

ST.LAWRENCE R.

GATINEAU

CANOE LAKE

ALGONQUIN PARK

ESPANOLA

ALGOMA

SAULT STE. MARIE

Mississcogi R.

BISCOTASING

Ottawa R.

STE ANNE DE BEAUPR

ST. JOACHIM

CAP TOURMENT E

VALCARTIER

ST.TITE-DES-CAPS

BAIE ST. PAUL

LES ÉBOULEMENTS

ST. IRENÉE

ST. ONTARIO STHE

LAKE ST. JOHN

LA MALBAIE

FRANZ

HERON BAY

PORT ARTHUR

NELLIE LAKE

LAKE ABITIBI

ONTARIO

HEARST

QUEBE

JAMES BAY

HUDSON BAY

N

A PAINTER'S COUNTRY

THE AUTOBIOGRAPHY OF
A. Y. JACKSON

with a Foreword by
The Rt. Hon. Vincent Massey, C.H.

Centennial Edition

CLARKE, IRWIN & COMPANY LIMITED

Copyright, Canada, 1958, by
CLARKE, IRWIN & COMPANY LIMITED

First printed 1958
Reset and reprinted 1963
Reprinted with an additional chapter 1967

Printed in Canada

To the memory of

J. E. H. MACDONALD

who visualized a Canadian school
of painting, and devoted his life
to the realization of it

Contents

Illustrations

Foreword

AN EXTRACT FROM THE GOVERNOR-GENERAL'S ADDRESS
AT THE ART GALLERY, TORONTO
THURSDAY, OCTOBER 22ND, 1953

NOW MAY I come to the other exhibition, a very important event in the field of the fine arts, which gives us the opportunity to see a comprehensive collection of works by Mr. A. Y. Jackson. It seems to me that anything I could say about this exhibition would be entirely superfluous. It would be almost impertinence to comment on the works of a painter so familiar to Canadians everywhere. They have the breath of Canada in them and are treasured wherever they are owned.

And what am I to say about my old friend Alex Jackson himself? Few Canadians are less in need of an introduction to any group of fellow-Canadians. As you know, for well over forty years Mr. Jackson has painted all over Canada. This is no idle phrase, for his painting embodies his interpretation of the landscape of this vast country from one coast to the other and well into the Arctic North. His first trip to the Georgian Bay as a painter was in 1913; seven years later you will recall he was one of four to form that group of artists which, during a spirited chapter in the history of Canadian art, taught Canadians to perceive the peculiar beauty of their own country. Alex Jackson is not only a great Canadian painter, he is a great Canadian, and a legendary figure in the Canadian scene. We welcome him here tonight with gratitude and affection and all of us who love his canvases, and who does not? are happy to find so representative an exhibition of them here in this gallery.

[ix]

Introduction

THIS BOOK is not another history of Canadian art; that service has been rendered already by Newton McTavish in *The Fine Arts in Canada,* by William Colgate in *Canadian Art* and by Graham McInnes in *A Short History of Canadian Art.* Even before these books were written, almost every artist in Canada worthy of notice had been mentioned in some publication or other, some of them too briefly, others much beyond their merits. One has only to look over old catalogues or newspaper reviews of exhibitions to realize that laudatory press notices and honours heaped upon some mediocre painter on the grounds that he was a great genius did not prevent him from passing into oblivion. It would be interesting to know how much of Canadian art is going to survive the passing of the years.

Nor will the reader learn here much of contemporary trends or influences. The Group of Seven, with which this book is largely concerned, has no influence on art in Canada to-day. If the arts reflect the times in which we live the remarkable scientific developments of to-day must find a parallel in the work of our advanced painters. But while the scientific truths can be demonstrated immediately, it may take thirty years or more before an artist's contribution can be estimated. In the meantime the painter who continues to be concerned with the world as it appears may be regarded merely as a craftsman.

Until just before the first World War, art in Canada had never been a subject for controversy. There was complacency on the part of the artists and apathy on that of the public. The paintings of Cullen and Morrice at the beginning of this century gave Canadians the first intimation of the art revolution going on in Europe. While the work of these men was not approved of, it was not derided.

The movement in Toronto, which later resulted in the formation of the Group of Seven, was more disturbing to Canadians. It was a target for the reactionary from the very beginning. About 1910 I

wrote a letter to the Montreal *Herald* criticizing the indifference of Canadians to the arts. William Brymner, President of the Royal Canadian Academy in that year, with whom I had studied, was not pleased at my action. Artists, he said, should stick to painting and not engage in controversy in the columns of the press. He was probably right, but later on when the Group of Seven was subjected to much unreasonable abuse (in 1913 we were dubbed the Hot Mush School), we started to give expression to our convictions wherever they might be heard. One result was that people, who until then had been quite indifferent to the arts, became interested, and the idea that Canadian painting should reflect this country and should not ape European fashions became generally acceptable. This book is, for the most part, about the evolution of that idea. It is also an account of my wanderings in a big and almost unknown country and of how I found in it all kinds of strange scenes to stir the heart and imagination of the painter.

Art movements come and go. When one becomes stabilized it is by-passed by younger and more vigorous groups. In some cases new movements work a revolution in art, as did the French Impressionists and Post-Impressionists. Others are important only to the countries that gave them birth. Members of the Hudson River and the Glasgow schools of painting, among many others, have been an influence in their time and place.

The Group of Seven ranks with such local movements. It is hard now to believe that years ago we who were members of it were regarded as radicals. We were revolutionaries only in that we expected an art movement to develop in our country at a time when most Canadians were completely indifferent to any form of art, and because we attempted to paint objectively the kind of country that comprises most of Canada. The majority of Canadians, at the time, were shocked by our efforts, yet we did create something in the field of painting that was distinctively our own. Lately, it has become the fashion to disparage our achievements as a mere symptom of nationalism in a backward country.

Most of the exhibitions that are now sent abroad show next to nothing to denote the country of their origin. To-day it is considered a virtue to have ideas and ideals that do not concern themselves with race or geography. Perhaps in these days of frenzied nationalism it is well to have the arts denatured and denationalized. But who will support art that knows no country? It seems obvious enough that the

general public will continue to prefer pictures of places and objects with which they are familiar, even though the painting is of a type that is considered by the higher critics to be obsolete.

Perhaps in the future we shall have divergent groups: the advanced artists who talk of spatial relationships, tensions, densities, tangible volumes and so on, and who will probably spend most of their time in New York or Paris; and the painters who look to nature and are content to draw their inspiration from a land of vast spaces and infinite variety of which we are only beginning to be aware.

Conditions are more favourable for the artist in Canada to-day than they were when I began painting. People are better informed than they were and more tolerant of ideas. The artist is not now regarded with suspicion. He can speak for himself; in fact, he has become so respectable that artists are in demand as speakers at service clubs and educational centres. Intelligent critics endeavour to interpret for the public the intentions of painters that are quite incomprehensible to the layman. Things were different forty years ago; then a little group of embattled artists found itself in opposition to nearly everybody in the country. Through their efforts the restraining hand of convention was loosened and new life was breathed into the arts in Canada. To-day the artist has few hindrances and much support in any effort he makes to win prestige in the wider field of international art.

Parts of two chapters of *A Painter's Country* have appeared in a somewhat different form in *Canadian Art*, part of a third in a publication of the Sun Life Assurance Company.

I should like to express my thanks to those owners of my paintings who made available canvases in their possession for reproduction in my book.

I am especially indebted to the Ryerson Press and to Thoreau MacDonald for permission to quote the two verses from J. E. H. MacDonald's poem "My High Horse," from *West by East and Other Poems*, which appear on page 115.

A. Y. JACKSON

Manotick,
August 1958

IT IS now almost nine years since I wrote the above. This year, when the publishers decided to print a new edition of *A Painter's Country*, they suggested to me that those who bought the book in future would be curious to know what has happened to me since 1958; and so I have brought my story up to date in a new chapter, "Tying Up the Ends." Chapter XIX, which bore that title previously, has been renamed "The Studio Closes."

Four new plates have been added to the eleven plates included in the previous edition. I should like to thank the owners for allowing paintings in their possession to be reproduced in my book.

<div style="text-align: right">A.Y. JACKSON</div>

Ottawa,
March 1967

I
Early Days

MY GRANDFATHER, Henry Fletcher Joseph Jackson, arrived in Montreal from England in 1846. There he became general agent of the St. Lawrence and Atlantic Railroad, an early line running between Portland, Maine and Montreal, which later was incorporated in the Grand Trunk Railway. Before the Victoria Bridge was built, the terminus of the St. Lawrence and Atlantic Railroad was at Longueuil, and my grandfather lived there until 1854. Krieghoff, the painter, was living in Longueuil at that time. It is probable that my grandfather was acquainted with Krieghoff for he owned several of his paintings. One of them, "The Ice Bridge," was presented by the family to the National Gallery of Canada some years ago.

Before coming to Canada, my grandfather had been to school in Switzerland and he spoke French fluently. In Montreal he married the sister of John Murphy, whose father was the founder of one of the big drygoods stores in that city. In 1854, my grandfather moved from Longueuil to Berlin, Ontario, where he lived for over twenty years. He was the contractor for the section of the Grand Trunk Railroad which was being built between Berlin and Breslau; he was also one of the founders of the Economical Fire Insurance Company, and its first President. Why he left Berlin where he was a successful and very respected citizen, and returned to Montreal, is a mystery. Later, he settled in Brockville where he died in 1894.

My maternal grandfather, Alexander Young, after whom I am named, came to Canada from Scotland in 1834. He was a person of distinguished mind, a quality not held in much esteem in Canada at that time. Most of his life was spent in the Galt, St. Thomas and Berlin

[1]

area where he earned his living as a school teacher. He was a keen entomologist and botanist and his collection of insects was one of the most complete made in Canada up to that time. He was a skilful gardener, expert in the grafting of fruit trees and shrubs. All his life he was poor. He seldom made over forty dollars a month and to keep a wife and family on that sum, even in those days, was difficult. His one venture in business was to put his savings into a flax mill in St. Thomas. The farmers in the district would not raise flax and he lost his money. His last position was as inspector of weights and measures for the Provincial Government. He died a year before I was born, after a long life of public service, leaving no estate; even his insurance was mortgaged. If heredity means anything, my brother Harry and I inherited from him a love of nature. Harry, to-day, is a well-known bird man and is much respected as an amateur mycologist. He has made a series of quite remarkable drawings of fungi and mushrooms for a book written by Dr. René Pomerleau.

I was the third in a family of six children. We lived in a large house on Mackay Street in Montreal where I was born. When she married my father, my mother was considered a very fortunate young woman; certainly her husband's family thought so. By the time I started school, however, I began to realize that other youngsters had many things that we had to do without. One day I came home from school to find my mother in tears and strange men in the house making lists of everything in the place. They were bailiffs. My father had departed for Chicago after a succession of business failures, leaving his family behind him.

My father's own wish, I believe, was to enter the ministry; not because he was zealous in his love for humanity—he was a conventional Anglican and a regular church-goer—but because he had little capacity for business. He ran a shoe last factory, published a paper called *The Dominion Grocer* and engaged in several other unsuccessful ventures, in all of which he was financed by his father. He was not lazy, nor did he use liquor or tobacco; he was merely lacking in initiative. An amateur musician, he played the violin and 'cello and often had amateur orchestras to play at the house. He spent much of his time at Lodge meetings and little time at home. Now, after successive failures, his father had refused to finance him any longer and he had left for the United States. He never returned to Montreal. For a time he sent small sums of money to my mother from Chicago, then even that ceased.

It was an ordeal for my mother to be left with no income and six

children to care for. Our uncle, John Murphy, helped her out until my two elder brothers and I were able to earn enough to take on that responsibility. We moved to St. Henry down below the railroad tracks, where living was cheaper. St. Henry was a fast-growing suburb of Montreal whose inhabitants were French-speaking. It was on the western fringe of the city and had open fields beyond, over which we hiked until we knew the countryside for twenty miles around. Most of our friends had been Protestants; we were rather bigoted and suspicious of Catholics. Here we lived in close contact with Shaughnessys, Murphys, Phelans, all of them Roman Catholics, and no one could have been kinder to my mother than they were. The Murphys had moved to Canada from the United States. They knew nothing of religious prejudice and were warm-hearted, friendly people to whom we became very devoted. We had little association with the French-speaking neighbours, which was unfortunate for both of us. The local police were all French-speaking; they used to chase us out of a nearby park. With the small merchants, the Décaries, the Peladeaus and others, we had the most friendly relations.

I attended the Prince Albert Public School until I reached the age of twelve. Except for mathematics, I was one of the outstanding pupils there. I was very serious about my studies and read everything I could lay my hands on, which was not much, as there were no libraries, except the one in the Sunday School, where the books of Henty, Kingston, and Ballantyne provided interesting fare for a boy.

In those days phrenology was all the rage, as psychiatry is to-day. My mother took me to a phrenologist to find out what kind of a career I might be best suited for. He suggested the legal profession. Some friends of the family had promised me a job in an insurance office when I was old enough. While waiting for that day, I started work as an office boy with a lithographing company. It was not the kind of career that promised to lead upward, or in any direction. In idle moments between running messages I used to make drawings, usually copying them from newspapers. The boss, seeing these drawings one day, decided to put me in the art department where I became assistant to Arthur Nantel, a most fortunate arrangement for me.

Nantel was bilingual and a very cultured person, for though he had little formal education he was a prolific reader, getting most of his books from the Fraser Institute, Montreal's first public library. He steeped himself in the classics, in biography and history, seeking, in this

[3]

way, to ignore the trivial routine that circumstances imposed upon him. As a fifteen-dollar-a-week lithographer, his job was humble enough. On the outbreak of war in 1914, Nantel went overseas. He was made a prisoner at the Battle of St. Julien and spent the rest of the war in Germany.

The art department had little to do with art. Mostly we designed labels for beer bottles or tinned vegetables. The hours were long and the wages low. At the end of six years I was earning six dollars a week, so I left that job and worked for a while as a designer in a printing house owned by Adam Beck, the father of Ontario Hydro. From there I moved to a photo-engraving house, and finally to another lithographing firm where I received a fairly good salary.

During these years I did a great deal of reading. I had always enjoyed reading, and Arthur Nantel had guided me to Dickens, Scott, Balzac, Victor Hugo. I waded through Ruskin's *Modern Painters* and most of the few books on art at the Fraser Institute. Occasionally I went to the theatre; the first time, I recall, was to see Martin-Harvey in "The Only Way," the play based on Dickens' *Tale of Two Cities* which is always associated with Martin-Harvey's name. I attended night school at the Monument National, four nights a week, and I was an occasional visitor at the Art Gallery in Montreal where there were annual exhibitions of Canadian work which appealed more to me than the permanent collection. I was not very critical in those days, and the notices of the exhibitions which appeared in the press were not very helpful to an amateur of art. Usually they expressed the writer's likes and dislikes without telling why one picture appealed to the critic, while another did not. In addition to all these activities, I attended the art classes conducted by William Brymner.

In 1905, my brother Harry and I worked our way to Europe on the *Devona*, a cattle boat large enough to hold four hundred head. The crossing was rough and it took us two weeks to get from Montreal to London. The cattle foremen were Irish Americans from Chicago and very tough, while the cattlemen included many failures going back to England. The foremen referred to these, contemptuously, as the "bloody empire builders." At that, though, the general level of culture was higher in the pigpen we occupied over the propeller than on the bridge. Among others, we had a stonemason who could recite Shakespeare by the hour and a big Swede who was familiar with the art

[4]

world. A different type was a man from New Brunswick who was going to London to introduce the British to spruce gum.

My first visit to Europe was a short one. We stayed in London a few days, then moved to Paris where we looked up Eddie Boyd and Clarence Gagnon, two of Brymner's students from Montreal. We visited as many art galleries as we could, inspected historic cathedrals and churches and spent some days at the World's Fair at Liége. All in all, we had a most thrilling time.

On my return to Montreal I met the wife of a friend of mine, Pat Farmer, who had lived in Hemmingford, thirty-six miles east of Montreal. Mrs. Farmer spoke often about her part of the country, and with such enthusiasm that I walked out one day to investigate it. Hemmingford was farming country, slightly undulating, which had been settled about a hundred years earlier. Some time after my first visit I went there for a month to paint in water colours. I stayed with Mrs. Farmer's brother-in-law, Jack Lipsey, an energetic and ambitious man, who had a farm, taught the local school, and ran a furniture store. I did occasional jobs for him, such as driving the milk to the station in the morning.

Hemmingford is close to the United States' border. One night I drove in a sleigh with Lipsey to make some purchases on the American side. On the way home, just at the border, we were stopped by a long freight train. Lipsey was nervous, for we had not declared our purchases and he was afraid some Canadian Customs official might come along and inspect our vehicle. When the freight was barely past Jack gave the horse a flick of the whip; it jumped forward and we missed by a few feet the express for New York which was thundering down the other track. Next morning it was below zero when we went to clear out some bush on the farm and to try out a couple of axes we had smuggled. At the first stroke I broke the handle of my axe. Lipsey was so annoyed he gave a swipe at a tree and broke the blade of his.

A strike in the lithographic business in Montreal was the cause of my going to Chicago. Years before, my grandfather had been in Chicago and had been urged to invest money in property there. He had no faith in the future of that city, however, and instead bought property in Montreal. Later the great department store of Marshall Field was built on the property in Chicago, while the land in Montreal, on St. Paul Street, was sold forty years afterwards for less than he had paid for it.

[5]

My father still lived in Chicago, as did an uncle whom I had never met. I saw my father a couple of times a month, generally on a Sunday, when we dined together at some modest restaurant. He was still a failure; he had a clerk's job with a small lodge regalia manufacturer. When he was past eighty he went to live with my brother Ernest and his family in Lethbridge where he died some years later.

The Art Institute in Chicago, where I put in four nights a week in study, was a stimulating place. I worked with a firm of designers in the daytime.

I left Chicago with regret. It had been a friendly place to me and both in my work and in art I had gained much experience. I might have remained there and never returned to Canada, but for one thing: I was now determined to go to Paris and study art. I had contributed to the family upkeep for many years, ever since I had begun to work. Now my younger brother, Bill, and my sister, Catherine, were grown up and working. By 1907 I had saved enough money to go to France.

II
Studies in France

IN 1907 I went to Paris. All right-minded Montreal artists aspired to go to Paris and most of them wanted to study at the Académie Julian. It was not the instruction, which amounted to about ten minutes a week, that attracted them to Julian's, it was the association with students from all over the world. They were a riotous but enthusiastic and hard-working crowd.

At Julian's I studied under Jean-Paul Laurens. Though he was not very well known as a painter, some of his best work is in the Panthéon in Paris. His paintings are strongly reminiscent of Caravaggio's, so much so that they might have been inspired by that artist. He liked plastic qualities. To students whose work lacked solidity he would say that the painting was like a glove with the hand withdrawn. Laurens had little encouragement for students who departed from established traditions. He frowned on superficiality or slickness, as on any effort at self-expression that departed from realism. Neither Bouguereau nor Cézanne were approved of by Laurens.

My closest associates in France, at this time, were New Zealanders, Spencer Macky and Frederick Porter, serious students and good companions both. Later Macky moved to San Francisco where he became Director of the California School of Fine Arts. Porter stayed on in London. During the war, when I was working for the Canadian War Records, I had a studio on Charlotte Street in London. Porter had a studio near by and I renewed my acquaintance with him. He was a member of the London Group which had come into existence shortly before the war. Such well-known painters as Gilman, Ginner, Duncan

[7]

Grant and Vanessa Bell were members. The Group was considered at that time to be very radical.

What becomes of art students? Of all the crowds of students I knew in Paris, some of whom had great ability, few of the names are known to-day. Yasui, a little Japanese, was outstanding. He could draw like Michelangelo, but he took liberties in drawing from the models; he would widen the wrists and ankles to give them strength. When Jean-Paul Laurens criticized his work, the other Japanese would gather round to listen. Jean-Paul would explain patiently that in school one was expected to draw the character of the model; then he would take the charcoal and narrow the wrists and ankles on Yasui's drawing. All the Japanese would smile and nod their heads in agreement. As soon as Jean-Paul was out of the room, Yasui would take a rubber, delete the teacher's lines and put his own back as they had been.

Among the students I remember were Anton Otto Fischer, who had started life as a sailor and who is well known today as an illustrator of sea stories; Balfour Ker, who made bold drawing in the old *Life*, and who died years ago; and Eric Goldberg, a little German with a mop of yellow hair, who turned up years afterwards in Montreal; to-day he is one of Canada's good painters. Roy Brown became a member of the National Academy in New York. Many of the French artists were killed in the war; no doubt many of the others became teachers or took up jobs of commercial art. Probably not one art student in ten thousand achieves real fame.

One of the attractions that brought thousands of students to Paris to study was the low cost of living. Looking over an old account book recently, I found such items as meals at twenty-five cents—and good meals too—and a seat at the cinema for ten cents. The two rooms I shared with the New Zealanders cost us each two dollars a month; a month's study at the Julian Academy cost about five dollars. Six hundred dollars paid for my studies in France for a year and students from other parts of Europe had to live on much less.

The walls of the classrooms at Julian's were covered right up to the ceiling with paintings from the nude, compositions and drawings by medal winners from all parts of the world, going back for many years.

The models, too, were expert in their work and there were lots of them. One did not have to put up with the same old models year after year until their muscles sagged or they got arthritis. John Russell, the Canadian painter, paid this tribute to the Paris models:

[8]

These girls go down to posterity with the artist on his canvas. They have done their bit as well, often better, than the artist himself and I think they should get credit for it. It is no easy task to pose. We have no central heating in Paris and it is often cold. Yet there is no complaint. These girls are making their living by posing, just as a doctor makes his living by care of the human body. They have a big share in the making of a picture, which goes down to posterity, and they should not be looked down upon.

After six months at Julian's, I went with a group on an Easter excursion to Italy, where we visited Rome, Florence and Venice, spending most of the time in galleries. Before we left Paris, we were required to get a letter certifying that we were art students, and so entitled to enter the museums free. American students went to the United States' embassy where they got their letters without any difficulty at all. When Macky and I applied at the British embassy, we were told that the Consul looked after such matters, so we made our way to the British consulate where we kicked our heels for a couple of hours. When we were finally interviewed, we were asked for our passports; I had mine, but my New Zealand friend said, "I don't know where mine is, I probably lost the bally thing." The Consul looked shocked. "Young man," he said, "do you realize that most serious international complications might ensue through the loss of a passport?" We were advised to go back and look for it. Eventually we got from the Consul papers with two shilling stamps stuck on them which were so non-committal that they were of no use to us.

One of our fellow travellers was a Scotsman who had lived for years in Rome, working as a chemist. We could not have had a better guide in a city where the creative arts have flourished for hundreds of years. He took us about Rome to see the work of the great masters on the very walls where they had been painted. From Rome we went on to Florence and Venice then back to Paris.

In the spring, Macky and I went to Etaples just south of Boulogne, which at that time was an art centre for Britons and Americans who were attracted by studios, models and hotels, all at moderate prices, a fishing fleet, sand dunes, and a bathing beach at Paris Plage. There were about forty or more artists at Etaples that year: Tanner, Barlow, Max Bohm, Austin Brown, Koopman and many others. Few of their names have survived the passing of the years.

In a society such as that at Etaples it was an advantage to be a Canadian or a New Zealander. We were regarded as compatriots by

[9]

both British and American circles, which at times were not in complete accord.

I painted a landscape at Etaples, of sand dunes, which was hung in the Paris Salon. The only notice I got on it was a brief one in a provincial paper: "A. Y. Jackson, *Paysage embrumé*." There were clipping services in France which sent artists clippings for ten cents apiece. These organizations supplied the provincial press with articles containing two or three hundred names of artists exhibiting, with two to five words of comment on each picture. Any that were used provided revenue for the clipping services. At Salon time in Etaples the artists would proclaim loudly that they had nothing to send, or that it was too much bother. If you got up early, however, any morning just before Salon time, you might see, heading in the direction of the railway station, an artist accompanying a man with a pushcart on which lay a case.

These were happy years in a France untroubled by thoughts of war; there were friendly people everywhere, living conditions were easy, and art, so far as we were concerned, was largely a matter of good craftsmanship. The famous creator of the Gibson girl was in France when I was a student. C. D. Gibson's admirers thought he was going to take Paris by storm, for probably no French artist earned a fifth of what Gibson made in the United States. He was no doubt weary of all the adulation, and happy to get to France where no one knew anything about him. American artists and illustrators in Paris soon learned that, though they might earn a couple of hundred dollars a week at home, that fact did not win them any prestige in France. The Salons, of course, catered to foreigners, handing out bushels of medals each year. A medal from the Paris Salon went a long way to help establish an American artist in his home town. The only Americans who had reputations in France in my days there were Whistler and Sargent, both expatriates, French in their training and manner of expression, and Anglo-Americans in their social relations.

An American artist told me about some good painting country on the Canal du Loing, near Episy, a little village south of Fontainebleau, in a part of France well known to artists. There was neither hotel nor pension in the village; but he had stayed with a farmer named Goix and his wife. In France the owners of small farms often live in the villages. Such smallholders have little plots of land in different directions from

the village, one for fruit trees, another for vegetables, a third for sugar beets. I went to Episy with Porter, with whom I had lived in Paris. There was much to paint there: the Canal, bordered with Picardy poplars, old farms, the gently rolling country, the barges towed by mules along the canal—the bargeman's wife often helping the mule—all of it close enough at hand so that we could take our canvases out into the fields.

For several months we shared the humble life of the farmer, Goix, and his wife. This was my first contact with people who lived close to, and off the soil. The Goix house stood in the middle of the village. Of whitewashed stone, it was built close to the road; a passageway protected by an iron gate led into a courtyard which had a high stone wall around it, topped with broken glass embedded in cement on top. Madame Goix did not intend to be robbed. A couple of goats, a few hens, a small horse were the livestock. There was not much domestic bliss in the household. Monsieur Goix was an old rascal and rather proud of it. He had a mop of grey hair and sharp little eyes that peered from under bushy eyebrows. Madame Goix' big obsession was economy. We were young and the country enchanting, so in spite of Madame's continued lamentations that we were all going to die of hunger Porter and I stuck it out.

We shared a large room over the living room. At six a.m. the thump of a broom on the ceiling below informed us that breakfast was served and that Madame had gone off to the fields. A bowl of cocoa made of goat's milk and a slice of bread without butter was left on the table for us. The noon meal was potatoes and stew meat, or a type of small green sausage which Porter claimed was made from the donkeys which hauled the barges. Monsieur Goix got the gristle or the soup bones, and wine diluted with water; the old lady explained that, diluted it was better for his stomach. He would wink at us slyly when the meal was over and go out to the stable where he had a supply of his own wine hidden away.

"*La soupe nourrit soldat*" was a kind of grace with which Madame started off the evening meal and soup was about all there was to eat. She made a week's supply at a time, adding bread to it each day. By the weekend, when it had the consistency of mortar, she called it *soup au limousin*. "*Aimez-vous les épinards?*" she asked me, on one occasion. "Yes," I replied, "I like spinach." There was a large bowl of it on the

[11]

table that evening and nothing else. After the third plateful she urged me to take more, and when I politely declined, she said, "But you said you *liked* spinach."

"Trop de vinaigre" was her usual comment when we had a salad of dandelions grown in the cellar. She soaked the greens in vinegar so we would not notice the absence of salad oil.

With Madame Goix, economy was a way of life. She had worked in a laundry before she was married, and she told me, on one occasion, that the principal advantage of this kind of work was that the *laveuses* did not have to buy many clothes. They knew which customers wore sizes the same as their own, their clothes were washed quickly, worn for a couple of days by the laundress, washed again, and delivered to the owner. Madame Goix kept a sharp eye on passing traffic; she was always first on to the street if there were any horse droppings. A fellow lodger told me about some of her other economies. On one occasion she borrowed some cocoa from him. She had a balanced scale and she put the cocoa on a piece of tissue paper and weighed it against six sou pieces, all new. When she returned it, she put the cocoa on a piece of heavy wrapping paper and balanced it against six old worn sous.

The lockmaster did a good trade in home-grown vegetables with bargemen going through the locks. He looked on the business as his private monopoly, but Madame had started cutting into it, offering hers for less. The lockmaster nourished a grudge against her and eventually got his revenge. Each autumn the canal was emptied for repairs and notices were posted up informing the public of the fact. The women of the village did their washing on a flat recession on the canal bank just above water level. Madame, not being in good standing with the other women, had waited until the day the canal was to be emptied to do her washing. The lockmaster, farther up the canal, spied her alone hard at work. He opened the sluice gates quickly as he could and sent down a wall of water which swept all Madame's clothing into the canal.

The people of Episy were quiet, hard working and too polite to be inquisitive about our work. They were not very religious; on the walls of the church there were always to be seen posters with the words, *A bas l'église* or similar slogans. Madame told me once she would have liked to be a Protestant. When I asked her why, she said it cost nothing to be a Protestant. Her last economy was a rusty iron crucifix which was

lying in the courtyard. It had seen service on her grandfather's grave, then her mother's, and was waiting until she required it.

I did a great deal of painting around Episy, and I was sorry to leave it, but my funds were running low. I had been away from Canada for two and a half years. It was time to return home and begin earning some more money.

III
Canada and France

AFTER THE soft atmosphere of France, the clear crisp air and sharp shadows of my native country in the spring were exciting. I painted my first canvases in Canada at Sweetsburg, Quebec. It was good country to paint, with its snake fences and weathered barns, the pasture fields that had never been under the plough, the boulders too big to remove, the ground all bumps and hollows. It was here, while the sap pails were still on the trees, that I painted "Edge of the Maple Wood" and a couple of other canvases.

Then I went to Berlin, Ontario, for the first time, to visit my aunts who had moved there from Brockville after my grandfather Jackson died. As I passed through Toronto on my way there, the newspapers carried big headlines, "King Edward dying." When I arrived at Berlin the bells were tolling for his death.

Berlin had changed very much since my grandfather had lived there. The German people, who had moved in from Pennsylvania, had created all sorts of industries and become prosperous. They lived well, were devoutly religious, had great respect for wealth, few social pretensions and were not much interested in the arts. Financially my aunts had no standing at all; moreover they were staunchly Conservative in a neighbourhood where Willie King was very highly regarded. They had many antiques from the Brockville home, some steel engravings, and a large library. At the end of the long drawing room there was a big sombre canvas, entitled "The Incredulity of St. Thomas." It was a most impressive painting and I greatly admired it. My aunts believed it to be a Caravaggio, but beyond the fact that it had come from England as part of the Jackson estate in the early eighties, they knew nothing

[14]

about it. They also had the Krieghoffs which my grandfather had acquired from the artist.

These family art treasures were to have a very mixed history. My Aunt Geneva died in 1951, an old lady of eighty-six. Her sister, Mrs. Hayward, was taken to Hamilton to live and the house was sold. The antiques and other treasures they set such store by were auctioned off for next to nothing, the old steel engravings being bought by people who wanted the glass over them.

The big painting, "The Incredulity of St. Thomas," was sent for safe-keeping to the National Gallery where no one showed much interest in it. Later it went to the Art Gallery of Toronto. When the Golden Age of Dutch Art Exhibition was closing, Dr. van Schendel of the Rijksmuseum came to Toronto to arrange for shipment of the Dutch paintings that were being returned to Europe; he saw the painting and said it was probably by Terbrugghen, who had been in Italy while Caravaggio was alive, and was much influenced by him. Two paintings by Terbrugghen were in the Dutch Exhibition. Rather than keep the painting in storage, it was sent to the Laing Gallery in Toronto. A month later, a London dealer purchased it and sent it to England where, shortly after, it was acquired by the Rijksmuseum of Amsterdam. *The Burlington Magazine* reproduced it as a frontispiece along with a lengthy article about Terbrugghen. It was a strange reversal of form that had Canada selling old masters to European museums.

It was during this visit that I met my cousins, the Clements, who took me with them to Georgian Bay, where they owned an island. This was the first of my visits to a part of Canada that has always attracted me, and to which I was to return many times.

At Berlin, I met the Williams, Elinor and Esther, their parents, S. J. and Mrs. Williams, and the Breithaupts, William and L. J. During the ensuing years I was to see a great deal of both the Breithaupts and the Williams, and their families, and I was to continue this association at Georgian Bay, where they spent their summers.

In Montreal for some time there had been signs of restlessness in art circles. Collectors there had pinned their faith on the Dutch School: the Maris brothers, Mesdag, Israels, Weissenbruch and others. They boasted that there were more pictures by these artists in Montreal than in any other city in America. The Montreal collectors had been ill-advised; the early collectors there had acquired Barbizon paintings, and it would have been logical if they had continued to buy French

[15]

work, but when French art went impressionistic Montreal buyers dropped it. Instead of purchasing Pissarros, Sisleys, Manets, Cézannes, and Renoirs, they played safe and bought Dutch paintings at high prices. The only artists they ignored were Van Gogh and later Mondrian, probably the most important Dutch painters of the past hundred years.

When I first went to Paris, I was under the impression that Weissenbruch, Mesdag and company were great artists, since, in Montreal, I had seen very little other work. I soon found out that in the art centre of the world they were almost unknown. In Montreal, however, the word had spread that Dutch art was a good investment; besides, to possess a few canvases by these artists gave their owner social prestige. I remember going to a banker's house once to see a Weissenbruch. It was in an elaborate gold frame with a plate glass over it. From the pride with which the owner allowed me to gaze at it, it might have been a Raphael. A few years ago I went to an exhibition of these Dutch paintings. Though the prices had been marked down to a third of what had been paid for them, there were no sales, and the dealer, disgusted, told me that people would not even come in to see them. As an investment, the paintings of the Dutch school had proved of little worth. The Montreal investors would have done better to put their money into the canvases of their fellow-townsmen, Morrice and Cullen.

While we in Canada were cautiously buying sound and sane art, so-called, the Americans were acquiring the work of the modern French school to such an extent that today there are probably as many great examples of it in the United States as there are in France.

It was through Cullen and Morrice that we in Montreal first became aware of the fresh and invigorating movements going on in the art circles of France; and it was their influence that weakened the respect of the younger generation of painters for the stuffy traditions that prevailed in that city. Maurice Cullen and James Wilson Morrice were contemporaries, born within a year of each other. Both studied in France where they often worked together, but while Cullen returned to Canada and devoted his whole life to painting the Canadian landscape, Morrice remained in Europe and became one of the outstanding painters of the modern French school. He was a wanderer who found inspiration in Paris along the Seine, in North Africa, in the West Indies, and occasionally in Canada. With all the variety of subject matter, his work was always characteristically his own. He died in

[16]

Tunis in 1925; his painting at that time was as lively and adventurous as it had ever been. In Canada the collectors have made amends for their tardy recognition of his genius, and his paintings have mostly returned to this country. In fact, students returning from Paris tell me that to-day his name is almost forgotten there.

On Cullen's first return from France he held an exhibition at the Fraser Institute. As there were no sales, he put his paintings up at auction and sold a hundred canvases for eight hundred dollars, an average of eight dollars apiece. Despite such pitiful returns, he continued to go his own way, painting pictures that nobody wanted, of snow, Montreal streets, and other subjects. To us he was a hero. His paintings of Quebec City, from Lévis and along the river, are among the most distinguished works produced in Canada, but they brought him little recognition; by the time it was realized what a great painter he was, the creative urge was well nigh spent. Yet, in his later years, his work became very popular and he made a comfortable living.

There were other influences at work in Canada, in those early years of the present century. William Clapp was showing paintings in the pointillist manner, dots and dashes of pure colour. He got little encouragement and drifted off to the United States. Clarence Gagnon sent over from France paintings which were high-keyed, but not otherwise radical. Later he became famous as an illustrator. Albert Robinson had moved from Hamilton to Montreal where he found many interesting subjects around the harbour.

The most successful painter in Canada at that time was Horatio Walker, who lived on the Ile d'Orléans and painted pictures reminiscent of the Barbizon school. Chiefly he was influenced by Troyon and Millet. His pictures sold at big prices in the United States. If he had been a contemporary of Corot and the other Barbizon painters, he might still be considered a great figure in the art world, but he was a follower only, and Corot's dictum that "those who follow are always behind" applies to him.

The press in Montreal was not over-friendly to new art movements. *The Gazette*, while not espousing radical movements, has probably the best and longest record of any paper in Canada for its appreciative reviews of the work of Canadian artists. I remember, too, the editor of the sports page of *La Presse*, Albert Laberge, who used to write the art reviews for that paper with the same goodwill and enthusiasm he devoted to sports.

[17]

In the autumn of 1911 after a year of earning money at commercial art with a photo-engraving company, I returned to France, this time in the company of Albert Robinson. About eight years earlier Robinson had spent some time in Europe and had studied at the Beaux Arts in Paris. We crossed on the *Sicilian* of the Allan Line. It was a one-class boat, which went directly to Le Havre, and the passengers were partly French and partly British. Robinson and I decided to brush up our French by sitting at the French table. They were a gay company, friendly and full of fun. One of their jokes was to confer mock titles on each of us. The Comte de Winnipeg was a Frenchman who had settled in that city and who was going back to France for a holiday. Then there was the young Comte de Blois, and a handsome young Frenchwoman we called Madame la Duchesse. There was also an old fellow from Brittany who had worked as a gardener for a seminary in Quebec, and who was now going home after twenty-five years. He was a very naive old man. Robinson used to spar at one of the ventilators, pretending it was Jack Johnson. He and I were sitting quietly in the dark one night when the old fellow came along. He stood looking at the ventilator for a while, then stepped up and made a swipe at it. Once he asked us, *"Est-ce que ce sont les vagues qui font pousser les vents, ou les vents qui font pousser les vagues?"* We told him it had never been determined. When we all parted at Le Havre, the old fellow, saying good-bye, told us he had never before mixed with the aristocracy and he was amazed to find we were such pleasant, modest people.

We landed at Le Havre and moved on to St. Malo where we stayed with the Garniers. We had amusing times there. In the evenings we would engage in dominoes, or Chicago as they called it, with Papa Garnier, or play at school with little André and Berthe. In this game, Robinson spent most of his time standing in the dunce's corner.

One stormy afternoon in November we walked along the ramparts, making notes of the sea dashing against the wall and the fishing schooners tugging at their anchors. That evening we were playing school, when Berthe cried out, *"Monsieur Robinson, vous avez perdu votre petit lapin."* The *"petit lapin"* was a silver watch fob given to him by a lady admirer. He looked quite distressed. By some kind of intuition I knew where it was. I told him to get his coat on, and we'd go and find it. The night was black and the storm still raging as we fought our way along the ramparts. There was a bastion at one of the

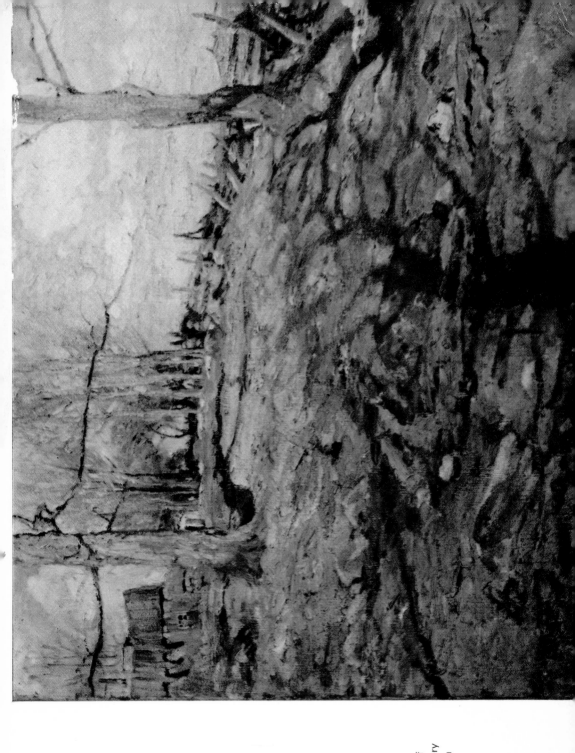

EDGE OF THE
MAPLE WOOD
1910
In the collection of
The National Gallery
of Canada, Ottawa

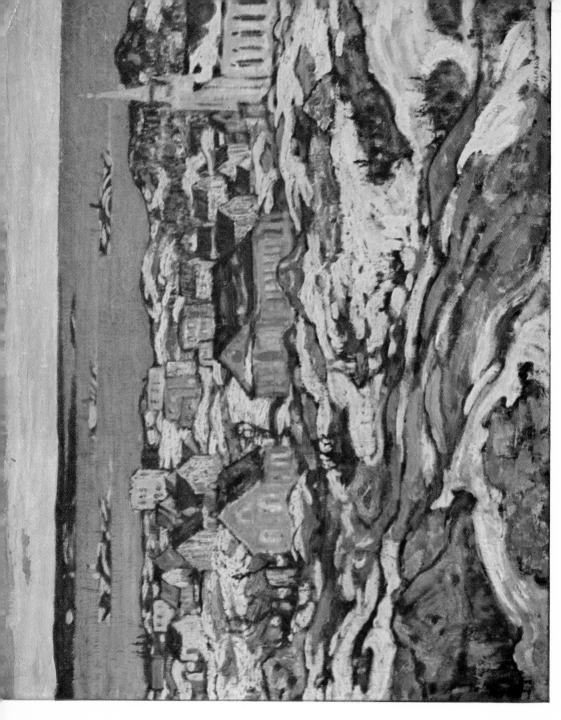

ENTRANCE TO
HALIFAX HARBOUR
1919
Reproduced by courtesy
of the Trustees of
The Tate Gallery,
London

corners where a puddle of water had gathered. I said to Robinson, "Your silver rabbit is in that puddle." In the dark he felt around in the water with his hands and found it. He had made a drawing of boats there earlier and to keep out of the puddle he had leaned over the buttress; in so doing he had scraped off the rabbit.

What honest people they were in St. Malo! On one occasion, my watch went dead, and I left it with a watchmaker for repairs. When he returned it to me, I asked him how much I owed him. He said, "Nothing. I used only a drop of oil."

While we were in St. Malo, a little circus arrived there. The performances took place in a small green tent, outside of which stood a covered wagon drawn by a mule. I made a sketch of the tent in the evening light. Some years later in Montreal, when I was clearing out a lot of old drawings, I came across the circus sketch and told my sister to put it, with other rejected material, in the furnace.

One day Robinson said to me, "Do you remember a sketch you made in St. Malo of a green circus tent? Do you still have it?" I told him it had gone into the furnace years before. He was shocked. "Why," he said, "that was one of the finest things you ever painted." Thereafter he would often refer to it, and in retrospect the sketch got better with each telling. "It was as good as a Morrice," he declared, and in time I came to believe that it was, and that I had been very foolish to destroy it.

This belief persisted until the day in Montreal when I found myself short of sketch panels and remembered there were some old ones in the basement. Poking around down there, I discovered the sketch of the green tent which my sister, after all, had not destroyed. I took a good look at it, then went over to the furnace and shoved it in.

In the four months we were together at St. Malo and Carhaix in Brittany, I learned a lot from Robinson. I used to waste a good deal of time in hunting about for ready-made compositions. Robinson would sit and wait for effects of light, and then he would push fishing schooners and market carts and such things about on his canvas to arrange a composition.

Robinson got suddenly homesick and rushed off to Le Havre where he just caught the steamer *Grampian*. It was December and he had a dreadful passage home. I stayed on at Carhaix for the winter and it rained all the time. I wore wooden shoes which were clumsy but they kept the feet dry and warm. In the spring I went to Paris, and then

[19]

with an old friend, Baker-Clack, an Australian, I moved on to Picquigny on the Somme, a river which was soon to witness some of the most terrible struggles of the war. Our little hotel abutted right on the river. The village was serene and peaceful in the spring, but even here there were ugly incidents. I was painting on a small island in the river one day when there was the sound of a shot and a splash in the water quite close to me. I thought at first that a careless hunter was at large, then another shot came closer and this time in a house across the river I saw a head bob down at the window. I did not wait for the third shot, but went back to the hotel, where the *patronne* reported the incident to the police. The marksman turned out to be a lunatic who had been released from the asylum. He was returned there.

Clack was a very interesting painter, who revelled in colours which he could not afford. I asked him one day what he would do if someone left him a million dollars. "I would buy a bucket of cadmium," he replied. Later, Clack and his wife rented an old farmhouse at Trépied near Etaples and I spent several months with them painting on the sand dunes.

During this stay in Europe, I went to Leeds to visit an elderly cousin, Will Beck, and painted the only canvases I have ever made of England. Then with my cousin and some English friends I travelled to Assisi in Italy. This old hill town, with the famous monastery where much of Giotto's work, depicting the life of St. Francis of Assisi, is to be seen on the walls, is a glorious place to paint. My English friends had rented a house with a studio where I worked. I not only painted all day but on moonlight nights as well. That was before electric lights had ruined all the subtlety of night effects. Before leaving Europe I visited Venice, a damp chilly place in January, and Fiume. From there I sailed for home with a lot of canvases which no one wanted; they were around my studio for years.

A Montreal architect wanted to buy one of these pictures. He took it home for a few weeks and then returned it; his wife had said either she or the canvas had to go. Thirty years later it was purchased by the Art Gallery of Toronto. Most of the other paintings in this group were painted over or destroyed. The Montreal Arts Club, formed about the time I arrived home, gave me a life membership for one of the paintings, "A Fountain in Assisi at Night." But few people liked the work I brought home from Europe. The French Impressionist influence in it was regarded as extreme modernism.

[20]

IV
The Toronto Group

RANDOLPH HEWTON, the son of an Anglican clergyman from Lachine, Quebec, returned to Montreal from France about the same time that I did, and we held an exhibition together at the new Art Museum on Sherbrooke Street. Financially it was a failure; I sold nothing and Hewton sold a sketch to his aunt. I had had an exhibition of sketches at a dealer's and had sold a few of them, but I could not collect the proceeds. I did not want to return to commercial art, yet my future as an artist in Canada was not promising. Several of Brymner's students had gone to the United States. It seemed the only thing for me to do was to follow their example.

Spring was in the air: before reaching any definite conclusion about our plans for the future, Hewton and I decided to go to a little place called Emileville, forty miles east of Montreal. I had passed that way years before on one of my hikes, and remembered it. A family by the name of Guertin put us up, and we forgot all our troubles while we painted to our hearts' content. The Guertins did not want us to pay board: they had never seen an artist before and said it was fun having us around. Finally they consented to take fifty cents a day.

Among the canvases I painted at this time were "Cedar Swamp," "Hardwoods" and "Morning after Sleet." The circumstances in which this last picture was painted, and its subsequent history, are rather interesting. It had rained in the night, the temperature fell rapidly, and when we awoke the trees were covered with ice. The sun came up and transformed the scene into a fairyland. We grabbed our canvases and, hurrying into the birch woods, we started to paint. As the sun rose higher the ice kept falling from the trees and soon I was

[21]

looking at a lot of little birch trees denuded of their jewellery. Disgusted, I was about to scrape the paint off the canvas when Hewton said he would give me a clean canvas for it. Ten years later, when he was principal of the school conducted by the Montreal Art Association, Hewton asked me if he could send the canvas to their annual Spring Exhibition. I was agreeable, and it was awarded the Jessie Dow prize. I had another canvas in the exhibition which Hewton preferred, so he exchanged it for "Morning after Sleet" which was later purchased for the National Gallery.

While I was at Emileville I received a letter from Toronto signed "J. E. H. MacDonald." I was familiar with the name; two years earlier I had seen it in a Montreal exhibition on a little canvas to which I had been very much attracted. Painting among our group in Montreal drew its inspiration from France; this canvas showed an artist with no knowledge of any school, who was trying to express in his own way his feelings for nature.

MacDonald's letter was about "Edge of the Maple Wood," the canvas I had painted in 1910. If I still possessed it, he wrote, a young Toronto artist, Lawren Harris, wanted to buy it. If I still possessed it! I still possessed everything I had ever painted. MacDonald wrote also about the belief of some of the younger Toronto artists that it was time Canadian painters relied less on European traditions and began to paint our own country as it was. The immediate result of MacDonald's letter was that Harris bought my canvas, "Edge of the Maple Wood." A second result was that I began my association with the artists responsible for changing the course of Canadian art for many years to come.

When next I went to Berlin to visit my aunts I stopped off at Toronto to meet MacDonald, and by him I was introduced to Arthur Lismer, Fred Varley, and other artists at the Arts and Letters Club. All of these men were commercial artists, employed by the Grip Company, designers and illustrators. In Montreal there was no close association between painters and commercial artists. In Toronto there was little distinction between one and the other. The men who made designs for advertising went painting on weekends. The head of the department at the Grip company, Ab Robson, encouraged the men to spend as much time as they could sketching in the open. Later on it was Robson who was chiefly responsible for the Art Gallery of Toronto

[22]

acquiring a number of paintings by the Group of Seven. He also wrote a series of short biographies of Canadian artists.

Toronto, then, as now, was a stimulating city in which to pursue the arts. It was the centre of the publishing business, and illustrating and designing which provided a market for the artist's talents had reached a high level. Roy Mitchell, who later became the first director of Hart House Theatre, was putting on plays at the Arts and Letters Club which gave impetus to the Little Theatre movement. There was less of established tradition among collectors in Toronto, and a more lively interest in the arts generally, than elsewhere in Canada. More-over, Torontonians had not enough money to buy expensive impor-tations. The Ontario Society of Artists had been founded to look after the interests of the local painters. It was a good society with no probationary stages of membership. Any member could get up and express his or her views at the monthly meetings.

The artists in Toronto were woefully lacking in information about trends in art in other parts of the world. A few good paintings by Monet, Sisley and Pissarro would have been an inspiration to them. They saw nothing at all to give them direction.

The members of the Toronto Art League were probably the first artists in Canada who believed that art in this country should be rooted in our soil, a principal which is sound theoretically but difficult to put into practice. If one were to see an exhibition of their work to-day, it would be found that it departed only slightly from the rest of the European-inspired work being produced in Canada at that time. What that art was like, and why the members of the Toronto Art League wanted to free themselves from old conventions, may be gathered from this review of an exhibition which appeared in *The Week* for 20th March, 1891.

The exhibition held by the Academy in the Toronto Art Gallery is one of which any patriotic Canadian may well be proud, and though hyper-critical foreigners might utter a sneer at such an exhibit, yet without vainglory we would challenge any country of our age or with similar limitations to put Canadian art or artists to the blush by a fair comparison with their own work. Mr. John A. Fraser's exhibit is of unusual merit; "Neath Threatening Skies in Springtime" a poetic conception and exquisite in execution. It is a fascinating picture and one difficult to leave. The woman feeding the ducks, the soft vernal tint of grass and foliage, the group of trees and the stormy sky—all contribute to the impressive effect of the

scene. "Family Prayer," by G. A. Reid, is another triumph of pure Canadian art and of the splendid series which is flowing from this gifted artist's brush. The children whispering on their knees recall the line "One touch of nature makes the whole world kin," and we may ask to what may not art attain at the hand of such an artist?

"The Silurian Gates of Elora," by Arthur Cox, is a large imposing picture of a striking scene; the towering rock angle at the left, the hollow cavern at right, the softened light and shadow, the pool in the foreground with the rising water fowl, the stream flowing towards you through the narrow gorge, the trees and bushes on the upper ground and the sky are all well and faithfully detailed and the general effect is pleasing and impressive.

This was not the art of a young pioneering country, but as yet the Canadian artists had devised no plan to escape from these accepted standards.

I was received by MacDonald and the others as a kindred spirit. Like them, I had been a commercial artist for years. Now I had thrown up that job to devote myself exclusively to painting, and had, at the moment, no idea how I was going to live while I was doing it.

I did not meet Lawren Harris in Toronto, so he came to Berlin to see me. He was, I found, a young man, well educated, widely travelled, and well to do; his grandfather had been one of the founders of the Massey-Harris Company. To Lawren Harris art was almost a mission. He believed that a country that ignored the arts left no record of itself worth preserving. He deplored our neglect of the artist in Canada and believed that we, a young vigorous people, who had pioneered in so many ways, should put the same spirit of adventure into our cultivation of the arts. With MacDonald, Lismer, Varley and others, whose acquaintance he had recently made, he believed that art in Canada should assume a more aggressive role, and he had exalted ideas about the place of the artist in the community. After the apathy of Montreal it was exciting to meet such a man.

Looking back after all these years, I can think of no one who has so consistently devoted himself to increasing the public's interest in the arts, and upholding the ideals of the artists in Canada. In 1913, however, he was planning a more practical form of aid for artists. With his friend, Dr. MacCallum, he was engaged in constructing a building in Toronto where artists might live and work in comfort.

J. E. H. MacDonald, while he lacked the energy and initiative of Harris, was probably the first to dream of a school of painting in Canada that would realize the wealth of motifs we had all round us.

[24]

His canvas, "Tracks and Traffic," painted in 1912, was a break from the general run of stereotype compositions. That he was a designer before he was a painter is evident in almost everything he painted. He was, too, an ardent naturalist who loved, in his designs, Canadian motifs—the trillium, pine trees, blue jays, and various kinds of wild life. In his early paintings there were always to be found the homely things around the farm house, the wood pile, the picket fence, the pump, shingled roofs, pumpkins ripening on the back verandah, the kind of thing other painters ignored. He taught Tom Thomson much about design; later it was the big Thomson canvases that inspired many of MacDonald's own notable paintings.

June in Berlin was not very exciting for an artist. I painted a portrait of my aunt's dog, a frieze around her bedroom, some still life, and then I departed for Georgian Bay. I stayed at the Breithaupts' summer cottage in Penetang for a time, taking the young people out sketching; then I moved to the islands where I lived with my cousins, the Clements, and their neighbours, the Williams. Swimming, paddling, fishing, exploring, and looking for wild flowers, I forgot for the time being the problem of earning a living. Then the summer came to an end, the houses were closed up and my friends departed, leaving me a lot of surplus supplies. I moved into a bathing shack on Portage Island and started to paint seriously.

It was late in September and it became obvious that it was going to be difficult to keep my living quarters warm. There were large cracks between the boards through which the cold came pouring. I was at work one day covering them up with birch bark, when a motor-boat nosed on to my beach. The owner introduced himself; he was Dr. James MacCallum, the friend of Lawren Harris. He wanted to see the work I was doing. I showed him, and he liked it. Then he inspected the shack, pronounced it rather draughty, asked how long I was staying, and when I told him till the end of October, he said he would send someone to take me to his place at Go Home Bay where I could live in a comfortable house. When he started back I went along with him part way towards Penetang with my boat in tow.

"Where are you going when you leave the Bay?" he asked.

I said that I would probably go to the States.

"If all you young fellows go off to the States," he growled, "art in Canada is never going to get anywhere."

Then he made me a surprising proposition. If I would take a

studio in the building he and Harris were having erected, he would guarantee my expenses for a year. Of course I accepted.

Billy France, who was a year-round resident on the Bay, came to take me to the Doctor's island. Arthur Lismer and Mrs. Lismer, with a six-months-old baby, were waiting on the dock with their luggage. France took them to Penetang and I settled into Dr. MacCallum's house and began to work.

After painting in Europe where everything was mellowed by time and human association, I found it a problem to paint a country in outward appearance pretty much as it had been when Champlain passed through its thousands of rocky islands three hundred years before. It was a perfect autumn; there were a few snow flurries, but no cold weather. I did a lot of work, both canvases and sketches. The canvases were direct transcripts from nature. One of them, "Maple in the Pine Woods," was among the paintings that later roused to anger the critics of the Group of Seven. It wasn't sold for forty years.

Paddling around islands and exploring intricate channels and bays that cut into the mainland provided me with much material. I made studies for "Terre Sauvage," the first large canvas of the new movement. Then at the end of October I closed up the house, rowed to Whelan's, met a man going by boat to Penetang and went with him. It was more than five years before I saw Georgian Bay again.

In Toronto, Lawren Harris had a studio on the top floor of the branch of the Bank of Commerce at Bloor and Yonge Streets; it is now occupied by the Toronto Ladies' Club. I stayed there until the Studio Building was ready for occupation, working on the large canvas, "Terre Sauvage," which MacDonald called Mount Ararat, because, he said, it looked like the first land that appeared after the Flood subsided.

One day, Dr. MacCallum brought to Harris' studio a shy young fellow by the name of Tom Thomson, who had just returned from Algonquin Park with a number of sketches, meticulous but faithful records of rough bush country. Thomson, like Lismer, Varley, and MacDonald, was an employee of the Grip company, and Dr. MacCallum was trying to persuade him to drop commercial art and devote all his time to painting. Thomson was dubious about his ability to make a living out of his painting, doubtful also of his own talents. MacCallum made him the same offer he had made to me: to guarantee his expenses if he would devote a year to painting. At first Thomson would not entertain the idea. He wanted to paint for his own pleasure and to

[26]

earn his living at commercial art. He enjoyed going off with his canoe and a tent for three or four months of the year to paint, but to make painting his life work, he felt, was to take his abilities too seriously. However, in his boarding house on Isabella Street, we talked it over on several occasions and finally he decided to try it for a year. Early in January 1914, Thomson and I took over a studio together in the new building, then almost completed, and settled down to work.

It was Harris' belief that if conditions favourable to the artist were created, good results would surely follow in his painting. But the human element is very complex; some of Harris' hopefuls did not share his ideas or enthusiasm. They got big studios for low rents and went their own ways. Some of them did not even remember to pay the rent.

Curtis Williamson was one of the original tenants in the Studio Building. Older than the rest of us, he had till then worked in a dark little studio in the Toronto Arcade. He was a Beaux Arts man, who had spent some years in Europe and who in his work reminded me of Delacroix. Aloof, proud, scornful of anything superficial, he was a good technician and should have been outstanding as a portrait painter, but his harsh criticism of his own work was against him. He would undertake a commission, then, after the sitter had posed for him a dozen times, he would rip up the canvas and quit. He never did find himself as an artist. Williamson had no sympathy with what we were doing and not much respect for anything done in Canada. Once MacCallum showed him some of Tom Thomson's sketches, and asked him, "What do you think of these?"

"Who are they by?" asked Williamson.

"Why do you need to know who they are by in order to express an opinion?"

"Well," said Williamson, candidly, "they might be by some blighter I dislike."

Arthur Heming was another of the original occupants of the Studio Building. It was generally believed that Heming knew more about the north country than anyone else in Canada, and Harris hoped he would inspire a northern movement. In the Studio Building all he did, however, was to make pencil portraits of pretty women. He told me once he had returned to Canada from the States where he had worked as an illustrator in order to help Canadian artists to a higher level of achievement, and he felt he was not appreciated. He said to me one day, "They bite the hand that feeds them." I had many conversations

[27]

with him; his talk was always about his experiences in the United States, his acquaintance with the Woodrow Wilson family, and his life at Lyme, Connecticut. In his book, *The Drama of the Forest*, he writes that he made twenty-three trips into the north country. I do not remember that he ever mentioned the north country or expressed a desire to go there.

J. W. (Bill) Beatty had a studio in the building from the time it was erected until he died in 1942. He loved the north country, but could never free himself from traditional ways of painting. He disliked the Academy and the Group of Seven about equally, and was never restrained in expressing his views on both. Beatty was a most likable person, warm-hearted and, to most people, generous.

About all that Williamson, Heming and Beatty had in common was a hearty dislike of one another.

Apart from the notable contribution made to Canadian art by Harris himself, the work done there by MacDonald and Thomson alone was well worth all the effort and expense involved in putting up the Studio Building. The building was a lively centre for new ideas, experiments, discussions, plans for the future and visions of an art inspired by the Canadian countryside. It was, of course, to be a northern movement.

We were inclined to be very vocal about our ideas. Harris and I wrote letters to the papers, criticizing the National Gallery for its neglect of Canadian art. We expected to be black-listed by the Gallery for our effrontery; instead of that, Sir Edmund Walker, who was Chairman of the Board of Trustees, came around to see Harris and asked to know what all the fuss was about. Harris told him of our intention to paint our own country and to put life into Canadian art. Sir Edmund said that was just what the National Gallery wanted to see happen; if it did, the Gallery would back us up. The Gallery was as good as its word.

Tom Thomson was a dedicated artist, and a good companion. He was a friendly chap, tall, good-looking, lithe and quick in his movements, the result of his being in a canoe so much. We had much to talk about; he would tell me about canoe trips, wild life, fishing, things about which I knew nothing. In turn I would talk to him of Europe, the art schools, famous paintings I had seen and the Impressionist school which I admired. He had seen nothing in the way of art except the second-rate paintings which came to the Canadian National Exhi-

bitions in Toronto. He had an intuitive appreciation of what was good in painting, but apart from what was being done in Canada, there were few examples of the work of contemporary artists to be seen.

A movie on Saturday night was all we could afford in the way of recreation. Thomson was not a great reader, but if he found a book that interested him he would sit up all night to read it through, then go on with his work without a break for sleep.

From time to time Dr. MacCallum would drop in, look over our sketches and pretend to be very critical of them. "You fellows must have something wrong with your eyesight," he would say. Then, just before he left, he would add, "Well, I think I'll take this one along with me," and he would dig into his pocket for some bills.

Many of our young artists spend years learning the technique of painting, and then are turned loose with no particular convictions about what to paint. With Thomson there was no uncertainty at all about what he wanted to do. His task, and one in which he succeeded, was to acquire a technique that suited his purpose perfectly.

For Thomson, the only country he knew or cared about was the bush country of northern Ontario. He talked of his beloved Algonquin Park so much that I decided to see it for myself. I arrived there late one night in February and was met at the railway station by Shannon Fraser, who ran the boarding house on Canoe Lake where Thomson made his headquarters. It was forty-five degrees below zero. Next morning it was milder, only twenty below, so I put on my snowshoes and went off exploring. I saw a patch of spruce woods that looked interesting, but I did not investigate it; a pack of wolves which had killed a deer started howling from the edge of the woods, and this was sufficient to deter me.

Thomson's name was a password in the country. I met all the natives: Bud Callaghan and Mark Robinson, the wardens; Larry Dixon who did a little poaching; and the Fraser family. Theirs was a ragged country; a lumber company had slashed it up, and fire had run through it. Then the lumber company had gone bankrupt, and now all that was left of the mill was the old boarding house which the Frasers ran.

Thomson was much indebted to the lumber companies. They had built dams and log chutes, and had made clearings for camps. But for them the landscape would have been just bush, difficult to travel in and with nothing to paint.

Shortly after I returned to Toronto, Thomson went to Canoe Lake

with Lismer. It was Lismer's first adventure of that nature and very thrilling for him; on the other hand his loose style of impressionistic painting was a revelation to Thomson, whose work up to that time was inclined to be factual and meticulous.

About the same time Bill Beatty got a commission for himself and me to paint in the construction camps of the Canadian Northern Railway which was laying track through the Rocky Mountains. It was an exciting prospect for me particularly, since it would afford my first glimpse of the Canadian West. We travelled first to Saskatoon, then from Saskatoon we went to Calgary by Canadian Northern over a road recently strung across the prairie. It was very rough; every now and then the engine broke loose from the train and had to back up and pick us up.

On this trip I saw my first cowboy. There were two of them on the train, drunk and so noisy that the conductor threatened to put them off. Beatty and I were in a double seat talking to a big husky traveller who was telling us about the country through which we were passing, when we stopped at a half-finished station for refreshments. The conductor was standing below just outside our window, when one of the cowboys came up from behind and hit him a blow on the chin, knocking him cold. In two seconds our big friend was out of the train and had handcuffs on the cowboy. There was not another squeak out of him all the way to Calgary.

The day of our arrival at the camp in the Yellowhead Pass, the engineer, Howard Dixon, took us around. The Canadian Northern was being built on the south side of the Fraser River up above the Grand Trunk Pacific. There was no place for a camp on the south side which went steeply down to the river, so the camp was strung along the north bank. The valley was narrow, but there was plenty of room for a camp. The men going to work crossed the river on temporary bridges and the engineer led us on to one of these. There was a pier in the middle of the river and one on either bank, from which big spruce trees ran out to the centre pier. The water was high and when we stopped on the centre of the bridge it made such a roar we could scarcely hear the engineer shouting to us, "This bridge was supposed to have been washed out last month." If the bridges stood up through the June floods they would usually hold for another year.

Crossing these bridges at night was an experience. One day I had been exploring the country to the south with one of the engineers. We

planned to be back in time for supper but we got into a stretch of brûlé which held us up for hours. It was pitch dark when we reached a point opposite the camp. There a railway bridge was only partially constructed. It was at the trestle stage and consisted of a single line of planks strung across; below it lay the swiftly flowing river. Across the river we could see the lights of the cookhouse and the cook made good pies. With such an incentive, of course, we made it; but we needed an incentive.

Working from the tracks was not very exciting, so I took to climbing the mountains. The chief engineer did not approve of my going alone, and he arranged that I should always be accompanied by one of the staff. There was no lack of volunteers. The young engineers were tough, husky boys who had much to teach me. I learned from them how to get about in the mountains with neither blankets nor tent, on a diet restricted to bread, oatmeal, bacon and tea. Most of my trips were made with Bert Wilson, one of the engineers. We had good times in the mountains, and exciting ones. We took many chances, sliding down snow slopes with only a stick for a brake, climbing over glaciers without ropes, and crossing rivers too swift to wade, by felling trees across them. I made many sketches which were never used, as the railway which had commissioned them went bankrupt during the war. Later I came to the conclusion that mountains were not in my line, and I kept throwing the sketches into the furnace until there was none left.

I was returning from a scramble over the mountains one day when I met the guide, Curly Phillips. His first words were, "What do you think about the war?"

"What war?" I asked.

Then Curly told me that all Europe was at war, and that Canada was in it, too.

In the autumn, when I joined Thomson in Algonquin Park on my return from the Rocky Mountains, I found that he had made remarkable progress. He was a good designer, but he had not before realized that his abilities could be put to good use in simplifying, eliminating and reorganizing the scene before him. He had a fine colour sense too; he loved paint and put in on with a full brush.

That autumn of 1914 was wonderful, with sunny days and frosty nights and after the mountains this intimate landscape appealed to me. We camped first below Tea Lake Dam. It was here that I made the sketch from which later I painted "Red Maple." Then we moved on

to Smoke and afterwards to Ragged Lake. Thomson was an expert canoeman who paddled like an Indian. Using the weight of his body more than his arms, he could keep going all day with no sign of fatigue. I sat in the bottom of the canoe keeping a lookout for subjects. In the evening, by the camp fire, we discussed plans for the next day while we cooked good husky meals. Thomson's specialty was making bannock and flapjacks; mine was doughnuts. We worked on little $8\frac{1}{2} \times 10\frac{1}{2}$-inch birch panels; travelling by canoe and living in a tent made it impossible to work on larger sizes.

Sometimes Thomson got discouraged. I remember one night, after a frustrating day, he hurled his sketch box into the woods and said he was going to paint no more. The next morning we hunted for the box, found it, and took it to Bud Callaghan to be repaired.

The maple, the birch and the poplar ran their gamut of colour and finally the tamarac tinted to shimmering gold; falling leaves and snow flurries made us aware that the sketching season was over. There was a war on too; in Algonquin we heard little about it and hoped it would soon be over. When we reached Toronto, however, we realized that we had been unduly optimistic, that the war was likely to be a long one, and that our relatively carefree days were over.

In Toronto I worked up the painting "Red Maple." At the same time Lismer was painting "The Guide's Home." Both were shown at the Academy exhibition, and were purchased for the National Gallery. But I could not settle down to serious work. The war made me restless. Besides, the year during which Dr. MacCallum had undertaken to guarantee my expenses was now up. I left Toronto and returned to Montreal with the intention of joining the army.

After I left, Thomson could not afford to pay the rent of the studio alone and he moved into the shack, an old cabinet-maker's shop behind the Studio Building. He had had a great year, and he believed now that a field of adventure in painting lay ahead for him. True, he lived in a shack and had no money, and only a very few people had any faith in him. None of this dampened his ardour or weakened his determination to devote himself exclusively to painting.

The desire to liberate art from stale traditions arose in Montreal and Toronto at about the same time, but with quite different intentions. In Montreal it sprang from the radical art movements in France, reaching us through the work of J. W. Morrice. In Toronto it derived from the conviction that our own country could inspire us

[32]

to create an art that did not depend on Europe at all. The paintings of Morrice and Thomson symbolize the two ideas.

It was not Thomson who projected the new art movement. When I arrived in Toronto in 1913, the idea of a form of art that was to develop here was fairly well crystallized, and MacDonald, Harris and Lismer were all enthusiastic about it. Nor was it he alone who directed the movement towards the north. There were a number of other artists who shared his love of the north country, who paddled and camped, worked as fire rangers and sketched in every corner of it. Among these men were Ab Robson, Tom McLean, Bill Beatty, Tom Mitchell, Neil McKechnie and others. Thomson was never a member of the Group of Seven; his untimely death prevented that. Yet his contribution to the movement that eventually found expression in the Group cannot be measured.

There is an old saying that "Gazing man is keenest fed on sparing beauty." To most people Thomson's country was a monotonous dreary waste, yet out of one little stretch he found riches undreamed of. Not knowing all the conventional definitions of beauty, he found it all beautiful: muskeg, burnt and drowned land, log chutes, beaver dams, creeks, wild rivers and placid lakes, wild flowers, northern lights, the flight of wild geese and the changing seasons from spring to summer to autumn. He was never able to do much sketching in summer, since he was compelled to supplement his meagre income by acting as a guide and taking out fishing parties.

When you look over Thomson's sketches, you are struck by the slightness of the motif which induced the painting; he made endless variations on the same subject matter. Imagination and fine craftsmanship endow it with a life of its own. Seldom, in his painting, is there the feeling of being tied down to a particular place.

"The power of the imagination is put to very feeble use if it seems merely to preserve and reinforce that which already exists." Thomson realized that. He gave us the fleeting moment, the mood, the haunting memory of things he felt.

Most of what we know about Tom Thomson has been recorded in a little book by Blodwen Davies. Many articles have been written about him but these add little to what we already know. He left no records or letters. He was a silent man, interested in the technical side of painting, not the theoretical or philosophical. He took many chances, running rapids alone, paddling in stormy weather, carrying a canoe

across rough portages, yet he died on a quiet day with only a drizzle of rain, a few yards from shore in a small lake he knew intimately. He was unknown except to a few friends and his death passed almost unnoticed. It was not till years later when he had been acclaimed a genius that strange tales were told about his having been the victim of foul play. These tales persist, as do others of mysterious canoemen who are supposed to haunt the lakes he frequented, and who disappear suddenly when hailed.

I never saw him again after we said good-bye in Toronto.

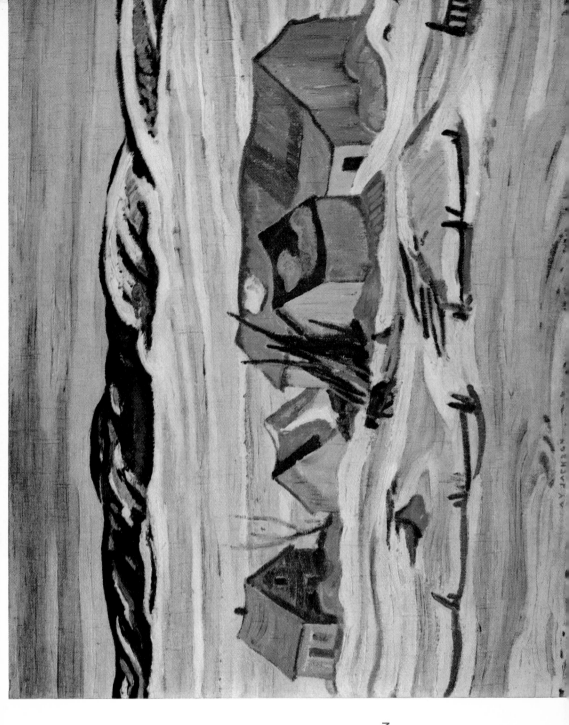

ROAD TO ST. SIMON
1946
In the collection of
Mrs. H. A. Dyde,
Edmonton

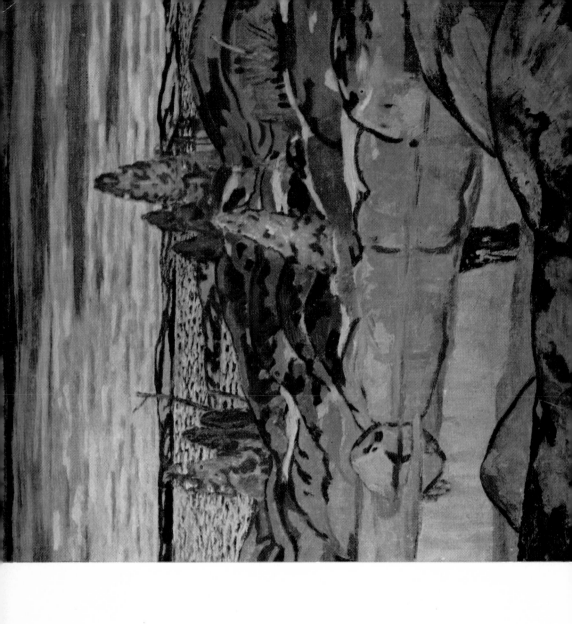

NOVEMBER, TADENAC,
GEORGIAN BAY
1925
In the collection of
Pickering College,
Newmarket

V
Army Life

AT THE end of 1914 recruiting for the Canadian Army seemed less urgent than it had been. Many people still believed that the German drive would collapse, or that the blockade would force them to quit. In Montreal, the war had had a depressing effect on the arts, and the rather meagre patronage we had enjoyed had almost dried up. William Brymner, who conducted the Art Association classes, was perhaps the only artist making a decent living. Maurice Cullen continued his one-man campaign to depict the Canadian landscape without modifying it to please conventional tastes; Albert Robinson had found a job as inspector in a munitions plant; and Randolph Hewton was in the 24th Battalion which was about to go overseas. For a short time I taught a life class for William Clapp, who was ill. Then I went to Emileville, where I had worked with Hewton two years previously, and painted several canvases out of doors. At the railway station one morning I heard the first news of the Battle of St. Julien. I knew then that all the wishful thinking about the war being of short duration was over.

I remember a poster which ended any doubts I had about enlisting. "You said you would go when you were needed," it proclaimed in large letters. "You are needed *now*." Lawren Harris wanted me to apply for a commission and offered to defray all expenses in connection with it, but I knew nothing about soldiering, and decided to start at the bottom as a private in the infantry. Accordingly, I enlisted in the 60th Battalion. We were a mixed lot and looked pretty tough before we were issued uniforms. From Montreal we moved to Valcartier for training. The recruiting campaign was running at full speed now, and the newspapers were printing articles about the fine type of men

who were enlisting. When a eulogistic article appeared about a well-known artist who had joined the 60th, my platoon commander was so embarrassed that he started calling me Mr. Jackson.

In the 60th Battalion we were neither heroes nor idealists. The conversation in the tents was seldom over the head of the least intellectual member of the group. Religion, patriotism, culture were not discussed at all; but among us there was goodwill, a rough sense of humour and a spirit of independence that resisted too much regimentation. Our Captain, Fred Shaughnessy, was a prince. He knew the name of every man in the company and we all regarded him as a personal friend.

After more than forty years I still look back with a feeling of affection and admiration for many old comrades, whose names live in my memory: Aspinall, Mackay, Woolgar; Jimmy Baird, who after three years in the line was wounded the day of the Armistice and died two days later; and Teddy Eaton, a youngster of sixteen, who later as a pilot brought down a dozen German planes. Teddy was my first convert to the arts. We had to draw defence plans of the Valcartier district, and in Teddy's plan, under the heading "Military Information," he indicated a farm house where chocolate bars and soft drinks were obtainable. There was an Arthur Jackson in the Battalion; we got acquainted because each of us kept getting the other's mail, and we have been in correspondence with each other ever since.

After four months at Valcartier we returned to Montreal for a short time. Sunburned, hardened, disciplined, few would have recognized in us the ill-assorted, motley crowd of civilians that had left the city such a brief time before. Then we were on the high seas. There followed four months' training in the mud and rain in England and we were in France. The flag waving was over.

Our first day in France was not auspicious. We marched through Le Havre in snow and slush, with no one taking any notice of us. A five-mile march brought us to an empty camp in the dark; the flaps had not been tied up and the tents were full of wet snow. And, army-fashion, our field kitchens had gone astray. We crawled into the tents and huddled together for warmth, having had nothing to eat since breakfast.

But Flanders in early spring was beautiful, as was Ypres by moonlight and the weird ruined landscapes under the light of flares or rockets. Apart from a few diagrams, enlargements from maps and plans

of the sectors we were in, I had no chance of doing any sketching.

My opportunity to paint again came after I had been wounded at Maple Copse in June 1916. At the end of a long, miserable journey in a hospital train, I found myself in a landscape of sand dunes and clumps of pine which looked familiar, and I realized we were coming into Etaples where I had lived for over a year when I was a student. Some months earlier I had seen it announced that McGill University was to establish a hospital unit at Etaples; it was in this hospital that I landed. My old friends, Baker-Clack and his wife, were still at Etaples. I told my nurse I had once lived here and wanted to get in touch with my friends. She thought I was imagining things, but through a friendly chaplain I was able to send word to them. When Clack came to see me, his first question was, "Where were you hit, Jackie?" I said I had a bullet in the shoulder. He looked incredulous. "Perhaps you have forgotten," he said, "but from Montreal you wrote me last year that you would probably be landing at Etaples with a bullet in your shoulder."

From Etaples I was moved to various hospitals in England—Norwich, Brundall and Epsom; then I was attached for three months' light duty to the Army Post Office at Hastings. Everything was a mess there. In typical army style no one with post office experience was wanted in the Army Post Office. In addition to myself, there was a bricklayer, a motorman, a gardener, a boxer, and my old friend Woolgar, who was an electrician. Whenever an officer came along we all tried to look very busy, but, in fact, life was very dull in the A.P.O., with little to do. Some of the boys relieved the tedium by steaming open letters of an intimate nature, which, they had learned, were being received by some of their comrades, and reading them aloud for the entertainment of the rest of us. Our big excitement, however, was the weekly visit to the local cinema to see Pearl White in the motion picture serial, *The Iron Claw*. On one memorable occasion a circus which was mostly made up of little side shows came to town. Woolgar and I went in to see the tattooed lady, who squirmed about showing off the serpents and dragons with which her back and arms were covered. Unimpressed by all this, Woolgar called out, "Is that all we're going to see?"

"It's all you're going to see for tuppence," replied the lady.

Then I was transferred to the reserve battalion at Shoreham. I have no pleasant memory of my stay there. There was not enough food and too many military police; also the soldiers, who were mostly

convalescent casualties, were drilled and disciplined by men who had not been to France. An air raid warning was sounded one morning, and we were ordered to stay indoors. The boys spent their time there praying the German pilots would find our camp and drop a bomb on the O.C.

I was at Shoreham when I received, from J. E. H. MacDonald, a letter telling me about an empty canoe and an artist missing in far-away Algonquin Park. The thought of getting back to the north country with Thomson, and going farther afield with him on painting trips after the war was over, had always buoyed me up when the going was rough. Now I would never go sketching with Tom Thomson again.

One evening the Sergeant-Major came over to my hut.

"An officer to see you, Jackson, at my place," he said.

It was Captain Fosbery of Ottawa. I stood to attention and saluted him. "Forget all that stuff, Jackson," he said, "we are just artists together." He told me about the Canadian War Records which was being formed for the purpose of making a pictorial record of Canada's achievements in the war. Fosbery, who had been wounded, had been to see Lord Beaverbrook, the organizer of the Canadian War Records. All the artists so far engaged were British; Fosbery had suggested to Beaverbrook that they should give some of the Canadian artists a chance. Beaverbrook approved of the idea in principle but said he did not know of any Canadian artists. Fosbery went to the Red Cross Office. The girl at the information desk there was my old friend, Lilias Torrance (later Newton), who knew where I was, and this had brought Fosbery to Shoreham.

A few days later I received orders to report to London for an interview with Lord Beaverbrook. At the Shoreham Station I bought *Canada in Flanders*, a book written by His Lordship, and read it on the way to London. I waited at the War Records Office until Beaverbrook came in. The conversation which ensued was brief.

"So you are an artist? Are you a good artist?"

"That is not for me to say, sir."

"Have you any of your work with you?"

"I have been in the infantry for over two years and cannot carry it with me."

"Can you find any of your work?"

"I might find some examples in *The Studio*."

"*The Studio*? What's that?"

I explained that it was an arts magazine and he advised me to try and find some copies.

"So you are in the 60th Battalion?" he asked. "Your Colonel does not like me."

"That's no concern of mine, sir."

"Have you read my book?"

"Yes, sir."

That ended the interview. I went on to the offices of *The Studio* where an obliging clerk looked up some back numbers with articles on my work, which I took to his hotel to show His Lordship. They were very flattering opinions and he was impressed by them. I did not tell him they were written by my old friend, Mortimer Lamb.

I arrived back in Shoreham just in time to get mixed up in a mutiny. The company of which I was a member refused to go on parade. The poor food and bullying by N.C.O.s had been too much for us. A sergeant-major came around to ask the men to appoint a spokesman to present their complaints to the captain. I was older than most of the others, and they chose me to represent them. I could not refuse, neither could I tell my comrades that I expected a transfer shortly, for my posting to the Canadian War Records had already come through. The captain was worried about the whole affair. He said he was aware the food was rotten, and that he had been complaining about it to the proper authorities, who paid no attention to him. "Now," he said, "it will all be reported to Headquarters, so tell the men to go on parade this afternoon." Which I did. I was happy to get away from Shoreham.

I had to see Lord Beaverbrook again. I awaited his arrival in his office where his little secretary, Sgt. Alexander, had his mail all arranged in piles of greater and lesser importance. He was poised with his notebook ready when His Lordship blew in like a cyclone. Beaverbrook read rapidly through the first letters, and began a running fire of instructions to Alexander. "Tell Winston Churchill I will have lunch with him tomorrow at one. Tell Bonar Law I will see him at eight o'clock tonight. Tell Lloyd George to meet me on Thursday afternoon at four." He looked at me; for a moment he had forgotten who I was. Then, "Alexander," he said, "make this man a lieutenant." And he was gone as swiftly as he had come.

It was thanks to His Lordship that I was spared the Passchendaele show. I heard later that nearly all the men who were involved in the mutiny at Shoreham were shortly afterwards drafted off to the front.

My first assignment as a Canadian war artist proved, if nothing else, that army practice operated even in the War Records. The Adjutant

sent for me one afternoon. I went to his office, stood to attention, and saluted.

"Do you paint portraits, Jackson?" he asked.

"No, sir, I am a landscape man."

"Well, anyhow, we want you to go to No. 3 Earl's Court; there is a large studio that has been taken over by the Canadian War Records. There you will find canvas, colours, everything you need. You'll also find Corporal Kerr, V.C., of the 49th Battalion. We want you to paint his portrait."

I went to No. 3 Earl's Court. Kerr was there, a tall Westerner who had captured sixty-two Germans all by himself, for which exploit he had been awarded the V.C. I told Kerr he was out of luck; they had sent a landscape painter to do his portrait. He said that was O.K. with him; he had been given ten days' leave to have it done. With considerable trepidation I started. The Press had announced that all the Canadian holders of the Victoria Cross were to have their portraits painted by outstanding British artists. Hanging over me was the prospect of being returned to the infantry if I failed in this first assignment. I drew in the head and rubbed it out many times; later I scraped out the painting until finally I got a passable likeness and took no more chances. I was still a private, but on the last day when I went to put in the highlights, my commission and my uniform had both arrived and I put on the final touches as a lieutenant, much to the amusement of my sitter.

The next day I went to France. When I reported at Headquarters the Staff Major said, "One of Beaverbrook's men, eh? I'd cheerfully shoot him through the back."

What to paint was a problem for the war artist. There was nothing to serve as a guide. War had gone underground, and there was little to see. The old heroics, the death and glory stuff, were gone for ever; there was no more "Thin Red Line" or "Scotland For Ever." I had no interest in painting the horrors of war and I wasted a lot of canvas. The impressionist technique I had adopted in painting was now ineffective, for visual impressions were not enough. Elsewhere, along with many literary paintings of war, works of keener import were appearing: Paul Nash's "Void," Wyndham Lewis' "Gunpit," Roberts' "Gas Attack," and others in which line and movement were used with dramatic effect. The old type of factual painting had been superseded by good photography.

My first work was back of the lines in the Vimy-Lens sector. Most

of it consisted of charming landscapes. I worked largely from notes made in the line, using abbreviations for tones and colour. Away from the line I used my sketch box. I had a small studio on Charlotte Street, London, where I worked up my canvases. The Adjutant asked me one day how it was I produced so much work and yet cost the War Records less than any other artist on the staff. I told him that if the others had been in the ranks for two years they would know when they had a cushy job.

The War Records Unit moved to Poperinghe at the time the Canadian Corps took over the Passchendaele operation. We were given an isolated house near the railroad station; it was not a comfortable location as German bombers were around every night trying to get the station, and if there were bombs left over they dumped them in our vicinity. D. Y. Cameron, the Scottish painter, arrived at Poperinghe while we were there. He was very apologetic about his rank of major, which he had not wanted. "You know, Jackson," he said, "all these fine young Canadians saluting me is not right. I should be saluting them." He was a very likable and modest person. I went to Ypres with him several times where he got material for two notable canvases, "Flanders from Kemmel," and "Refugees," both of which are now in Ottawa.

Drizzle, rain and mud and the costly and useless offensive at Passchendaele took the heart out of everybody. It was good to get away from it and back to London. By this time I was quite used to being an officer. Back at the War Records Office in London, I dropped in to see the Adjutant. Last time I had stood to attention and saluted; now, quite nonchalantly, I said, "Hello, Watkins." We had a chat and then I asked him about the portrait I had done of Corporal Kerr. "It was fine," he said. "We want you to do two more."

In the spring of 1918 I stayed for a while with the Third Brigade Artillery at Liévin. As a war artist I did not receive much of a welcome from the troops until they found that earlier I had been in the line with the infantry. Then they could not do enough for me. The country round Lens was exciting, in a way, for an artist. The permanent lines had long been established, and back of them was a swath, about five miles wide, of seemingly empty country, cut up by old trench lines, gun pits, old shell holes, ruins of villages and farm houses. In the daytime there was not a sign of life. Of all the stuff I painted at Lens the canvas I liked best was "Springtime in Picardy," which showed a little peach tree blooming in the courtyard of a smashed-up farm house.

I remember a Sunday afternoon, warm and sunny, when the war

seemed to have been called off. We were sitting outside our concrete shelter at Liéven playing with Pagoda, a friendly little mongrel. With no warning at all a shell from a German naval gun came roaring over us, and we all toppled into the shelters. A few minutes later we looked out; the only sign of life was Pagoda sitting in the middle of the road wondering where his friends had gone.

I went with Augustus John one night to see a gas attack we made on the German lines. It was like a wonderful display of fireworks, with the clouds of gas and the German flares and rockets of all colours. John was getting material for the big decoration he had been commissioned to do for the projected War Records Gallery in Ottawa, which was never built. The cartoon only was completed. He was making studies of Canadian soldiers. With Lt. Douglas of the War Records it was my task to help select some typical Canadian soldiers for John to paint. The studies were outstanding.

Most of the artists with the Canadian War Records were British. In Canada it was urged that more Canadians be commissioned, so in the spring of 1918 Maurice Cullen, J. W. Beatty, Charles Simpson and Fred Varley came over, all with the rank of Captain. Cullen was rather self-conscious about his rank; he had four stepsons at the front (one of them, Robert Pilot, was later President of the Royal Canadian Academy) who were all in the ranks, and Captain Cullen had to put up with a good deal of chaffing from his boys. Getting to the front in 1918 was difficult. Simpson did not get to France at all and Varley not until the final offensive had started. But it was an exciting time and Varley responded by painting some of the finest work in our war records. I was not in France during these days. Simpson and I had received twenty-four hours' notice to go to Siberia with the expeditionary force which was being organized to support the White Russians, and we found ourselves back in Canada receiving instructions and getting information about extra equipment. The Armistice was signed while I was in Canada and the Siberian affair collapsed. All I got out of it was twenty tubes of white paint. It was probably this paint that was responsible for my becoming a snow painter as I had to find some use for it.

There was a big exhibition of Canadian War Records work in London before the paintings were shipped to Canada. The press notices must have been very confusing to the reader. There were paintings there made from preconceived ideas of war, using all the old

formulas, and there were others, more modest in size, made from personal observation. These are some excerpts from the press notices:

"Augustus John is the greatest disappointment in the show."

"Augustus John has done the greatest decoration of modern times."

"The finest work in the exhibition is 'Canada's Golgotha' by Derwent Wood."

"The outstanding work is Richard Jack's 'Vimy Ridge'."

If the critics had looked carefully they might have discovered the little thirty-inch canvas by Paul Nash, entitled "Void," which expressed more about war then all of the big twenty-foot canvases put together.

Early in 1919, through the efforts of Eric Brown, I was sent to Halifax to make some records of the returning troopships. Lismer had gone to Halifax in 1916 to take over the Art School there and was living at Bedford Basin, a few miles out of the city. It was like old times, swapping experiences with him, considering plans for the future and looking around for subjects to paint. I found material for a large canvas of the *Olympic* anchored in the middle of the harbour surrounded by tugs. Later I painted it up and exhibited it with the War Records; it was returned to me after the exhibition, since Records had no funds from which to purchase it. It was a nuisance in the studio, and a couple of years afterwards I shoved it in the furnace.

Finally, I was returned to Montreal to be discharged from the army. Then I went to Toronto where, in the Studio Building, a studio was awaiting me. After an absence of four and a half years, I set about trying to revive my interest in painting the Canadian scene, and to regain the excitement which had sustained me in the months before the war.

Several canvases I finished after the war were left on my hands. "The Entrance to Halifax Harbour" was purchased at Wembley for the Tate Gallery, London; "Springtime in Picardy" was acquired by the Art Gallery of Toronto, twenty-five years after I painted it; and the Art Gallery of Hamilton purchased "Evening—Riaumont" in 1953. I presented to the National Gallery a painting called "Liévin 1918."

VI
Home Again

THERE HAD been changes in the Studio Building during my absence. After I left in 1914, Thomson, for reasons of economy, had moved into the shack at the rear of the building. Harris had it re-roofed, put in a larger window, and made it quite snug, and rented it to Thomson for one dollar a month. He could save money there by cooking his own meals. Marion Long, a portrait painter, took over the studio that Thomson and I had occupied. Lismer and Carmichael worked with Thomson occasionally, but after Harris enlisted in the army and Lismer went to Halifax, Thomson was very much alone. Beatty and Williamson liked him but they were older than he was and not much in sympathy with our circle. Of the three winters he spent in the shack, we have scanty record. He painted about twenty canvases. "Northern River," "Chill November," "West Wind" and some smaller ones were most successful. Others not so good were "Autumn's Garland" and a large canvas of a waterfall. "Jack Pine" was long considered his masterpiece, but to-day "West Wind" is looked on as his most important work. Arthur Heming during the war sublet his studio to a gay bachelor who was requested to leave when the war ended. Harris moved into this studio.

I took a studio on the top floor of the building. All Thomson's work was stored there, "West Wind," "Chill November," and a dozen other canvases, and about two hundred sketches. They were not even insured. At to-day's prices they would be worth over a hundred thousand dollars.

After Thomson's death the shack was used occasionally by Williamson, Varley and others. Gradually it fell into disrepair; it was uncared

[44]

for, the roof leaked, the floor rotted and the back wall, built against a hill, gave way and mud flowed in. In this condition, it was rented by Keith MacIver, a prospector, who had seen worse shacks up north. He built a new roof, a floor and a concrete wall at the back, and the shed made a good winter home for himself and his dog, Brownie. The artists from the Studio Building took a hand in decorating the place. Among the paintings there on the walls were a mining town by Yvonne McKague, "Iceberg" by Lawren Harris, and a big osprey by Thoreau MacDonald, the son of J. E. H. A young German used to stay with MacIver occasionally, and Florence Wyle, to stir his aesthetic emotions, painted a nude over his couch. It was painted at night with a colour which in daylight was a violet pink, a German colour, and the lady was known from the name on the paint tube as "Hell Rosa."

MacIver was an interesting chap who had come to Canada from the Hebrides by way of Malaya where he had been a rubber planter, and Mesopotamia, where he had spent the war years. Here, he worked in a packing house for some time, then he went to Quebec to work for Frank Loring on a mining property. It was probably through Loring's daughter, Frances, the sculptor, that MacIver became associated with artists. Though he never took to painting, he felt a kinship with the artist fraternity. During the winter months when we were both in Toronto, he and I would take our meals together at the shack. On a number of occasions we went camping together, he to hunt for minerals and I to sketch. He made enough money staking properties for other people to keep him going.

MacIver's partner Swanson, who lived in the north, stayed at the shack on several occasions. He would recite poetry by the hour and argue about anything. He had a number of amiable eccentricities. For example, he read teacups admirably; whether through shrewdness or second sight, he astonished people with his accurate predictions and was fast becoming a tea-room celebrity. Swanson told me once he could hardly restrain himself from howling like a wolf at the corner of Bloor and Yonge streets. One lady described him as fascinating, but regretted that he was not housebroken.

After operating for years without making any money, MacIver heard of a property in Gaspé which contained some copper claims that had lapsed. He tried to get Swanson to charter a plane with him and stake the claims, but Swanson was not interested. MacIver went to Gaspé by train and paid some people to go forty miles into the bush to

[45]

stake the claims; a ten per cent interest was reserved for himself. He wrote out the agreement in pencil in a little notebook, and one of the others signed it. Some years later Noranda geologists investigated, then took up the claims. It was the only time MacIver ever made any money from mining claims. He had married, some time before, the daughter of Professor W. J. Alexander; nowadays he and his wife live on a little farm near Albion where they have a garden and grow their own vegetables. Swanson had died suddenly in the north country before the claims were taken up.

Part of the shack had never been used. When MacIver met a Russian cabinet-maker, who was down and out, he made the unused part into a workshop and installed Walter, who was a remarkable person, an artist at his work. He loved wood and took pride in everything he made; necklaces, violins, chairs, tables, everything was turned out to perfection. Walter was a philosopher with vast ideas which, even with his limited English, he somehow managed to communicate. His son served in the Canadian Navy during the second World War and his daughter in an aircraft factory. He himself made furniture to be raffled for war charities. He worked too hard and a heart attack finished the poor fellow.

The shack was the subject of an article in Toronto's *Saturday Night*, and of a film made for the National Film Board by Radford Crawley. I appeared in the film. In one scene I was to go to the shack for breakfast and whistle for Brownie, MacIver's dog. The rehearsal went off very well, with Brownie running out to welcome me when I whistled. A second run-through was equally successful. "Now," said Crawley, "we'll shoot, this time." The camera was set to roll; I made my appearance and whistled. This time there was no dog. Brownie had had enough and had vanished.

The shack is much less impressive than Casa Loma, but much more important historically. Thomson's best work was all produced in Toronto although Toronto did very little for him. He lived on next to nothing but, whatever economies he was forced to practise, he never saved money on colours. After he died his masterpiece, "The West Wind," was offered to the Art Gallery of Toronto for six hundred and fifty dollars. The offer was turned down. The canvas was sent to Wembley to the famous exhibition of which I shall tell later, where it was much admired. On its return the National Gallery proposed to buy it. At the last minute Dr. Harold Tovell persuaded the Canadian

[46]

Club to purchase it and present it to the Art Gallery of Toronto. But for Dr. Tovell's efforts there would have been not one of Thomson's canvases in the Gallery.

If there was any spiritual awakening as a result of the war it was not in evidence in Toronto; nor did it extend to the arts. There never had been less interest in painting. The returning soldier soon found it was advisable to say nothing about his war services. I realized that when I bought a suit of clothes which were a wretched fit. I went back to the store to complain to the merchant, an unpleasant person. All the satisfaction I got was, "Don't you come around here telling us how to make clothes." I realized it was my service badge that inspired this attitude, and I don't think I wore it again for ten years. As for the suit, I wore it on Georgian Bay to go fishing in.

MacDonald had advised me to send my canvas, "Terre Sauvage," to the exhibition at the Academy in Montreal. It had not been previously exhibited. The painting got past the jury as the work of a returned hero; immediately afterwards the row started. The critics tore it to pieces; only Mortimer Lamb came to my defence.

I had little desire to paint, but it was good to get back to Georgian Bay again that summer, to paddle and swim, to go fishing and exploring. Then, in the autumn, Harris arranged a sketching party in Algoma and had a box car fitted up with bunks and a stove to accommodate us. In addition to a canoe, we had a three-wheel jigger, worked by hand, to go up and down the tracks.

There were few trains on the Algoma Central Railway at that time. The railroad runs north for two hundred miles from Sault Ste. Marie to Hearst on the C.N.R., crossing the C.P.R. at Franz. It passes through country heavily wooded with birch and maple, poplar, spruce and white pine, a country of big hills that drop down steeply to Lake Superior. The rivers cut through the hills and fall down in a series of rapids and waterfalls to the lake. In October it is a blaze of colour. The box car became a studio, and the party consisted of Harris, Mac-Donald, Frank Johnston and myself. Our car was hitched to the passenger train or the way freight. When we reached a place where we wished to paint it was left on a siding where the only inhabitants were the section men.

I always think of Algoma as MacDonald's country. He was a quiet, unadventurous person, who could not swim, or paddle, or swing an axe, or find his way in the bush. He was awed and thrilled by the

[47]

landscape of Algoma and he got the feel of it in his painting. He loved the big panorama; "Solemn Land," "Mist Fantasy," "Gleams on the Hills" were some of the titles of his paintings.

The nights were frosty, but in the box car, with the fire in the stove, we were snug and warm. Discussions and arguments would last until late in the night, ranging from Plato to Picasso, to Madame Blavatsky and Mary Baker Eddy. Harris, a Baptist who later became a theosophist, and MacDonald, a Presbyterian who was interested in Christian Science, inspired many of the arguments. Outside, the aurora played antics in the sky, and the murmur of the rapids or a distant waterfall blended with the silence of the night. Every few days we would have our box car moved to another siding.

Since this country was on the height of land, there were dozens of lakes, many of them not on the map. For identification purposes we gave them names. The bright sparkling lakes we named after people we admired like Thomson and MacCallum; to the swampy ones, all messed up with moose tracks, we gave the names of the critics who disparaged us. It was during this trip that MacDonald made studies for "October Shower Gleam" and I got the sketch that I later painted into a large canvas, "October, Algoma"; both paintings were acquired by Hart House, University of Toronto.

The following year we rented a cottage in the same district, at Mongoose Lake. We asked a trapper how such a name got up there. He didn't know; all he knew was that a mongoose was a kind of a bird!

The Algoma country was too opulent for Harris; he wanted something bare and stark, so at the conclusion of one of our sketching trips he and I went to the north shore of Lake Superior, a country much of which had been burnt over years before. New growth was slowly appearing. The C.P.R. main line follows the north shore of Lake Superior from Heron Bay westward to Port Arthur. I know of no more impressive scenery in Canada for the landscape painter. There is a sublime order to it, the long curves of the beaches, the sweeping ranges of hills, and headlands that push out into the lake. Inland there are intimate little lakes, stretches of muskeg, outcrops of rock; there is little soil for agriculture. In the autumn the whole country glows with colour; the huckleberry and the pincherry turn crimson, the mountain ash is loaded with red berries, the poplar and the birch turn yellow and the tamarac greenish gold.

There were few places to stay in this country, so we took with us a

[48]

tent and camping equipment. We chose our camp sites with great care, always near water, protected from wind, and on ground that sloped away from the tent. In poor painting weather we built a big stone fireplace where we could sit and gossip until it was time to turn in. Whisky jacks soon found our camp, and came to it to pick up food; they would even swoop down and fly off with a slice of bread or bacon. A weasel came to the tent once and tried to steal our eggs; he refused to move and we had to push him out. We had no stove in the tent, so we dug a trench between our sleeping bags, which we filled up with hot embers from the fire. Then we would close up the tent and turn in comfortably even on cold nights.

When we camped near a sand beach we went in swimming although the water was very cold. Harris, who liked to have a system for everything, worked out one for bathing in cold water. We would start off far upon the beach, then run at the lake, waving our arms and yelling like wild Indians. This procedure was supposed to distract our attention from the cold water.

It was a strenuous life. Harris was up before daylight, making a lot of noise with pots and pans as he got breakfast. The rain would be pattering on the tent when Harris would call, "Come on, get up."

"What's the use of getting up," I would growl. "It's raining."

"It is clearing in the west," was Harris' invariable reply.

So I would get up, breakfast, and we would go off in the rain. Three days later when it stopped raining, Harris would say, "I told you it was clearing."

One of Harris' fads was for Roman Meal. He claimed it made us impervious to wet and cold, and we had a large bowl of it each morning. At a later date we got a folding stove for these expeditions; it was practical, it kept the tent dry and warm, but we couldn't see a glimmer of light from it. Harris dubbed it the gloom box.

Then the approach of winter sent us back to Toronto. The newspapers had been busy with our paintings in our absence, and had a great many unpleasant things to say about us and our work. One of them, commenting on Harris' painting, said that if it was allowed to continue it would discourage immigration to Canada.

The year I made my first trip to the Arctic, Lismer went with Harris to Lake Superior. It rained continuously. Harris carried a large sketching umbrella, and he kept on working while Lismer sulked in the tent. He had thrown his pack-sack in a corner; as he looked at it

[49]

with half-closed eyes, it began to assume the form of a big island lying off the mainland; the straps became a ridge of rock in the foreground and the light coming through the folds of the tent became an intriguing sky. When Harris returned there was a sketch in Lismer's box.

"Gosh, Arthur," said Harris, "where did you get that? It's a beauty, the best thing you've done."

There is a large canvas of Harris, entitled "North Shore, Lake Superior," which won the gold medal at an exhibition in Baltimore; it shows a big pine stump right in the centre of the canvas and Lake Superior shimmering in the background. Among the members of the Group it was known as "The Grand Trunk." I was with him when he found the stump, which was almost lost in the bush; from its position we could not see Lake Superior at all. Harris isolated the trunk and created a nobler background for it.

In May 1920 I was in Algoma with Harris when I received a wire that my mother was very ill. She died on her seventieth birthday before I arrived home. We had moved to Westmount during the last years, and our circumstances had become easier. My younger brother and I had come home safely from the war, so that cause of anxiety was over for her. My mother was always frail, and housekeeping in those days was not the simple matter it is to-day. She lived to see all her six children grow up; that we were devoted to her was all she ever hoped for. She was a sweet and gentle soul.

INDIAN HOME
1926
In the collection of
Miss Isabel McLaughlin,
Toronto

ARCTIC SUMMER
1952
In the collection of
Mr. and Mrs. R. E.
Dowsett, Toronto

VII

The Group of Seven

GEORGIAN BAY has been one of my happy hunting grounds for camping and fishing at all seasons, and in all kinds of weather. Few people have seen it in wintertime and I had an urge to do so. In February 1920 I went to Penetang where I was forced by bad weather to stay for some days. When the weather cleared, I put on my snowshoes and headed for Franceville, fifteen miles away. Crossing the wide gap between the mainland and the islands I followed an old sleigh track. At Williams' Island where I had spent several summers I sat on the dock and fortified myself with a bar of chocolate. It was strange to see all frozen up and lifeless, the little bays and channels where I had paddled in summer time with various charming companions.

I received a very warm welcome at Franceville. The Frances were a Yorkshire family who had settled there years before and ran a boarding house for a lumber company that later shut down. The air was clear and sharp during my stay and it was generally sunny. On snowshoes I went in all directions and found so much material to paint that I used up all my panels and had to paint on the back of them. We were almost isolated and seldom received any mail. Among our few visitors were two timber estimators, or timber wolves as they called themselves, named Sword and Stanley. They were very much at home in the bush, and though both were over sixty they were as hardy as young fellows of thirty. Stanley told me of an occasion when Sword went through twenty-eight miles of featureless bush and hit dead on a survey mark.

I amused the natives by carrying around with me a long pole in case I went through the ice. As the weather got milder, the ice got

rotten and open water appeared. I had a little dinghy mounted on runners which I would pole over the ice; when I came to open water I would shove the dinghy in and take to the oars.

Yorkshire people are wilful and independent. After Grandfather France's house burned down, he had to live with his son Billy. The old fellow got tired of this arrangement and announced to Billy one day that he was going to build a place of his own that would make Billy's look like a hen house. At the age of eighty, from all kinds of used material, he built a house that looked like a grain elevator. When it was time to start furnishing the rooms, people around who owned summer houses gave him some of their discarded things. Orville Wright, the famous inventor of the aeroplane, and his sister had an island near by, and Miss Wright, when the old man told her that in his youth in Sheffield he had played in a band, presented him with a flute. It was rather pathetic to hear the old man play "The Last Rose of Summer." However, a wind storm blew the top storey off his house and he had not the heart to replace it.

Orville Wright was the most modest of famous men. Perhaps because he was alone much of the time, he would confide in my friends, the Williams, with whom I often stayed. Among other things he told us of the difficult time he and his brother went through while they were at work on their invention. One year, when we stayed on into September, we found it difficult to get supplies after the boat service stopped. The most difficult item of all to secure was milk. Orville Wright, who had a big fast boat, went for his milk every second day, and picked up ours at the same time. We used to impress people by saying, "And who do you think we have as a milkman?"

As we drew closer to spring, the ice between Franceville and Penetang became too dangerous for travelling, and I was forced to stay on. The Frances ran out of feed for the horse and had to gather maple twigs. Social life at the Frances' was of the simplest. In the evening we sat around the old Hudson Bay stove and tried to pick up news on the radio. Before bedtime, Billy would say, "Will you 'ave a touch?" and would disappear into the cellar from which he would emerge with a jug of home brew. With biscuits and cheese it was good.

The ice got more and more rotten, but it seemed to cause no worry to the Frances. Young Wilf went through the ice, once, coming from Penetang with his dog team. He simply pushed his supplies up on the ice, crawled out, pulled the dogs out after him and went on. I saw

him, one day, with his dogs, tearing down the Freddy Channel when the ice was so soft that if he had stopped he would have gone through it.

Later I painted up a number of canvases from sketches made that winter, among them "Freddy Channel" and "Cognashene Lake" and, now in the National Gallery, "Storm over a Frozen Lake" and "Early Spring, Georgian Bay."

I have an old letter I wrote to J. E. H. MacDonald on St. Patrick's Day:

> France Villa,
> Via Penetang,
> 17th of Ireland, 1920

My dear Jim:

Still dull and windy, but the cold is no longer making the flake white hard and I have used a considerable quantity of it. We had a couple of strenuous thaws and the snow went off the ice and the south sides of the islands in a great rush; with sunlight it is finer than ever, only there isn't any such thing. This afternoon about four it cleared up and I beheld a most remarkable phenomenon. Whether it was a sign for Ireland or the future of Canadian art remains to be seen; anyway about four the sun came out, a cold wintry sun that made grey washed-out shadows on the snow; and then quite suddenly the whole sky seemed full of rainbows, sun dogs and other things. Directly overhead there was a brilliant rainbow, the blues and violets most intense on the west side; meeting this and forming a vast circle around the sun was a paler rainbow fading toward the horizon, and inside this another rainbow, on either side of it a sun dog of such brightness that it was almost like gazing at the sun. From the sun and through the sun dogs ran a line of light stretching almost entirely round the horizon. In the east directly opposite the sun was a whitish blur stretching upward, and in the line of light on either side, but much wider apart than the sun dogs, were two more blurs of light. It lasted over half an hour, getting fainter and then brilliant again, sometimes one sun dog disappearing entirely; then it faded until nothing was left but the sun and the opposite blur in the eastern sky. I hope it means a sunny day to-morrow, if nothing else.

> Yours,
> Alex

Towards the end of April the ice got honeycombed, turned almost black and suddenly disappeared. I went by boat into Penetang, and from there to Toronto. The first thing I heard when I reached that city was that the Group of Seven had been formed, and that I was a member of it.

Had it not been for the war, the Group would have been formed

[53]

several years earlier and it would have included Thomson. Even before the war, we had attempted to interpret Canada and to express, in paint, the spirit of our country. The men who formed the first Group, dedicated to this purpose, and who turned their backs on the European tradition, were Lawren Harris, Arthur Lismer, J. E. H. MacDonald, Fred Varley, Frank Johnston, Frank Carmichael and myself. The organization was a loose one; it had a name and a purpose but it had no officers, no by-laws and no fees.

It must not be thought that the movement was a local one, confined to Toronto only. About the same time an effort was made to establish a similar group in Montreal. It was named the Beaver Hall Group as its members rented a house on that street. It brought a number of talented young artists together but financially it was a failure.

Our first exhibition had a very poor reception. In addition to the work of the members of the Group, there were canvases from three invited contributors, R. S. Hewton, Robert Pilot, and Albert Robinson, all of Montreal. Among the paintings exhibited were J. E. H. MacDonald's "Wild River" and "The Beaver Dam," some of Harris' old Toronto houses, a number of canvases that Lismer had painted while he was living in Nova Scotia, and some lyrical paintings of trees by Frank Carmichael. My own canvas was "Terre Sauvage," perhaps the most radical painting in the show.

Some people who saw the exhibition were amused, and some indignant. Some members threatened to resign from the Art Gallery of Toronto. In the catalogue it was announced that "the artists invite adverse criticism. Indifference is the greatest evil they have to contend with." There was plenty of adverse criticism, little of it intelligent. A great deal of it was mere abuse, much of it from people who had not even seen the exhibition. It came not only from laymen but from artists as well. "Products of a deranged mind," "art gone mad," "the cult of ugliness," these were some of the terms used to describe paintings which, whatever their faults, attempted to depict the Canadian scene sincerely and honestly.

The only possible explanation for the uproar caused by that first exhibition is that we, in Canada, had become so accustomed to seeing paintings that were made according to a European formula that a simple portrayal of a Canadian subject was incomprehensible to us.

Looking back after thirty-eight years it is difficult to know now what all the shouting was about. Paintings that were in the first exhibition

are now in our National Gallery, in Hart House, the Art Gallery of Toronto, and in private collections all over Canada. Nowadays they are considered "sound and sane art," to use the expression that one of our most virulent critics employed to praise dull academic pictures.

One result of the opposition was that we were confirmed in our resolution to carry on. While the bad publicity received did not bother us, it did have an immediate consequence: Frank Johnston resigned from the Group. From the economic standpoint he had difficulty in earning a living from his painting. People were afraid to buy pictures that were the subject of ridicule.

The second exhibition of the Group of Seven showed that we were far from being deflated by our experience. A note in the catalogue said:

A word as to Canada; these pictures have all been executed in Canada during the past year. They express Canadian experience in the onlooker. These are still pioneer days for artists and after the fashion of pioneers we believe wholeheartedly in the land. Some day we think that the land will return the compliment and believe in the artist not as a nuisance nor as a luxury, but as a real, civilizing factor in the national life.

Harris and I made the sets for the first plays at Hart House; we were friends of Roy Mitchell, the first director of Hart House Theatre. My set was for "The Queen's Enemies." I went to the Royal Ontario Museum to find some Egyptian costumes to serve as models. Later, at the production, Dr. Currelly, the Director of the Museum, was shocked to see slaves wearing headgear that was reserved for royalty. Harris' set was for "Patelin." Partly because we knew so little about it, we made some very unconventional settings for plays. Later on, Lismer took over the job as experimental work for his students at the Ontario College of Art.

Meanwhile, there remained the bothersome business of earning a living. We made a series of Christmas cards that were most successful. They were sold not only in Canada; orders came from New York, and even from Liberty's in London. Most of the Group depended on teaching, or commercial art. I did an occasional commercial job.

I was approached by Watson McClain of the Kent-McClain Company, who made showcases, to undertake a commission. His company was having its offices redecorated and there was a space between the cornice and the ceiling which was covered with a very commonplace stencilled ornament. If the stencil had to be done over it would cost two hundred dollars. Could I, for the same sum, paint something, a

[55]

simple landscape or anything else, to replace the stencil? Two hundred dollars was a lot of money to me at that time, so I accepted the commission. I roughed out a northern Ontario landscape in four colours, with hills, lakes, creeks, rivers, all in a hundred and fifty feet. It was great fun. The men from the factory would drop in to watch my progress, and their comments pleased me. "There should be fish in that lake," they would say, or, "I bet you that is good hunting country." An old gunner said there was fine cover for guns back of that hill. When I was finished, Watson McClain said, "You know, when I asked you to paint something in place of that old stencil I did not expect to have two hundred miles of northern Ontario in our office. I have made out the cheque for three hundred dollars. I hope you don't mind." My feelings were not hurt.

Another job proved less satisfying. Clarence Gagnon had a book of essays by Adjutor Rivard which he greatly admired; he thought an English edition of the book should be brought out. After reading the essays I agreed with him. I suggested to a Toronto publisher that his house should publish the book and he agreed on condition that W. H. Blake would undertake the translation. Blake was very happy to do so and I was asked to make, as illustrations, a series of chapter headings. I made them while in Baie St. Paul and sent them to the publisher but received no acknowledgement from him. I wrote to Jim MacDonald, who went to the publisher's to inquire after them, and was told that the drawings were no good. Jim told the publisher he did not know good work when he saw it. When I returned, I saw the man in charge of production. He had an edition of *Maria Chapdelaine* with drawings by Suzor-Côté. "Why can't you do something like that?" he asked me. I said, because I wasn't Suzor-Côté. He objected to the title, *Chez Nous*. No one in Ontario, he said, would know what it meant. I replied, "Just the sound of it is lovely; they do not have to know what it means." He went over my drawings and pronounced them poor. When the book finally came out, only a few of the drawings were used, not as chapter headings but on blank pages as illustrations. In spite of his misguided efforts, the book was a real success. Many of the drawings were reproduced in a review of *Chez Nouz* in the *New York Tribune*.

About the same time, MacDonald undertook a commission to decorate St. Anne's Church in Toronto. This was one of the first efforts to introduce more modern ideas into church decoration. There

was not much money available, but with the help of several other artists he got away from the kind of stock and machine-made ornament with which most of our churches were embellished. His work at St. Anne's was perhaps a mild assertion of the belief that a place of worship should be beautiful.

MacDonald was growing more confident of his abilities. Everything he undertook now bore a mark of distinction; but there was never enough work for him and the returns from it were inadequate for him to live on. He turned his hand to all kinds of things: book covers, illuminated addresses, posters. He had a sound knowledge of historical ornament and his lettering was quite distinguished.

Among my critics were my aunts in Berlin, which had changed its name to Kitchener during the war. My Aunt Geneva took pride in any success that came my way, as when the Tate Gallery acquired one of my paintings, but she had no sympathy with radical movements and I had to submit to many a tongue-lashing from her about painting pictures no sane person could understand. Living on incomes that remained stationary, while expenses went up year after year, was difficult for the aunts. They expected their servants to know their place as they did in the days of dear Queen Victoria. To one maid my aunt said, "Mary, I'll tell you what I want for desert," and went into a full description of the dainty she expected.

"All right, Miss Jackson," said Mary. "Now I'll tell you what you are going to get."

Aunt Geneva liked to go sketching though she was not very successful at it; she niggled with small brushes while I tried vainly to get her to paint with more breadth. She was always making things for bazaars, among other items tea cozies of coloured felt which were most attractive in design. I told her that the next time she went sketching she should leave her paints at home and take her coloured felts along.

When my work was finally acquired by various public galleries, she rather reluctantly admitted there must be some virtue in it. She was very fond of me in spite of my lack of respect for her many cherished traditions.

[57]

VIII
Quebec

SOMEONE TOLD me about a farm below Rivière du Loup where the family took in boarders. Their name was Plourde, and their farm was a half mile from the St. Lawrence River, which here is about eighteen miles across. Below Rivière du Loup, the river remains open all winter, but big ice fields go up and down with the tides. The village of Cacouna, close to the river, was about two miles east of the Plourde farm. It was old, settled country; the farms ran back from the highway, long and narrow, and all the houses on the highway were close together. The Plourdes lived in an old house built sixty years earlier that belonged to people named MacFarlane. It was too far from the railway for them to ship cream so there was always a jugful on the table; chicken and maple syrup were much in evidence, and I found the diet rather rich. Every day I used to run a mile with "Bustare," the dog, who needed exercise too. The social life was limited; in the evenings we played cards. To get about the country in the daytime, I used snowshoes.

At first, in my painting, I was interested in the old farm houses, in the barns and the trees. Later it was snow that captured my attention; the sun and the wind continually changed its colour and texture. Towards spring there was slush and pools of water, and finally the furrowed fields appeared through the slush.

After some weeks with the Plourdes I moved into the village of Cacouna where I stayed at a little hotel. Since it was winter time, and there were few guests, the hotel was all shut up except the basement. Evenings were dull as there was nothing to do. After supper Monsieur Lafleur read *Le Soleil* which came from Quebec; he made it last until

bedtime. His wife sat by the stove; and from time to time she would rise to give the ragout a stir. Three little girls were at the table, busy with their lessons. In a corner sat Napoléon, the son, waiting until it was time to go to bed; near him was Madame's sister, who must at some time have been kicked by a horse, as she had a broken nose and impaired speech.

I wrote letters to Albert Robinson, urging him to come, and to my joy he arrived one evening. There was something about Robinson that melted all reserve as the frost disappears when the sun rises. Monsieur Lafleur and Madame beamed at their new guest. Robinson was a boxing fan, but I don't know how he surmised that Napoléon's ideal and hero was the boxer Georges Carpentier. Having, in this way, won Napoléon's devotion, Robinson then went to the eldest girl.

"Jouez-vous du piano, mademoiselle?" he asked.

"Un peu, monsieur."

He almost lifted and put her on the piano stool. *"Alors, jouez,"* he said. Then he bowed like a courtier to Madame's sister, as he asked, *"Dansez-vous, mademoiselle?"* She was just about in heaven as he swung her gaily round the room.

The village was a very picturesque place, piled up with snow, with a fine old parish church, and, across the river, the bold line of hills on the north shore around Tadoussac. It was here that Robinson made the sketch for his painting, "Return from Easter Mass."

People were suspicious of us at first, as we moved about the country sketching; the war was still fresh in their minds. An old gentleman approached us on one occasion, and said, "Pardon, messieurs, are you spies?" We assured him that we were not. He said people had been wondering, and he thought the best way to find out was to ask us. The villagers could not understand why we painted old houses and barns and were surprised that we were not interested in the Chateau Allan, a large summer house that belonged to the Allans of Montreal.

This was the first time I painted in the French part of Quebec; I was to continue going back there for many years.

The following year Robinson and I went to Bienville, a small village just below Quebec on the south shore. In March when the snow was melting, when the roads were covered with slush and the ice was going up and down the river with the tides, it was a fascinating place to paint.

Board was a problem at Bienville, for there was neither hotel nor

pension. There was a widow in the village who sometimes took in boarders, but when we applied there she said she couldn't take us. As we were talking with her, her son, Pierre-Albert, came in; he was an attractive youngster who, she explained, had been born after his father died. He broke the ice for us, and finally she agreed that if we would be satisfied with very simple living she would put us up.

We went to the station to get our luggage; when we returned more youngsters had come home. The last one to arrive was Paul who worked in the shipyards. We were part of the family right away. We told them we were artists, and every night we had to make drawings for them. *"Etes vous capable de faire un éléphant volant?"* one of them asked me. The flying elephant was a great success; it was taken to school and I became known all over the village. Robinson was asked to paint three swallows on a lamp shade intended as a gift for a bride and groom, and he too became famous. Our meals were somewhat haphazard; it was alternately feast and famine. When we paid our board there would be a string of youngsters rushing out to the dairy to get a quart of cream, to the butcher's for chops, to the baker's for cakes; a day or two later the meals would drop off to pork and potatoes; so we stopped paying our board at the same time. It was a gay household. Madame bought a gramophone by instalments and everybody danced.

One of our favourite sketching locations was on the Canadian National tracks beside the river, where we could look across to Quebec, with the ice drifting up and down in the foreground. On the cliff up above we could hear Charles-Arthur boasting in his shrill voice to his friends: *"Voilà les pensionnaires de chez nous."* Pierre-Albert took to drawing too; we had to be careful to leave nothing about for him to draw on. Every morning he demanded a pencil, and I began to keep stubs for him. I made the mistake of giving him a purple-coloured pencil with a rubber on it, one morning; the next day I gave him a plain one. He wouldn't have it and threw it on the floor. *"Donnez-moi un beau crayon avec un efface,"* he said.

Towards the end of the month we told Madame and the family we were leaving, and gloom descended on the house. Then, with some diffidence, they invited us to stay another week as their guests. We felt like deserters at leaving them. There was something about these associations that touched the heart. They were poor yet they sought no advantage for themselves.

Another place at which we had happy times was the Hotel Victoria

at Baie St. Paul. It was a very uncommercial hotel. When I asked M. Simard, the proprietor, how much I owed him, he would answer, "Oh, you figure it out, Mr. Jackson; whatever you say will be all right." There were two asylums near the hotel, one for women, the other for men. The milder cases among the men were permitted to perform odd jobs. One morning four men were carrying chairs to the women's building when one of them fell on the ice and couldn't get up. I was passing and helped the others to carry him to the door. It was opened by a pretty little nun who told us to take his coat off, loosen his collar and lay him on a bench. Suddenly she started to laugh and, turning to me, she said, "Pardon, monsieur, but I thought you were one of the patients."

Jane Bertram, the Secretary of the Women's Art Association in Toronto, was much interested in Quebec handicrafts, especially weaving, and she asked me if I saw anything good to buy it for her. The only condition I made was that I should be free to give more than was asked if I thought the prices were too low. One family in Baie St. Paul, the Cimons, were expert weavers and had remarkably good taste. They kept open house for artists, and it was a great pleasure to visit them. Later, one of the daughters, Blanche, married René Richard, an accomplished painter who had studied with Clarence Gagnon.

Here is a letter I wrote to J. E. H. MacDonald from Baie St. Paul, January, 1924:

My dear Jim:
Here we are in the Christmas card country, at least it often looks that way. I see cards waiting to be done in two printings and a few dabs of colour put on by hand, while what I want to see are big bold compositions that will enrage the critics. The Hotel Victoria is not changed, except that Joe, the proprietor's son, has a baby, the first of a dozen, I expect; the French idea is to raise your own immigrants and save steamship fare. There is plenty of snow for the old snowshoes, but I fear it is their last season; the gut is beginning to break, so I am thinking of taking to skis and keeping up with the younger generation, though I doubt if I will ever jump one hundred and twenty feet. Academicians' bones get set and brittle. In most cases the brain gets into the same state. Mr. and Mrs. Newton, Mabel May and Holgate are expecting to come here next week and with the Gagnons, Baie St Paul will be for the time the liveliest art centre in Canada. I did not see any of the old guard in Montreal. They are not pleasant company and are much annoyed at the younger set for the part they played in the Wembley show. The belief there is that they never even dreamed of being left out of it. They thought they were in a position to dictate to the trustees

of the National Gallery. There is no great stir in Montreal art circles,
Robinson is ill, Hewton is running a painting system he acquired in the
U.S., "Maratti," which makes everyone paint alike, Holgate is making
mezzo-tints and wood blocks, Anne Savage is getting wonderful results
teaching art at the Baron Byng High School from youngsters, mostly Jewish;
this is about the most interesting development in Montreal. Leave here
24th January to go to Bon Echo. Expect to find myself in a very exclusive
literary circle with Merrill Denison and Artie Heming.

<div align="center">Yours,
Alex</div>

In our little circle at Baie St. Paul I was known as Père Raquette
because of my snowshoes. I think it was Edwin Holgate who first gave
me the title. He and Gagnon were skiers and when we went out
sketching I would trudge along with them on my big snowshoes.
Gagnon told us once how, before the railroad went through, he had
skied over Cap Tourmente. The first skier to arrive in Baie St. Paul,
he stopped to rest at the little hotel. Some time afterwards, two team-
sters came in who had travelled over the same road. They were arguing
about some strange tracks they had seen along the side of the road.
One of them said they were made by something dragging from a loaded
sleigh. The other one answered, "Yes? Then you tell me how those
tracks were so often on the far side of the telephone poles."

Marius Barbeau had an article in *La Presse,* and a chapter in his
book, *The Kingdom of the Saguenay,* on Père Raquette, and the poet,
Charles Doyen, had a poem in "Les Idées" inscribed to this rather
mythical character.

At St. Hilarion, another village in which we painted, there was no
hotel either, so I stayed at the Mayor's house. St. Hilarion is like one
of the Italian hill towns; the country around is cleared of trees, and
the town stands on the top of a hill. Old Grandpère Tremblay used to
be worried lest I get lost. First his son, the Mayor, would reassure him,
then his daughter-in-law. The old man was very deaf; when she wished
to communicate something to him his wife would yell in his ear. She
only had one front tooth left, and Lismer, who was with me here once,
said she had blown all the others out trying to make the old man hear
her. One of my favourite possessions is the rocking chair of old Grand-
père Tremblay. I am sitting in it now as I write these words.

Before the coming of the radio, these St. Lawrence villages were
somewhat isolated. The villagers used to like to hear about the outside
world, about New York, London, Paris and Chicago. I told them once

<div align="center">[62]</div>

about Chicago where everyone was in a hurry. That amused them. One Easter week I was staying in the Mayor's house at St. Hilarion; it was opposite the church and, while I was having breakfast, all the villagers gathered there, smoking and striking their matches on the low ceiling, and gossiping. Then someone opened the door and called out, *"A la messe."* Everyone trooped out, except Madame who took her broom and swept up slush, matches, cigarette butts; then turning to me she said, *"C'est comme à Chicago, toujours pressé."*

An occasional sketching companion in Quebec was Dr. Frederick Banting. I had met him when he called at my studio in Toronto and asked to see some of my sketches. He was particularly interested in the war sketches, since he had been with the Canadian Army, and when he found one he liked, he asked if he could buy it. I found him very shy and very modest. After that first meeting, I saw him from time to time. He had dabbled a little in painting when he set up practice in London, Ontario, after the war, while he was waiting for patients; now he had started to paint again and he appreciated advice. When I told him I was planning to spend some part of the winter in St. Jean Port Joli he asked if he might come along with me.

This was Banting's first experience of painting out of doors in winter time. It was March, but there was no sign of spring, and we were working in very exposed country. The winds swept in from the Gulf and there was no shelter from them. Banting persisted, though it was an ordeal for him. I found him one day crouched behind a rail fence, the snow drifting into his sketch box and his hands so cold he could hardly work. He turned to me and said, "And I thought this was a sissy game." Later, we went to Bic and to Tobin, a little dead saw-mill town; here the spring found us and we painted the melting snows. The Berubés put us up. He was an insurance agent with three charming daughters; he drove a Dodge, so did Banting, and this formed a bond between them.

Another village I painted in was St. Fidèle on the north shore east of La Malbaie. It was a remote little village overlooking the St. Lawrence, not known to tourists, very primitive, but good material for the painters. We spent several weeks there and Banting made great progress. When he brought a sketch in, invariably his first question when he showed it to me was, "Now, what's wrong with it?" He was careful not to let it be known he was a doctor; sometimes he would go under the name of Frederick Grant. There was little chance of anyone

[63]

knowing about him in that country, but he was nearly caught at St. Fidèle. The curé came to visit us one day with a man in a coonskin coat whom he introduced as his brother. When I introduced Fred as Mr. Banting, the curé's brother said, "Is it Doctor Banting?" Fred said, "No, he is my cousin." The other looked sceptical and as we were leaving in a couple of hours, and I could see no harm in it, I said, "He is Dr. Banting." The curé's brother said, "I thought so. I am a veterinarian; I have been at the University of Toronto several times and had Dr. Banting pointed out to me." Then, to impress the curé, he gave a short lecture on what a famous man Dr. Banting was. The curé remained unimpressed. *"Oui, oui!"* he said, sarcastically. *"Comme les Americains,* greatest in the world." All the same, within an hour Banting was asked if he would go and see a woman who had just had a baby.

In a letter to Dr. MacCallum about this trip I wrote:

We are plugging away. It is still midwinter here and piles of snow. "Bigger and better snow drifts" is Banting's slogan. We went for a short-cut through the woods yesterday and that nearly cured him. We did not have our snowshoes, and we sank in the snow up to our waists. No newspapers, no radio and only enough water to wash once a day and yet we are happy.

When we left St. Fidèle, Banting returned to Toronto, while I went on to St. Hilarion. The Tremblay family predominates in this part of the country. We had stayed with Tremblays at St. Fidèle. At Les Eboulements Station I engaged a driver to take me to St. Hilarion; he was a Tremblay too; and I was going to stay with the Tremblays at St. Hilarion. Along the water front of Les Eboulements, the winter had disappeared, and the roads were dusty. We started up the long hill in a buggy. At the top of the hill there were still patches of snow; a half mile beyond that the driver had left his sleigh. Here we changed vehicles and hitched the horse to the sleigh. By the time we were in St. Hilarion, ten miles back, the snow still lay deep, and had not even started to melt. Just before we reached the village we had to leave the road and push into the deep snow to allow another sleigh, on which lay a long box, a coffin, to pass. At the village I found there was an epidemic of 'flu. Grandpère Tremblay gave me the news in all its horror. *"Quatre voisins morts, tous morts,"* he told me, over and over again. A lady visitor in deep mourning told me more tales of the distress caused by the epidemic. Outside, a bell started ringing; it was the curé on his way to administer the last rites to some poor soul.

[64]

I had caught a chill from the long drive. Now I started to shiver, and went for a walk hoping to throw it off. On my return, Madame gave me some medicine which she called "Pain Killaire." She poured some in hot water and I sat around sipping it until the Mayor came home. When I told him I had a chill, he said, "These medicines, if you take a lot and have much faith, they might do you a little good." He disappeared and came back with a glass of brandy. "With this," he said, "you don't even need faith." It took my breath away, but in an hour I was feeling fine. I am not advocating this as a cure for 'flu; all I know is that it fixed me up. This was in April and the sun was so warm I could go about without an overcoat, yet the snow was not even melting.

Another year, with Banting and Randolph Hewton, I went to St. Irénée and here Banting was nearly found out again. He liked to wear old clothes; thus dressed, he hoped he looked like a farmer. In St. Irénée, he fell into conversation with a candy salesman on the subject of sugar. The candy salesman knew a great deal about the chemistry of sugar, and was very surprised by this farmer-looking person who seemed equally well informed. Finally he said, "You're Dr. Banting, aren't you?" Banting, of course, denied it, but the other man knew perfectly well he was right. Banting's comment afterwards was, "You know, that fellow knows almost as much about sugar as I do."

Banting and Hewton had both been awarded the Military Cross during the first World War. They never would tell each how or why the awards were made; it was always the subject of joshing between them.

On a sketching trip, when one is working with oil colours on card or wood panels a great problem is how to carry around wet sketches. Boxes can be made with slots to put the sketches in, but they are clumsy things to carry about. Dr. Banting found a solution to this difficulty. He broke a wooden match into five little pieces, and before the sketch was too dry he put the pieces of match right in the paint (in the direction of the brush strokes), one near each corner and one in the centre; in this way they left no mark. When he was ready to leave the place where he had been sketching, he made a bundle of the sketches and tied them tight with a cord. I have adopted this method and had no trouble with wet sketches since. Banting once said, "People who don't like me say that after insulin I will never make another discovery. Well, how about this?"

[65]

One of the places we loved to paint was St. Tite des Caps on Cap Tourmente, a high plateau, forty miles below Quebec. It was not one of the old villages, but it lay in a hollow encircled by hills, and we could look down on it from several directions. The snow lingered there when it had gone in most other places. There was a ramshack and hotel there which creaked and groaned on windy nights. Ma Tremblay—this too was Tremblay country—was a dear old soul, cared for us as though we were her own children. She made wonderf pea soup. We never knew when a meal was over; she kept on bringi in more and more dishes. We liked to tease her. Once I pre we were not satisfied with the board and she looked most dis I said, "Is it still ten dollars a week?"

"*Oui, monsieur.*"

"Well, we figure you are not making enough money and w raising it to twelve."

Her husband was a good fellow when he was sober and would tell us wild tales of the days when he was a sailor. It was in this village that Crawley made the movie "Canadian Landscape" and got a fine picture of the old people at the card table. The last time I went there they were gone and the hotel too; there was an ugly new one in its place.

For several seasons, Robinson, Holgate, Hewton and I worked in the late winter at La Malbaie. It was a charming little town, and Robinson did some of his best work here. Later the fine old parish church there was burned down, and a post office and other buildings erected that spoiled it for the artists.

Among Robinson's other accomplishments was mimicry. I came in one day and was surprised to hear in the next room the voices of Holgate and Clarence Gagnon. I thought Gagnon, who was in Paris, must have returned and rushed in, only to find it was Robinson taking off Gagnon.

With Robinson I went up the Murray River on the ice. In the wintertime the frozen river is used as a road, but in April it was unsafe. Robinson stopped to sketch while I went farther on. After finishing my sketch I returned to find Robinson making a sketch, sitting down among some little spruce trees. I asked him why he was sitting there; he replied that he thought it was safer being near the trees. When I told him that the trees were there to mark where the villagers had been cutting ice, he was off without finishing his sketch.

[66]

OCTOBER, TWIN BUTTE
1951
In the collection of
The National Gallery
of Canada, Ottawa

A LAKE IN LABRADOR
1930
In the collection of
Mr. R. MacG. Russell,
Toronto

In March of 1935 I went to St. Fabien on the south shore near Bic. The train got in after midnight. The full moon was shining as we drove through the sleeping village; there was not a light in the hotel. We finally roused the proprietor, who assigned me a room. It was cold and damp, the room had been shut up, and I spent a miserable night fully expecting to catch pneumonia. By dawn I had decided to go somewhere else. When I went down to breakfast I found I was the only guest. The door opened and a vision appeared who looked as though she had just stepped off Fifth Avenue. Her name was Thérèse.

"What would monsieur like," she asked; *"pamplemousse ou jus d'orange; et quel céréal?"*

The service was delightful right through to toast and coffee. I sent for my friends, Albert Cloutier and D. I. MacLeod. St. Fabien, after a shaky start, turned out to be a most delightful place. Thérèse and all her family made us very comfortable; there were wonderful meals and service, and good sketching. The villagers, too, were most hospitable. Among other festivities we went to a sugaring-off party with a group of young people. One of the men, in an old sweater, climbed on the roof of the sugar shanty and started declaiming Rostand's *Chantecler*. We found out later he was the vicar. On the way home, MacLeod, solicitous for the horse, walked up a couple of long hills. Then he asked the driver, "How old is that horse?"

"Three years," replied the driver.

"And I thought he was twenty," said MacLeod. There was no more walking up hills.

On another occasion, with Marius Barbeau and the Lismers, I went to the Ile d'Orléans on the St. Lawrence just below Quebec. This island was considered as the private preserve of Horatio Walker, who had his home and painted there for many years. He sold his paintings mostly to art galleries and private collectors in the United States. He made little effort either to interpret the environment or the atmosphere of the place, and he continued to produce good Barbizon pictures years after they were superseded in France by the work of the Impressionists. I did not find the Island much of a place for landscape. It is a long island, high in the centre, and it slopes down to the river on both sides, so that compositions all seem to be sliding down the canvas. Marius Barbeau, Canada's most assiduous and enthusiastic gatherer of information about native arts and crafts, early pottery, weaving, furniture, family history and different versions of old songs, which he records or

[67]

makes notes of, found the Island rich in material. Lismer made many drawings, among them one of the friendly cow that persisted in licking the back of my neck when I was sketching. There was another of Mrs. Lismer, Marjorie, his daughter, and himself as La Sainte Famille walking down the road to the village of that name in the parish where we lived.

With Marius I called one day on friends of his, who had a cottage by the water. Mr. St. Laurent and his two youngsters were just going fishing in a small motorboat, so we went along and spent a happy afternoon with them. We had no inkling that this most likable person would later be Prime Minister of Canada.

Barbeau, Lismer and I went across to Ste. Anne de Beaupré to visit Louis Jobin, the last of the old woodcarvers. He looked very patriarchal, with long hair and white beard. We found him chopping a figure of Christ out of a pine log. Barbeau introduced Lismer and me as two members of the Group of Seven. He had heard of us, he said; *"Ils cassent les vitres."* We were the boys who were breaking windows. He told us woodcarving was finished; Belgian bronzes and Italian plaster casts had put it out of business. He had worked in New York and, during the hard times, in Montreal where he had made most of the wooden Indians that used to stand outside the tobacco stores. Out in his backyard there were a lot of rejected works, weathering and rotting; among them I found an admirable angel. I wrote to Mr. Greig, the Curator of the Art Gallery of Toronto, advising him the Gallery could have it for seventy-five dollars. Greig sent a cheque by return mail and Jobin was delighted, not only to have the money but to be represented at an important art gallery.

At Ste. Famille, I had a room and breakfast with a widow, who asked Marius what the *Anglais* had for breakfast. He brought her some bacon and cereals. The first morning she brought the bacon in on a plate uncooked. I could never get her to do more than warm it up. There was a crayon portrait of her late husband in the dining-room looking down dejectedly at the stuff she cooked.

I do not know how many Quebec canvases I have painted. I have worked in villages on both the north and south shores of the St. Lawrence. In thirty years I missed only one season, the year I was teaching at the Ontario College of Art. I have happy memories of a great many places, from St. Joachim to Tadoussac, and on the south shore from Lévis to Fox River in Gaspé. The canvases I painted there are scat-

tered from New Zealand to Brazil and Barbados, throughout the United States, and all over Canada.

While Robinson and I, in our paintings, accepted all the contemporary types of buildings which made the old Quebec villages a jumble, Gagnon, steeped in the traditions of Quebec, in his compositions would replace the new wooden boxes with old houses of which he had many studies. He told the farmers around Baie St. Paul that the Quebec Government was going to pay them to preserve their old houses and barns. It was not true, but it should have been. I made paintings of a great many barns, of which the one in the Art Gallery in Toronto is the best known. These barns disappeared shortly after I made the painting.

Gagnon had a project for creating a Canadian village near Montreal by buying up old houses, reconstructing them and furnishing them with everything made in Quebec. It was a grand idea and should be carried out.

Some of the villages where we painted are no longer of any interest to the artist. Now that the roads are cleared of snow, motorcars and trucks run all winter; the sleigh has disappeared. In the houses the shingle roof is now aluminum, asbestos sheeting covers the walls, and the oil furnace has done away with the woodpile. *"Les voyageurs de commerce,"* who used to support the hotels in the villages, now cover the country by car, and most of the small hotels have disappeared.

The most popular picture I ever painted was done in Quebec. Known as "The Red Barn," it is owned by William Watson, the art dealer in Montreal. Not very long after it was painted, the University of Saskatchewan wanted to purchase a couple of paintings and asked Dr. MacCallum to choose them. He sent them one by J. W. Beatty and my "Red Barn." They bought the Beatty canvas; the "Red Barn" was returned so quickly it could hardly have been taken out of the case. Later the Tate Gallery asked to buy it, and our Government wanted to present it to Princess Elizabeth when she was in Canada. Various other people have tried to purchase it but the owner will not part with it.

IX
Camping and Canoeing

APART FROM a canoe trip through the Rideau with my brother Harry, I had had little experience of canoeing when a young student from Harvard suggested that we make a journey from Georgian Bay up the Muskosh River and down the Moon River back to Georgian Bay, which was a popular canoe route at that time. My companion was a very cheerful, careless fellow, as inexperienced as I; thus, when we set off from Williams Island we had no proper equipment and we realized it on the first portages. We ran into trouble the very first day. We were paddling against some swift water at a bend in the river. Westengard was paddling bow, rather indolently, and the current caught the bow, swung it sideways and over we went. We swam around getting all our stuff ashore, retrieving the canoe, and getting it righted. As we were thus engaged another party came down the river. We tried to look unconcerned, as though this was normal practice with us, but they were not fooled. A few miles farther up-river, at a portage, we decided to camp and dry our stuff. We made a big fire and unpacked everything.

While we were making camp a canoe with a couple of lumberjacks landed going up the river. One of them picked up a heavy packsack, swung it on his shoulders, and piled a dunnage bag on top of it. The other pulled up the canoe, shoved the paddles under the thwart straps, swung the canoe bottom up on his shoulders, and they were off. The whole procedure took less than two minutes. They grinned at us as they passed, asking, "You the chaps that got dumped down there?" We felt like a couple of greenhorns, but not for long. Another party appeared going down the river; this was really an amateur outfit. It took four of them to carry one canoe, another trip for the second canoe

and still others for the armfuls of bedding, the cooking outfit, and the cushions. A good half hour was needed to transport the outfit across a portage a hundred yards long. In our short time at the portage we had had a perfect demonstration of what and what not to do.

We had some rope, and we arranged our dunnage in the canoe in such a way that we could get over a portage with one carry. The next morning as we went over the portage, a couple of young huskies who had been camping at the upper end were just leaving. I said to Westengard, "We won't see them again," but I was wrong; about three miles farther up the river we saw them swimming about, getting their stuff ashore. They had been dumped through carelessness, and we knew how they felt. At Bala we had to replace some of our supplies, bread, sugar and other stuff that had been ruined by water. The clerk said, "Are you the boys that had the spill?" I said, "Oh no. They should be along in about an hour."

By the end of that trip we had learned a lot about getting around by canoe, how to choose a camp site, how to make fires in the rain, and how to adapt ourselves philosophically to whatever transpired.

The association with Dr. James M. MacCallum, that began the day he arrived in his motorboat on the beach before the shack on Georgian Bay in which I was living, continued for thirty years, until the day of his death in Toronto in 1943, when he was in his eighty-third year. The doctor was a good friend to me and to many other artists. Did he know much about art? I would say, No, not very much, but he knew and loved the north country and looked for the feel of it in pictures, with the same sense that a lumberjack has for the feel of an axe, or that the trapper has for a paddle. In European painting he was not interested at all, and only mildly interested in paintings from other parts of Canada. After Thomson's tragic death, he became a kind of patron saint to the Group of Seven. He lived in a house whose walls were covered with Thomson's sketches and canvases, and he loved to show these to anyone who was interested. A standing joke with him was to find and point out all sorts of shapes of animals in their pictures, and on canoe trips he urged his boys to train their powers of observation by finding strange forms in the rocks. "Now, boys," he would say, pointing to some oddly shaped formation, "don't you see the elephant?"

He liked to think of himself as a cynic and he had Curtis William-

son paint him in that role, but in fact he was a very kind and generous person in his private life and in his practice. There are hundreds of people who remember him with affection. He had a remarkable memory and he seemed to be able to place people of his own generation who lived all over Ontario. He was a great sailor who knew every port and haven on the Great Lakes. Almost by instinct he could find his way in fog and darkness through the intricate channels of Georgian Bay, and even when he was past sixty he would take chances going through or over shoals, raising the centre board in the nick of time, and tacking into the wind in passages hardly wide enough to turn about. He would not allow us to use an oar; he did not consider it sporting.

MacCallum's Island was up near Split Rock and every year would see him there. Even after his family had scattered, he would go there alone to tinker with his leaky old boats, and pace his big verandah facing the west, which was often lashed by wind and rain. Around a sheltering point was the boat house on one wall of which could be seen the faint remains of a Chinese dragon which Lismer had painted there years before. His living-room had a big stone fireplace where the gleam of a burning log would light up the Thomson and MacDonald decorations and MacDonald's heroic figure of Thomson as a lumberjack. The old doctor loved to point out the place where Lismer had painted his bold "September Gale," and where Varley had got the sketches for his "Georgian Bay Squall." Four miles to the south could be seen Pine Island, where Thomson had found the subject for one of his big canvases. The doctor would point this out to his visitors and call to their attention the way in which the distant pines resembled a camel.

I have many memories of long canoe trips and rough portages with him, and of campfires on delectable islands, but what I remember best is MacCallum, the loyal friend to the artists of the Group of Seven when faith in us was low.

"You can't tell me you ever saw anything like that," he would say looking at my latest sketch; then after a long pause he would add, "But it is good just the same. I like it."

In a yawl, towing a couple of canoes, I went on several camping trips with the doctor and his boys. He wanted to keep moving all the time and as I had to look after the supplies and see that things were not

left behind when we changed our camping ground, I seldom found any time to paint.

Thomson and his friend, Broadhead, had gone down the Mississagi River from Biscotasing in 1912; it was a well-known canoe trip, and ten years later the doctor wanted to follow the course his protégé had taken. Some wealthy Americans had preceded us and hired all the guides except one named Joe, who had been away when the expedition left. Joe was feeling out of luck as he knew the doctor would not pay him the fancy rates the Americans handed out. In speaking to me of the doctor Joe always referred to him as "the old tightwad." Joe had his own canoe and took with him the youngest MacCallum boy, Fred. If he thought he had a bunch of greenhorns to handle, he was soon disillusioned; the MacCallums had been brought up in canoes at Go Home Bay. The doctor and I paddled together. We changed from bow to stern, paddling on alternate days, but whether he was paddling bow or stern he would shout orders at me. "Paddle on your right," he would call; or, "Paddle on your left." Though he was sixty-one at the time he was a good old sport; going over portages he always picked out the heaviest canoes or packsacks. I wanted to move in leisurely fashion, making sketches, but he was always in a hurry. We paddled through beautiful lakes, and down rivers, shooting the rapids. I remember one spot—I am sure Thomson had camped there—where the river widened to a little lake. Big escarpments rose in the background. Where the river entered the lake there was a little clearing from which the brush had been cut out. It was a lovely spot to camp, but the doctor said it was too early to stop. We pushed on into a miserable country, consisting of mile after mile of marsh. Finally, when it was almost too dark to paddle any longer, we saw patches of woods and shoved our canoes through the marsh towards them. We put up our tent in the dark. There was a frightful stench about the place, but we were too tired to worry about it, and went to sleep without investigating it. In the morning when we got up we found we had been sleeping among the bones and guts of moose; our resting place was an Indian hunting camp. We got out quickly.

At noon we generally stopped for lunch and a rest. I found a powdered soup, called Magi; we boiled that, and with bread, jam and tea it made an adequate meal. The boys and Joe used to spend the rest period arguing with one another. One day the subject of debate was cars, and Joe, who came from a place where there were none, was

the most loquacious on the subject. I was supposed to be asleep, but I heard his comments. "I have a sister married to a rich guy in Montreal," he said. "They have a whole bunch of motorcars, several yachts, and five or six hundred dollars."

One day we paddled into a large lake. The doctor, to continue his training in observation, said, "Now, boys, can you see the outlet?"

"No, Dad."

"Use your eyes. Can't you see down south where the land falls away. That's where the outlet is."

A few minutes later Joe caught up to us and turned sharply to the east. The doctor said, "Where are you going, Joe?"

"This is the way the outlet is," said Joe.

Joe left us at the railroad. The rest of us continued for another week, finally taking the train to Bala. In the early morning we paddled down the Muskosh River and reached Go Home Bay just in time for the annual regatta. The MacCallum youngsters, who had been paddling for a month, cleaned up all the boat races.

In November of 1922 I went to the Bay with Dr. MacCallum. He stopped with a friend, Wilton Morse, to do some duck shooting, while I, in a small boat, went farther north and camped on an island. I put up my tent between the shore and a small lake. During the night it got very cold and as I had only a single blanket, I was nearly frozen. I got up at daybreak to make a fire, and found half an inch of ice on the little lake. It was here that I made the studies for a canvas, "November, Georgian Bay," now in Hart House. The weather looked threatening, so I rowed back towards MacCallum's. That night I stopped at Mackenzie's Island and put up my tent. A wild night of snow and rain followed. If I had not set up my tent among some pine trees it would have blown away. The next day it was impossible to travel, as the storm continued. I moved into a deserted house and got in a lot of firewood. There was a brick fireplace and a couple of benches, which I pulled up before the fire to sleep on. The floor was full of wide cracks, cold air was pulled towards the fire, so I was roasted on one side and frozen on the other. I had a tube of blue paint with me which was badly ground, so to pass the time I decorated the blackened bricks of the fireplace by painting a number of them blue. About ten years later I was invited to Mackenzie's Island for lunch. In the interim it had been bought by Mr. and Mrs. C. S. Band who had turned the old house into a dining-room, and the fireplace with the blue bricks was

still there. I asked Mrs. Band if she knew who decorated the fireplace. She replied that she did not know; it had been like that when they bought the place. So I told her.

On another occasion I camped on South Pine Island, which is in the open, about four miles from MacCallum's Island. It is a rock about a third of a mile long, flat on top and sloping steeply down to deep water; a few wind-blown pines make a lively silhouette against the sky, and some years herons build their nests in the trees. In good weather people from Go Home Bay have picnics there. I put my tent up in a little hollow and secured the ropes to some stunted pines. I was protected from all directions except the north-east. It rained and blew and each night there were violent thunder storms, with flashes of lightning that seemed to shatter everything on the island. Every morning Doctor MacCallum, looking out with his field-glasses from his island, could just see the top of my tent. After blowing from all directions, the wind struck from the north-east. There was a blast and a squall of rain, and down came my tent. My flashlight had gone dead and it was very dark. There was an awning to the tent held up by two short poles; I squirmed round and got them inside and replaced the higher poles with them. This made the tent two feet lower and less vulnerable to wind. In the morning, the Doctor, looking out, could see no tent and he was greatly worried. I think it was the sixth morning at daybreak before it became calm. I lowered my boat into the water, got my stuff into it and rowed to MacCallum's Island. He was most relieved to see me.

Some time after the doctor died, his island was purchased by Harry and Mary Jackman, old friends of mine; and so I continued to go back to the island. Charles Comfort and Will Ogilvie also go there to sketch. Some time ago an article written about this place by Robert Ayre appeared under the title "Artists' Island."

Another island near by, where I was a frequent visitor, belonged to the Erichsen Browns. I had known Erichsen (or Frank to his intimates) for some time before we discovered that my grandfather Young and his grandmother were brother and sister. The family, now widely scattered, were Georgian Bay enthusiasts. Frank's wife Isa has the faculty of being able to place any quotation, from Shakespeare to George Bernard Shaw, almost before you complete it. Frank is a lawyer and a staunch Conservative; the family are outspoken radicals, as far to the left as the N.D.P. In the political discussions Frank did

[75]

not fare too well, particularly when his daughter, the novelist Gwethalyn Graham, made a devastating attack and demolished him. Defiantly, he would say, "Well I haven't changed my mind."

He found solace by going to some rocky island with his sketch box; he was an ardent weekend painter. Sometimes Lismer or I would accompany him, and he treasures some of our criticisms. Examining one sketch of pine trees that resembled an African jungle, I suggested that he put in some Zulus. Commenting on another, of a bullrush swamp, Lismer said, "Frank, I think that would be improved if you took the lettuce out."

Go Home Bay and the outer islands are filled for me with happy memories of good friends and of efforts, more or less successful, that I made to portray its ever-varying moods.

Camping and canoeing have been my favourite pastimes and though I never was an expert, like Thomson or MacIver, I managed to get around. My technique was to travel light, to take nothing that was not needed. In a country of many portages, it is killing work carrying unnecessary weight. I cut out all canned goods, taking instead prunes, dried apricots, rice, beans, desiccated potatoes, and soup powders, cabbage, country sausage and, of course, bacon and flour for pancakes. I could always hope to catch fish and find berries. I never carried a rifle. Half the fun in camping is to find a good camp site, and the smooth rocks of Georgian Bay were ideal. There was plenty of drift-wood or dead branches, red cedar, maple or pine, and birch bark to start the fire, spruce or balsam branches for a mattress under the sleeping bag. If there was time I could make a very snug camp, sheltered from the wind, and with many good places to swim. On the smooth rocks there was little danger of starting a forest fire.

It is always advisable to get settled into camp before dark. I remember one night we left it too late and found ourselves following the steep shore of a lake in the darkness; thick bush came right to the water's edge and a storm was coming up. It hit us just as we found a piece of level ground. We pulled the canoes up on the shore, got our dunnage in a pile, held up the tent with paddles while we got inside; then, when the storm was over, we cleared out the brush and put the tent up properly. We had kept the ground and ourselves dry.

I went on a number of camping trips with Dr. Barker Fairley of the University of Toronto, an early friend of the Group of Seven. On one such trip, he brought two other professors along. It was September,

[76]

sunny and warm, and for a week we never met a soul as we paddled. Then we turned into a camp where MacIver and his partner, Swanson, were trying to start a gold mine. (That was when gold was a valuable metal.) Swanson was in the cabin; he had been bottled up for weeks with MacIver who was a silent person, so there had been not a soul for the loquacious Swanson to talk to. His welcome to the three professors was vociferous. To start an argument, he disagreed with everything they said. He was for prohibition, Mackenzie King, puritanism; indeed he took the unpopular side in any discussion.

Swanson proposed we should go to Nellie Lake the next day. It was some miles away, nestled in high hills. There were a couple of portages on the way, and at the first one Swanson, a giant of a man with a small head and sharp eyes, picked up a canoe and stuck it on his head as though he were putting on a hat. There was a scow on Nellie Lake in which we embarked instead of our canoes. Two of the professors each took an oar and laboriously started rowing down the lake which was long and narrow, enclosed by big hills. After a while Swanson said, "Give me the oars," and he sent the scow along like a racing shell, calling our attention to the scenery as we went along.

We landed, put up our tent, made a fire and cooked supper. When we had finished eating, Swanson picked up Fairley's teacup and peered into it. "Huh!" he said, "there is something here. You will soon have to make one of the most important decisions you ever made." When Fairley returned to Toronto there was a letter awaiting him from Manchester University offering him a post as head of the German Department. He went to England for five years.

A storm was coming up, so we crowded into the tent. Immediately, we found we had forgotten to bring candles. Swanson's "flash" was the only light. He started again to argue that puritanism was the greatest force in creative writing, thinking such a theme would be anathema to the professors. When Fairley quoted something from Heine, Swanson shouted "You misquoted," and Fairley had. I shall remember that night as long as I live: rain pattering on the tent and mild thunder rolling down the lake as though it were a big bowling alley, the five of us crowded into one small tent while Swanson, almost shoving his flashlight down his opponent's throat, yelled down all opposition. It was not the most peaceful expedition I had ever undertaken but it was among the most memorable.

[77]

X

The Wembley Exhibition
and the Academy

IN THE autumn of 1924 I became a part-time instructor at the Ontario College of Art. This is how it came about. Lismer and I had lunch together one Saturday at the Arts and Letters Club. As we walked back together to the Studio Building, Lismer, who was Vice-Principal of the Ontario College of Art and always at loggerheads with the Principal, George Reid, told me about his difficulties. He was eager and impatient, always straining at the leash, an ardent spirit suffering no restraint, rousing alarm in the breasts of those who were content with things as they are. George Reid, on the other hand, firmly set in his ways, was always trying to hold him back. One of their instructors, C. M. Manly, had died, and Reid proposed to appoint Frank Johnston, who by this time had resigned from the Group, in his place. Lismer believed this appointment was designed to create more opposition to himself, and he was very much discouraged.

"Why don't you apply for the job?" he said, suddenly.

Without giving it a thought, I replied, "All right." A few days later the Board of Governors met, my application was read, and accepted.

Reid who had not expected it, was very annoyed. He put me in charge of the class drawing from the antique. The students had as models only bad copies of antiques made by former students. Then I was assigned a still-life class previously conducted by Manly. He had had a dozen assorted bottles which he shoved around in different positions each week. Inevitably, the students hated still life. I found it fun and tried to communicate some of this feeling to my students.

At Eaton's Gift Shop I had them save broken pottery and glass for me. Each morning, as I walked to school, I would pick up apples, pears, egg plants and other exciting things at the grocery stores. I had some good students in that class and was very proud of the work they did. But my two sketching seasons were the late winter, and autumn; these would be impossible if I continued to teach. Moreover, teaching had put an end to my free way of life. Every March I was accustomed to go to lower Quebec and sketch until the snow was gone. In the summer I went to Georgian Bay; in October I travelled somewhere up north to paint the autumn colour. The rest of the year I worked in my studio painting up my sketches. Had I remained teaching, this routine, very necessary for a painter, would have been destroyed; so after a year I resigned from the College. I did miss the monthly cheque, though.

The differences between George Reid and Lismer, in their own way typified the controversy that raged between the academic painter and those who, like the members of the Group of Seven, believed that Canada could never be adequately expressed on canvas by a rigid traditional style. In 1924 this conflict was brought to a head by the incident of the Wembley Exhibition and what followed.

The story of Wembley is too well known to need repeating. Briefly, the authorities of the British Empire Exhibition, to be held at Wembley in 1924, invited the National Gallery of Canada to send an exhibition of Canadian paintings to England. The invitation was accepted. Instead of co-operating with the Gallery the Royal Canadian Academy insisted on controlling the exhibition. On this demand being refused, the executives of the Academy advised its members to boycott the exhibition. If the executive had consulted the members before taking this action, there would have been no Wembley controversy at all, for in spite of the efforts made to secure a boycott of the exhibition, over half of the Academy painter members exhibited, including five members of the Council. The jury was composed of Franklyn Brownell, Horatio Walker, F. S. Challener, Wyly Grier, Clarence Gagnon, Arthur Lismer, R. S. Hewton and Florence Wyle. All of them were members of the Academy who had accepted the invitation of the National Gallery to serve in that capacity.

The President of the Academy, Horne Russell, wrote to the London *Times* explaining why the Canadian exhibition was going to be a failure. When the press notices arrived from London they were so

[79]

enthusiastic about Canadian pictures that the detractors of Canadian art at home could only splutter. They had been so sure that the exhibition, constituted as it was, would receive the most adverse criticism. As many of our newspapers failed to publish the favourable reports on Canadian art at Wembley, the National Gallery reprinted them in a booklet.

Among the canvases that went to Wembley was my "Entrance to Halifax Harbour" which was purchased after the Exhibition for the Tate Gallery in London. The event was recorded in the following tribute in the Toronto *Star*.

The critic (Rupert Lee) says of Jackson's "Entrance to Halifax Harbour" that he, too, shows that he is mainly concerned with the possibilities of paint. "The design," he says, "is not particularly strong, but the sombre glitter of the paint, especially in the greyness of the foreground, is highly fascinating." "Fascinating" is the word, but if it is not a good painting of Halifax harbour, it is fine if you conceive it as a spilt can of paint.

The very favourable notices in the British press on the Canadian paintings at Wembley made good copy for the next exhibition of the Group of Seven. We used some of them in an advertisement:

GROUP OF SEVEN
ART GALLERY OF TORONTO
9TH TO 30TH JANUARY
WHAT THE PRESS SAYS ABOUT MODERN CANADIAN ART
They are garish, they are loud, affected, freakish (Toronto Star)
A single, narrow and rigid formula of ugliness (Saturday Night,
Toronto)
A school of landscape painters who are strongly racy of the soil
(London Times)
The foundation of what may become one of the greatest schools of
landscape painting (The Morning Post, London)

We sent this as an advertisement to the Toronto *Star*; to its credit, the *Star* printed it and also gave us a very good review of the exhibition.

The next round in the battle was fought over the exhibition that was sent to the Philadelphia Tercentennial in 1926. There had been no intention of having a Canadian section there, till the Director of the Buffalo Gallery, William Hekking, advised the committee that there was a little group of artists in Canada who were doing quite unusual

work. The Group received an invitation to arrange an exhibition of forty paintings. This we did, and the reception was more than cordial. The visitors to the art exhibition had never heard of Canadian artists before, and were most impressed by the vigour and character of the work shown. It would have been quite impossible for the Academy to arrange such an exhibition. Imagine the chief officials choosing an exhibition of the work of young members and leaving themselves out! Nevertheless, it caused ill-feeling, and there was a tendency to blame the Director of the National Gallery for permitting the exhibition.

Gradually the criticism in Toronto of the Group's painting died down; only Hector Charlesworth, "old Heck" as we called him, continued to thunder in *Saturday Night,* and occasionally there were outbursts of letter-writing to the press by people who would begin their effusions with "I know nothing about art, but — —." The following were some of the titles appended to these letters:

"They daub and squirt"; "Art is desecrated by modernism"; "Daubing by immature children"; "A horrible bunch of junk"; "The brazenness of those daubers"; "Arrogance of Canadian Group"; "Figments of a drunkard's dream." Occasionally I would contribute to the denunciations with letters signed "Rose Madder," "Sap Green," etc.

By the close of the 1920's, however, the paintings of the Group had begun to find favour in eastern Canadian even in the eyes of the critics. In the West the criticism continued for several years, reaching its height in Vancouver when the National Gallery sent an exhibition of our work there in 1932.

When one looks back over the history of the Wembley exhibition, and all the squabbles which followed it, perhaps the most shameful aspect of the story concerns the efforts that were made to have Eric Brown, the Director of the National Gallery, dismissed. The campaign against Brown went on for years. Though it had its comical features it was not amusing to him; he was hurt and worried by it. His position at the best of times was an awkward one, as Director of a poor gallery with few paintings of importance and almost no funds. The chief reason for his appointment was that his brother, Arnesby Brown, was a member of the Royal Academy of England. The National Gallery owns a number of paintings, probably acquired on Arnesby's advice, that were executed by members of the British Academy. After a lapse of forty years most of these paintings, which in their time were lauded by the press in London, fail to stir our emotions. They included the

[81]

works of Alfred East, George Henry, Gwelo Goodman, Charles Shannon, John Lavery and others, all eminent artists in their day; but at that time Brown should have been buying paintings by Cézanne, Renoir, Van Gogh, Lautrec and others which could have been acquired for less than the paintings of the academicians. But there would have been loud protests from our Members of Parliament and the press if he had done so, and the Director would probably have lost his job. With the very limited funds at the disposal of the National Gallery, he was able to make quite a fair collection of old masters. Brown's detractors were not concerned with these, only with the Canadian acquisitions. They wanted the funds reserved for these to be evenly distributed, regardless of the quality of the work.

After various unsuccessful efforts had been made to oust Brown, a protest, signed by one hundred and eighteen artists, was sent to the Prime Minister, the Honourable R. B. Bennett. The Toronto *Star*, under a big headline, "Painters Demand the Head of Art Dictator of Canada," described him as a Mussolini. Brown was accused of favouring certain artists and discriminating against others in exhibitions held outside of Canada. The chief reason for all this rumpus was the belief that the National Gallery Director was showing favouritism in purchasing paintings by the Group of Seven. The purchases amounted to an average of about two thousand dollars for each member. I am sure that in the sale of reproductions of their work the National Gallery has recovered most of the money expended.

This is a letter I wrote concerning the activities of a foolish committee:

WHAT'S WRONG WITH THE ACADEMIC PAINTERS?

To the Editor of the *Mail and Empire*.

Sir: For nearly ten years there has been no cessation of the carping criticism by academic painters of the National Gallery at Ottawa, the Group of Seven and the modern movement in Canada generally, and efforts made to prove that what recognition the modernist has received is due only to favouritism of Ottawa.

That the many exhibitions the Group of Seven have held in the United States, at Boston, New York, Philadelphia, Washington and various other cities might have been due to the merits of their work is inconceivable to the academic mind. The fact that these travelling exhibitions have nearly always resulted in invitations to exhibit again might suggest that they were appreciated. Those in charge of American art galleries have heard that in Canada there are artists who are trying to interpret their country with

[82]

freedom and freshness of vision. Seldom has there been any of the harsh criticism these artists have received at home, and the generous recognition they have received from the U.S.A. should have been a stimulant to all Canadian artists instead of arousing feelings of envy and bitter partisanship.

No Canadian exhibition that ever went abroad has won the fine eulogies that the Wembley Show did. It was only in Canada that the praise of the London *Times* and *Morning Post* was sneered at. If the academic painters in Canada are not overwhelmed with invitations to exhibit abroad, it is simply because they have not the courage to overcome the weaknesses inherent in any long-established societies. The natural instinct is to look after their own members first and to show tolerance towards old members who should be retired. Inability to control members who are better politicians than artists results in exhibitions which may be representative, but which are nevertheless dull and monotonous. So in self protection they seek to gain control of the work of artists who have more vision than they and to be the sole and final arbitrators of what is to be called Canadian art.

They might better prove their right to such authority in some finer way than by getting a lot of malcontents to sign a petition to our overworked Prime Minister.

<div align="center">A. Y. Jackson</div>

Sept. 14th, 1932

One cannot say that our country has done much for art; of all our Members of Parliament in the last fifty years there have been no voices raised to appeal for greater assistance to the fine arts. Neither Mackenzie King nor R. B. Bennett took the slightest interest in art; indeed, in the Bennett regime, Eric Brown was afraid the National Gallery would be closed down for reasons of economy. What saved it was the smallness of the grant the Gallery received.

After Eric Brown died in 1939, there were petitions from most of the art societies asking that his assistant, H. O. McCurry, be appointed Director of the National Gallery. It was not an easy assignment. We were just getting over a depression, funds were restricted and continued so through the war years that followed. What funds there were, were administered cautiously and wisely by Mr. McCurry, and during his regime important paintings were acquired: Daumier's "Third Class Carriage," "Pieta" by Quentin Massys, and Rembrandt's "Bathsheba at Her Toilet." Paintings by Gauguin, Cézanne, Van Gogh, and Degas were also purchased. The modern French collection had always been weak and good examples of the work of these painters were becoming very difficult to acquire. Whether McCurry had more discretion or the Academy had become more liberal, there were no more disagreements.

<div align="center">[83]</div>

When he retired in 1955 there was a general feeling of regret in Canadian circles.

It is difficult now to know what the artists thought they might achieve by their tactics in demanding Brown's dismissal. Perhaps the Academy would have liked to have a voice in the National Gallery purchases, in the same way that the Royal Academy in Britain controlled the Chantrey bequest purchases. This, however, had unfortunately resulted in a collection of paintings in which artists of real distinction were not represented. Instead of the funds from the bequest being used to build up the finest collection of art produced in Britain, they were reserved largely for purchase of the works of the members of the Academy. If the same thing happened here, it would have been most unfortunate both for our National Gallery and the Royal Canadian Academy as well.

The following is a report of the Select Committee of the House of Lords on the Chantrey bequest:

Out of two hundred or more works acquired by the Royal Academy from the foundation of the Tate Gallery to 1922 when the Trustees of the Gallery were formally accorded a voice in the selection of the purchases, only a very few can now in our opinion be said to be of sufficient merit to be exhibited on the walls of the gallery.

Is there any reason to believe that our Academy would have shown better judgment?

On receiving the invitation to show at the Wembley Exhibition in 1924, the members of the Academy had to decide between accepting the finest opportunity Canadians had ever had to exhibit in Britain, or to be loyal to their society in its efforts to control all official exhibitions sent abroad.

If William Brymner had lived longer, I doubt if any dispute over the Wembley Exhibition would have taken place. Of all the artists I knew as a student, there was no one I admired more. Beyond an occasional word of advice in the Academy life classes, I was not one of his students. He was not a very good painter, but he was a great individual, much respected by James Morrice and Maurice Cullen, and the young artists in Montreal. Among his students were Clarence Gagnon, Edwin Holgate, Lilias Newton, Emily Coonan, Randolph Hewton, Prudence Heward, Anne Savage, Sarah Robertson and others who have given prestige to the arts in Montreal. Brymner was no

[84]

radical, but he encouraged his students to be independent. He was gruff and would stand for no interference from anyone, yet he was really a very kind and sympathetic person. Edmond Dyonnet, with whom he was closely associated for many years, writes of their frequent rows over trifles. Brymner would go off in a huff and would not speak to him for days. Among his fellow academicians he would stand for no intolerance or injustice toward the younger artists. Not long after the war, through illness, he gave up teaching at the Montreal Art Association and went to live in Europe. Brymner was no longer President of the Academy in 1924, and in charting its course the Academy lacked his wise guidance.

I knew something of its workings, because I had been elected a full member of the Royal Canadian Academy in 1920. Albert Robinson was elected the following year. When he and I served on the same jury we had some influence on the exhibitions. Two votes in favour of a youthful canvas would often put it in; they might also keep out paintings that were accepted because the painter was an old member. Edmond Dyonnet, the Secretary, would frequently caution us in this connection. "You know," he would say, when we voted against a canvas of this kind, "his work has never been rejected before."

In 1926 Horne Russell had been President of the Academy for three years. I thought it advisable to inject new life into the body, so I nominated Henri Hébert for the presidency, and Williamson was happy to second the nomination. Hébert was one of our outstanding sculptors. He was young, intelligent and not concerned with Academy politics; besides I felt it was time we honoured a French Canadian with the office. The chief objection to Hébert, I suppose, was that he was only thirty-six, and the presidency was an old man's job. So Henry Sproatt was nominated, the eminent architect who had designed Hart House. Though he was not active or much interested in Canadian art, he was elected by a large majority and the Academy was saved from any progressive nonsense.

After the Wembley Exhibition, the members of the Group of Seven gradually began to receive the ultimate recognition; our pictures began to find purchasers.

My circle of acquaintances was enlarged about this time to include Fred Housser and his wife, Bess. They became such enthusiastic supporters of Canadian art that Housser, who later became financial editor of the Toronto *Star*, was inspired to write a book. Published in

[85]

1927 with the title *A Canadian Art Movement,* it was not controversial, but an absorbing story told so simply that people who had regarded us as a public menace found themselves quite in accord with us.

Another good friend was Norah Thomson, who was book adviser at Eaton's. Her interest in art resulted in Eaton's bringing in more good books on the subject and after she married H. P. DePencier she became a collector of Canadian paintings. Her home in Owen Sound is a small art gallery.

Mr. and Mrs. Vincent Massey became interested in Canadian art and started what later developed into one of the most important collections in the country. I went one weekend to their home in Port Hope to discuss an acquisition with them. They asked me to stay on and do some sketches of their garden. A valet laid out my rather meagre wardrobe; I had only one suit of pyjamas, and to make last I tossed them carelessly on the bed every morning, but did not sleep in them. When one of the guests was leaving I accompanied him to the railway station in the big open Pierce Arrow, then asked the chauffeur to drive me to the gents' furnishing store where I extended my wardrobe. There was a summer art school at Port Hope at that time conducted by J. W. Beatty so I asked to be taken around that way. We stopped in front of the school. Beatty came to the door and blinked when he saw me. I waited for the chauffeur to go around and open the door before I stepped nonchalantly out. Beatty said, "What's this? Did you sell a picture?"

Harry Southam also started to buy Canadian paintings, then R. S. McLaughlin. Stanley McLean, too, got interested in Canadian art. He bought a great many pictures, not only for his home but for the offices of Canada Packers throughout Canada. His friend, J. J. Vaughan, followed his example and became an ardent collector; then Charles S. Band, and, in the West, Frederick Mendel also began to acquire Canadian paintings.

Stanley McLean liked the company of artists and, being a man of vision, he later financed the Kingston Conference, the first occasion when artists from all over Canada came together. Thomas Hart Benton was one of the guests from the United States, and several of the staff of the Fogg Museum came to lecture.

The Conference in 1942 afforded a fine opportunity for artists from every part of Canada to discuss the problems of art in general and the peculiar conditions that the Canadian artist had to contend with. The

lines of communication in this country are too extended for artists to meet each other often, or to exhibit their work, without being subsidized in some way. At the Conference, lectures on technical processes were given, and efforts were made to form some kind of organization that would bring together artists, professional and otherwise, right across Canada. As a result, the Federation of Canadian Artists was founded. It was not long before the Federation had a thousand members, with groups all over the country. In the cities, where there were already established art societies, it made little impression and after several years it petered out there, but it resulted in many art societies being formed in the smaller towns, and the general result of the Conference was more knowledge and understanding of the arts throughout Canada.

Among the early enthusiasts for Canadian painting were the late Alan Plaunt and his wife, now Mrs. H. A. Dyde. Their warm appreciation outweighed a great deal of the ill-will we encountered. Mrs. Dyde is now one of the Trustees of the National Gallery.

With such enlightened people giving a lead and showing their faith in the work of Canadian artists, the vital phase of the Group's battle against entrenched conservatism was ended.

XI
Jasper and Skeena

IN THE summer of 1924 Lawren Harris took his family to Jasper Park and I went along with him, as we planned to do some work for the Canadian National Railway. We did not find the landscapes in the neighbourhood of Jasper Lodge or along the railroad very interesting, and we wanted to get into the big country, so we arranged with the Park Superintendent, Colonel Rogers, to have our dunnage taken in by the wardens while we walked in, first to Maligne Lake, then to the Tonquin. At Maligne we borrowed an eighteen-foot canoe and paddled about fifteen miles to the far end of the lake. It was a weird and ancient country of crumbling mountains and big glaciers. Deciding we liked the look of the Colin Range to the east better, we borrowed a horse from the warden, piled all our supplies on him, and climbed to the top of the timber where we camped.

It was not easy to establish a camp there. We could find no level ground for the tent. The first night I rolled out of it, and next morning Harris found me some distance below, lying sound asleep against a tree. When we started off each morning to sketch we filled our packsacks with dry sticks, for there was no wood higher up. The trees were stunted spruce, very bushy at the bottom, and even if it had been raining for a week we could be sure of dry branches underneath. We found the six-thousand-foot level, where we could look both up and down, most satisfying for painting. At noon we made tea, usually under difficulties. I recall one day when it was raining and we were on a shale slope and could find no water. After a thorough search we located a baby glacier and got some drip off the bottom. Then came the task of building the fire. One of us held a raincoat over the dry

[88]

sticks we had brought with us while the other blew till he was deflated; then we changed over. With the last stick, the water bubbled, and we threw in the tea. We had enough breath left to raise a feeble cheer.

The Colin Range was an amazing place, a kind of cubists' paradise full of geometric formations, all waiting for the abstract painter. I painted a large canvas of it which no one liked, so I destroyed it. I lived to regret this rash act. It would have been considered a very good canvas twenty-five years later.

We had a young guide with us when we decided to travel over the Shovel Pass between Maligne Lake and the valley of the Athabaska. It was not an easy trip; we had to climb to eight thousand feet over the pass. On the way up, we ran into a snowstorm and spent the night near the top. Twenty-five years later I was flying to the Barren Lands from the Eldorado Mines. The pilot of the plane, Don Ferris, asked me if I remembered going over the Shovel Pass with an artist named Harris. I said I did. "Well," said Ferris, "I was your guide." He had been a squadron leader with the R.C.A.F. during the war.

We had intended to camp in the Tonquin country but it was raining when we got there after a long hike, so we spent the night with the warden, a man named Goodair. He was far from friendly, and made it quite clear that he did not like intruders among whom, obviously, he numbered us. After supper there was some desultory conversation in the course of which Harris asked Goodair what he did in the wintertime. Goodair replied that he went to Edmonton where he spent most of his time in the library. When Harris asked him what he read, he replied that he was most interested in history, biography, and theosophy. Harris was a theosophist and soon they were deep in a discussion of all the books they had read on the subject. After that evening we would have been welcome to stay a month with Goodair.

Goodair was a most remarkable man. A party of Harvard students, mountain climbers, were camped some way off. One of them came over to visit us, and as he was leaving he shot a phrase to Goodair in Latin. Goodair's reply was also in Latin. Through an occasional reference we learned that he had graduated from the University of London, that he had lived in Abyssinia, and that he had been in the Klondike. Talking one day about snakes, he pointed to a scar on his arm where he had been bitten by a poisonous snake in Peru and had nearly died of the bite.

[89]

We did little painting in the Tonquin. It rained all the time, and we were thoroughly fed up. One evening, as we were about to turn in, Goodair said, "What kind of weather do you want tomorrow?"

Harris answered, shortly, "I don't give a damn if it snows."

This was in August. Goodair was up at dawn; we could hear him chuckling as he moved about the cabin.

"Better get up and look out," he called.

We did so and found the country was covered with two feet of snow.

There was one hill from which the whole way around the horizon could be seen, a grand panorama of mountains and lakes with stretches of forest and Alpine pastures. From this panorama, we planned a scheme of decoration for a Canadian National hotel or station. Harris took one half and I took the other and we made drawings of it by sections all the way round. Later, when we returned to the East, Harris went to see Sir Henry Thornton about our plan. Thornton was much interested in it but his own position with the railroad became precarious soon after, and nothing came of it.

One night, shortly before we left the Tonquin, it was still pouring rain when we heard a shout outside Goodair's cabin, and opened the door to find two men with a pack train. They were the cook and the packer from the Harvard camp, who had been left to close up.

They had plenty of supplies with them, and the cook immediately turned to and produced an excellent meal. After dinner, with the rain pelting down on the cabin roof and a big fire roaring in the stove to dry wet clothes, we sat around and talked. The cook proved to be an Oxford graduate, an authority on music, so till late in the night we discussed art, music, theosophy and a variety of other subjects. We were just starting on cosmic consciousness when the packer and I went to sleep.

During our stay with him, Goodair was worried about a grizzly that had smashed up his cabin while he was away. I had several letters from him after we returned to Toronto in which he mentioned that the grizzly was still hanging around. Then I read in a press notice that he had been found dead outside his cabin. I never heard definitely that the grizzly had killed him.

Before we left Jasper, Harris and I got so tough that we hiked from the highway near Mount Edith Cavell to the Tonquin, down the Meadow Creek trail and back to Jasper in one day, a distance of over thirty miles.

Marius Barbeau, the anthropologist with whom I visited the Island of Orleans, had been on expeditions to the West Coast where Langdon Kihn of Lyme, Connecticut, the American artist, had worked with him. It was a most successful collaboration. Marius had been told that American archeologists, ethnologists and others had cleaned up everything of value in the country, but he found a great many fine examples of Indian handicrafts which he acquired for our National Museum, as well as much folklore and history which had not been recorded before.

In 1926 Marius Barbeau went West again and arranged that Edwin Holgate and I should accompany him to the Skeena River. He was particularly anxious to investigate the state of the Indian totem poles, for he had been instrumental in having Mr. T. B. Campbell, a C.N.R. engineer, sent out to make an effort to preserve them. The poles were not ancient in origin, having been made possible only when the white man's tools became available to the Indians. When we were in the area they were no longer being made, but the few remaining totem poles kept alive the memory of days when the tribes were numerous and powerful. They were regarded as idols by many people who encouraged the Indians to destroy them.

Holgate and I made many drawings of the totem poles around Kitwanga, where Campbell was straightening them up and setting them in good concrete foundations. For our purposes, we preferred the poles leaning forward or backward, and suggested to Campbell he set them that way. Campbell's comment on this was brief.

"I would do anything I could," he said, "to please you artists, but as an engineer I cannot put up leaning totem poles. You can make them lean any way you like in your drawings."

The restoration of the colours was absurd. The Indians had only a few earth colours, quiet and dignified. The government official in charge of the job got a complete line of garish colours from Vancouver and asked the Indians which should be used. The Indians, of course, advised the use of yellow, blue, red, and the poles were made to look ridiculous. The Indians were suspicious of the project and the people in charge of it, and they had good reason to be. The building of the Grand Trunk Pacific to Prince Rupert had ended their isolation and the white man was crowding into their country.

One day Holgate and I were making drawings of the Indian grave houses at Hazelton. They were made of wood and were of odd design.

[91]

Inside were placed all kinds of objects the deceased might have use for in the spirit world, such as clothes, tools, and a broken sewing machine (in the spirit world, evidently, the machines did not have to be in working order). A Negro with his arm in a sling came to watch us at work. He told me he was a prospector and that he had just got out of hospital where he had been sojourning as the result of an accident. He had, it appeared, had two tins exactly alike, one full of beans and the other of gunpowder. He had got them mixed. I asked him if he had lived long around these part. Anxious to impress on me the fact that he was not an Indian, he said, "Sir, I was the first white man in Hazelton."

On a previous expedition, Marius had met a medicine man who had masks, rattles and other things of a similar nature that Marius coveted for the National Museum, but no amount of money tempted the owner. Marius made some recordings of his conversation. The recording machine excited the medicine man; he quickly realized that his waning magic could be bolstered up with it. He became more tractable then, and Marius got most of the things he wanted in exchange for the machine.

The Skeena River was dangerous, cold, swift and muddy with glacial silt. Back from the river one soon encountered bush that was almost a jungle. The Skeena had once been the main highway from the sea into the interior, and Indian villages were scattered along the banks. I went with Barbeau to find the remains of an old village that had completely disappeared in the jungle. We had axes and machetes, yet it took us an hour to go a hundred yards; nettles, Devil's club, thimbleberry bushes eight feet high, and skunk cabbage, made the bush almost impenetrable. The totem poles had fallen to the ground and in the dank woods had almost disintegrated.

The Indians of the West Coast were a remarkably creative people. Their arts, Barbeau believes, kept twenty per cent of their people occupied. But the big powerful tribes, Tsimsyans, Tlingits, and Haidas, have dwindled to a mere shadow of their former greatness. They produce little to-day in the way of art. One native said to me sadly, "We are no longer Indians, neither are we white people."

We stayed at Usk, Port Essington, and other places on the Skeena. Holgate painted a couple of bold totem-pole canvases and made a number of studies of Indians. I made many drawings and sketches, but I worked up few canvases of this country. The most successful one, now owned by Isabel McLaughlin, was "Indian Home."

Our trip to the Skeena inspired similar journeys by other artists, and a book that Barbeau wrote, *The Downfall of Temlaham*, was illustrated by their drawings. Later, we tried to interest the Royal Ontario Museum in bringing on a couple of big totem poles from the Nass River. They would have been exciting outside the Museum, facing Bloor Street. The Museum, however, was not interested and the poles went to New York.

As a result of all this activity, an interest in West Coast art developed and an exhibition of it was arranged in 1927. It was through this exhibition that we first became acquainted with Emily Carr and her work.

No artist in Canada had a more difficult struggle than Emily Carr. Long years of neglect forced her to give up painting at times, and to earn her living by making pottery, weaving rugs, raising dogs, and keeping boarders in the house where she lived in Victoria, B.C. These years left their mark on her. A fiery spirit, she was not one to accept rebuffs with complacency; as she grew older she sometimes saw slights where none was intended, and this at times led her to be less gracious. Harry McCurry, the Assistant Director of the National Gallery, had included some of her work in an exhibition without her consent, which there had been no time to secure. The Director of the Gallery, Eric Brown, was away in England and McCurry was in charge. A letter arrived for the Director which he opened. It was a denunciation of his high-handed tactics from Emily Carr and a demand that Eric Brown should fire him. I, too, had occasion to feel the weight of her displeasure. I spent a great deal of time, once, persuading a collector to buy one of her canvases. He eventually bought it, and all I got from Emily in the way of thanks was a letter complaining about having had to wait so long. But such incidents were only the outer manifestations of a proud spirit that had suffered much and this we all understood.

The first person to realize the potentiality of Emily Carr's work was Mortimer Lamb, a mining executive, a friend of mine who had moved to Vancouver from Montreal. He wrote to Eric Brown about her, and directed several letters to me when the Group of Seven was formed. All we could do for her at that time was to invite her to share the abuse being hurled at the Group. It was Marius Barbeau who called attention to her work when he organized the exhibition of West Coast art for the National Gallery. She was invited to send a number of her canvases, and a railway pass was secured for her so that she might at-

[93]

tend the exhibition. She had many friends and admirers after that time, and no longer felt isolated. She was very familiar with the Skeena River country; some of her canvases at the exhibition were of that part of Canada.

It was after her return to Victoria, when she was over fifty-six years of age, that Emily Carr produced the succession of notable canvases of the West Coast country which to-day are most associated with her name. When she returned to the Coast, she depended less on subject and gave more play to her imagination. The totem pole paintings gave way to forests with great tree trunks, to seas of green foliage and dramatic lighting.

When she had to give up painting on account of her heart, she took to writing, and was as successful at it as she had been at painting. Her first book, *Klee Wyck* (meaning "The Laughing One," the name she went by among the Indians), was awarded the Governor-General's medal. It was followed by several other books of great interest.

XII

An Arctic Holiday with Dr. Banting

IN 1925, at the Empire Club in Toronto, as a sort of aftermath of the great controversy raised by the Wembley Exhibition, Wyly Grier, the well-known portrait painter, and I were invited to debate on academic and modern painting. It was a friendly debate, in the course of which Grier contended that the painters of the Group of Seven were moving away from the country that people were familiar with, and were going farther and farther north so that he believed our final objective must be the North Pole. The following year I heard a New Year's eve broadcast to the Canadian Arctic, which consisted largely of messages to R.C.M.P. constables, Hudson's Bay employees, missionaries and others. Many of the messages were addressed to R.C.M.P. Sgt. Joy "on top of the world," at Ellesmere Island. Listening to the broadcast, I recalled what Grier had said about the North Pole and immediately asked myself, "Well, why not?" Shortly afterwards I wrote to the Minister of the Interior, the Hon. Charles Stewart, that I should like to make a painting of the most northerly post in the world on the Bache Peninsula and present it to the Department. I doubted that he would reply, but I got a very friendly letter from him saying that he liked the idea, and advising me to write further on the subject to the Deputy Minister, O. S. Finnie. It was arranged in no time that I should go North on the next run made by a Department boat.

Dr. Banting was very interested in the North country, and owned an Arctic library of many volumes. He hoped he might be able to

[95]

accompany me on the journey to the North, but the Department wrote him that it was unable to provide accommodation for him. Actually, as we discovered later, the Department was afraid that the available accommodation was too rough for anyone so distinguished as Dr. Banting. In July, 1927, I was packed up and ready to leave. There had been a farewell party for me at the Loring-Wyle studio; after the party I went home with Banting. He found there a telegram from Ottawa telling him that room could be found for him on the voyage. There followed a wild scramble by Banting to get packed in time to catch the train to Sydney, Nova Scotia.

The Steamer *Beothic* was chartered by the Canadian Government from the Job Shipping Company of Newfoundland to make this annual trip to the Arctic. It took supplies to the R.C.M.P. posts established in the Arctic, and men to relieve constables who had been on duty for two years or more. Dr. Banting and I shared a cabin with Dr. Malte, the Government botanist. The *Beothic* was no luxury liner, but there was an interesting company aboard her, many of whom were familiar with the North from long experience with it. She was commanded by Captain Falke, who had been born within the Arctic Circle in Norway. Dr. Stringer, born on Hershell Island, and George MacKenzie, who had lived for years in the Yukon, were two other old hands in the Arctic. The *Beothic* herself had been to the Arctic several times previously as had some members of her Newfoundland crew.

Canada had established posts in the Arctic to make good her claims to it. Most of the country had been discovered and mapped by British, American and Norwegian expeditions. The Norwegians' most recent discovery had been Axel Heiberg Island. Vilhjälmur Stefansson, working for the Canadian Government, had made the last important discoveries in 1916. If Canada did not wish the Americans or the Norwegians to follow up their explorations by laying claim to the territory, she must herself occupy it; and so the R.C.M.P. outposts were established. The police who manned these posts were picked men, most of whom had already seen service in the North. Their job was to make patrols, report on weather and ice conditions, to administer the law, and to preserve order. It was also part of their task to restrain the Eskimos from throwing away girl babies and leaving their old people to die of starvation, and to advise the hunters of the folly of killing more game than they could use.

From the artist's standpoint this journey to the North was a great

[96]

adventure. The quarters aboard ship were cramped, it is true, but we could get ashore whenever supplies had to be landed. On such occasions we stayed overnight at police posts, and during the days we were free to wander where we wished, so long as we did not stray too far from the coast, which we never did, as we did not relish the idea of missing the boat and waiting until the following year to be picked up. The worst obstacle was fog, though we lost much time on days when we were stuck in the ice.

Our first stop, at Godhavn in Greenland, had some of the aspects of a ceremonial visit. The Governor came on board to welcome us; a public holiday was proclaimed, and the Mounties put on their scarlet tunics in honour of the occasion. The spectacle was like a scene from the *Chauve Souris,* or a fairly tale. As a back-drop the quaint Danish houses stood side by side with Eskimo shacks made of sods, tar paper, and old packing cases. The ladies of the ensemble wore top boots, fur pants, gaily coloured jackets and woollen toques. Grass and wild flowers abounded in pools of water, with outcroppings of smooth rounded rocks. In front of every house lay husky dogs; these would be silent and inert for brief periods then something would stir one pack to howl, and their howls would be taken up and repeated by the others until the whole countryside was a bedlam of noise which would subside as suddenly at it arose.

The passage to Pond Inlet, our next objective, gave us our first experience with the Melville pack. This sounds as though we indulged in fox hunting, but that was far from the case. The Melville pack has been the terror of the Arctic for hundreds of years. The icebergs to be met in the Atlantic come from the Greenland coast; these move slowly southward and finally dissolve in the Gulf Stream or run aground on the Labrador coast. The big ice packs, on the other hand, are moved about by wind and tide. As we passed through the Melville pack we observed old ice floes and patches of blue ice, and ice lifted off the shore with mud and stones all over it. To make studies when the ship was zigzagging through the ice fields was very difficult. The old floes were fantastic in shape; some resembled big mushrooms and were beautiful in colour, lavender white on the outside and green-blue under the water. We attempted to reach Pond Inlet and found the sea there still frozen over. There were fifteen miles of ice between us and the post. We stopped a few hours at the edge, hoping someone would come over the ice; then, as no one came, we turned north following the

coast of Bylot Island, which to me seemed the loveliest island in the Arctic. It was crowded with sharp peaks, all snow covered; between them ran the curved line of slow-moving glaciers; at the base lay a stretch of flat country where the snow was disappearing.

The first police post we called at was on Devon Island. From a distance I would have thought that there was no vegetation, but when I got ashore I found the ground covered with flowers and moss, heather, poppies, saxifrage, draba, lousewort. I found Malte, our botanist, at one a.m. lying on his rather prominent stomach on a patch of moss, a large magnifying glass in one hand and a notebook in the other.

We went into Craig Harbour on the south shore of Ellesmere Island but found too much ice to get ashore, so turned north to Etah on the Greenland coast. Etah is a well-known place, whose name turns up repeatedly in the stories of Arctic exploration. When we arrived, the settlement consisted of only four tents and about sixteen people; sometimes the population mounts as high as sixty. We took with us some of the Eskimos who wanted to move to Pond Inlet.

Then we cut across to Rice Strait, passing Pim Island where the Greely expedition spent the tragic winter of 1883, and on to the Bache Peninsula, where Canada's most northerly post was established. We anchored off the post. A small boat came out from the shore, pushing its way through the ice. As it came alongside a rope ladder was let down; a big husky chap climbed up and jumped down on the deck. This was the Sgt. Joy, to whom I had heard so many radio messages addressed during the New Year's eve broadcast. His post consisted of three little huts at the foot of high cliffs, and the whole population of Ellesmere Island was only three Eskimos and four police. I made a sketch of the *Beothic* anchored out a quarter of a mile from shore unloading supplies. Banting sat beside me as I sketched. We had little time to spare at the post; the Captain was afraid of ice closing in on us, and it nearly did too. Getting in and out was so hazardous that later the post was abandoned.

After my return to Toronto I painted a large canvas from the sketch I made at the post on Ellesmere Island and presented it to the Department of the Interior.

We had orders to go west on Lancaster Sound as far as Melville Island; the Sound, at one time, was supposed to be the North-West Passage to the Pacific Ocean. A cache had been made there by Captain Bernier in 1910 and it needed to be renewed and repaired. We

GEM LAKE
1941
In the collection of
The Art Gallery of
Toronto

LAKE IN THE HILLS
1922
In the collection of
Mr. and Mrs. R. E.
Dowsett, Toronto

anchored off Beechey Island where the Franklin expedition had wintered in 1845-46. It was a dismal spot, a gravel beach with high forbidding cliffs rising right behind. There was a shelter on the shore, made of water barrels and anything else that could be spared from Franklin's ships. Every once in a while a field of ice would come in and start pushing the *Beothic* shoreward and we had to pull up anchor and head out to sea. We got ashore at last, and found there a record left by Capt. Bernier in 1922, in a whiskey bottle, still pungent. There was the hull of a little schooner, the *Mary*, lying on the shore where it had been left for Franklin. A trader named James and some Eskimos stripped it of everything useful. Later the Eskimos murdered James. From the artist's point of view Beechey Island was a total loss. There was nothing to paint, the water was muddy, and we could barely see through the fog. Franklin, with two ships and one hundred and twenty-eight men, must have spent six months in this desolate place.

We moved on through ice and fog, the compass bedevilled by the magnetic pole. South of Cornwallis Island the ice got so bad that we gave up the idea of getting to Melville. We turned south to Port Leopold, Somerset Island, to close up a Hudson's Bay post established without government authority. James Ross wintered here in 1833. There were a number of old igloos still standing, which indicated that there must have been a fair-sized settlement there at one time. I made some drawings of the stone houses, the roofs supported with whale or walrus bones. We found a trailing saxifrage on the shore; Malte was very excited about this when we showed it to him, and went ashore to gather more specimens. Every time he found a rare plant, or a plant growing farther north than previously recorded, he came into the cabin to have a drink of rum. He insisted we join him in toasting our discovery of the trailing saxifrage.

When we left North Sydney a one-cylinder engine had been installed in one of the lifeboats, and we were compelled to take along a fourth engineer to run it. It was soon evident that he knew nothing about engines. He insisted the engine was no good and used impotently to curse it. At Somerset Island when the Hudson's Bay post was closed, we picked up several men from Labrador, nice quiet fellows. The Captain said to them one day:

"Do any of you chaps know how to run a gas engine?"

All of them did.

"Well, who knows most about it?"

After some consultation they decided Jimmie did.

"Very well, Jimmie," said the Captain, "you are in charge of the motorboat from now on."

Jimmie climbed into the boat, tinkered with the engine for half an hour and from then on it ran to perfection.

We turned east and went into Arctic Bay. Banting and I went ashore at two a.m. to sketch. It was impressive country, looking something like Colorado, but unfortunately we stayed there only a few hours. A party of Eskimos came over the ice to the steamer just as we were ready to leave. The ice was breaking up and it was exciting to see them jumping from floe to floe to get ashore.

The kind of expedition on which we were embarked, in the opinion of Sgt. Joy of the R.C.M.P., was expensive and purposeless. They went into places that were already well-known. Canadians, according to him, had done next to nothing in Arctic exploration. Joy wanted to take an expedition made up of geologists, naturalists, photographers and, of course, artists, round the north shore of Ellesmere Island. He should have liked to explore Lake Hazen also.

We got into Pond Inlet from the west by way of Navy Board Inlet. Pond is one of the happiest of our northern settlements. It has a sand beach that runs for over a mile (a little cool for bathing), a stretch of low country full of little lakes and streams and, away in the background, a ring of mountains. Across the strait is Bylot Island, but no one was living there at that time. We were busy all day at Pond. Banting said he would have liked to stay there two months. At Pond we took aboard a Dr. Livingstone who had arrived by dog team from Pangnirtung. Like his namesake, he was a great traveller. One of the police who came aboard at Pond began immediately to borrow tobacco. Approaching Banting, he said, "Hey, Doc, are you the guy that has the Edgeworth?"

When we left Pond, we were homeward bound. We followed the coast of Baffin Island southward; for miles we sailed past big mountains and glaciers but they were too far away for our purposes. At Pangnirtung, we picked up two geologists, Weeks and Haycock, who arrived at the last minute, just as we were about to pull away. They had spent a year in the district on a government survey in the interior. They told us a great deal about the country, but the fog prevented us from seeing much of it. Pangnirtung, as I first saw it, was the metropolis of the North. It stood on a long fiord surrounded by big hills, and many Eskimos lived there in skin tents, with hundreds of dogs.

In Hudson Strait we called at Lake Harbour which lay in lovely, almost pastoral, country with gently sloping hills and many shallow lakes. We found many old caribou horns mouldering in the moss, and there was fire weed, saxifrage, pyrola, Arctic cotton, buttercups, dandelions, and scrub willow. Lake Harbour seemed tropical after the places we had been in, and we very much regretted leaving there. We made a short stop at Wakeham Bay on the south side of the strait. I climbed a hill and made a hurried sketch, which was wasted effort. An air base was under construction at Wakeham; the pilots were to study ice conditions in the Straits during the winter months.

Our last stop was Port Burwell, a police post. It was a depressing place, cold and foggy, with rocky hills and the sea breaking on miles of granite coast. I saw a little gravestone there erected over one Solomon Lane, who had arrived in June when the flowers were impatiently pushing through the departing snows and had gone away four months later in September when the flowers were withered and dead and the snows returning. That night the aurora made great spirals in the sky, while the Eskimos were down in the steamer's hold enjoying a movie show. A painting of this aurora is in the permanent collection of the Art Gallery of Toronto.

After getting a frightful shaking up in a sea like a bucking broncho, we rounded Cape Chidley, the northern tip of Labrador. There were still patches of snow on the ground. On 4th September we arrived at Sydney, Nova Scotia, after a most successful voyage. Banting was a good companion and very popular with all hands. He was interested in everything and his painting was improving all the time. He told me that after he reached fifty he would like to devote all his time to art and leave research work to younger men.

There was a lively aftermath to our Arctic voyage. A reporter got on the train as we were leaving Montreal for Toronto and asked Banting for an interview about our experiences in the Arctic. The Deputy Minister, Department of the Interior, had told us the Government was at odds with the Hudson's Bay Company, and advised us to be cautious about any statements we made in public. The reporter wired his story from Kingston, and afterwards Banting was led into a discussion with him about conditions in the Arctic. When the story of the interview appeared, it was scarcely noticed, but a second story, which featured Banting's criticism of the Hudson's Bay Company, made sensational reading. The Deputy Minister telephoned him and Banting, feeling very dejected, took the next train to Ottawa to see him.

Realizing that there was trouble ahead, Banting spent some time in Ottawa looking up papers and reports about the health of the Eskimos, about how the tribes had diminished in the past hundred years since their contact with the white man, and other information of a similar nature. Some weeks later the General Manager of the Hudson's Bay Company telephoned him. Banting's criticism had been widely publicized, he said; it had done the Company much harm and they demanded a retraction. Banting went to his hotel to see him, armed with the information provided by his research in Ottawa. He had no trouble in proving that the Eskimo population had decreased; he had the Company's own reports for many years back showing a steady decline in numbers. Was the Company responsible? Not altogether, but Banting's argument was that the Eskimos had existed for hundreds of years by hunting. The fur companies had turned them into trappers, leaving them little time to hunt, so the Company supplied them with food—the wrong kind of food for that country. The meeting ended in a friendly discussion; there was no retraction.

The following year I made another northern journey in Banting's company. With Mackintosh Bell we left on a trip to Great Slave Lake in July 1928. This was a part of their country few Canadians at that time knew anything about. Bell had been there in 1900, when he and Dr. Camsell made a survey of the north shore of Great Bear Lake, and had tried to go overland to the Coppermine River, an adventure that nearly ended in tragedy. It was slow travelling getting to the Great Slave. We went by rail to Waterways, a dreary, monotonous trip. Here we met our first mosquitoes, very aggressive ones. I had brought some insect repellent with me from Toronto, but it seemed only to make me more appetizing to them. At Waterways we embarked on a river-boat. Alongside our boat lay the *Northern Echo*, which was taking a load of buffalo down the Athabaska River to Fort Smith. When Christie, the man in charge of the operation, heard that Dr. Banting was with us, he almost whooped for joy. He was a diabetic, and was having much trouble with his injections of insulin. Dr. Banting gave him instructions which enabled him to take the injections much more effectively. Our boat was a stern wheeler and burned wood, which was conveniently piled on the shore every few miles. Navigation was largely by instinct, as the channel changed constantly. The fast water would gouge a bank out and pile it up as a sand bar, then attack the

sand bar and pile it up farther along. From Fitzgerald we motored across a fifteen-mile portage to Fort Smith where we took a smaller boat the *Liard River*. We went on a scow pushed ahead of the steamer down the Slave River to Fort Resolution. In the summer the Indians congregate at Resolution, where they erect their tents and teepees, making of the settlement a most picturesque place. We had hoped to do some sketching here, but 1928 was the year of the influenza epidemic among the Indians. In a panic they had cleared out and scattered in all directions, so there was not much to sketch.

Awaiting the building of a railroad from the Peace River country, Bell was having some work done at Pine Point, which has since become one of the biggest mining projects in Canada. We went by motorboat along the south shore of the Great Slave, with C. B. Dawson, an engineer who worked for Bell; he had waited for us at Resolution. The shore was piled with old driftwood; back from the shore lay the woods, mostly spruce, birch and jack pine. We saw an Indian lying on the beach wrapped in a red blanket to keep off mosquitoes, although it was breathlessly hot. The woods were too sparse to afford any shade. We hiked the nine miles to the mining camp, with a cloud of mosquitoes torturing us, till a sudden rain squall cleared away the pests, and we arrived at the camp drenched to the skin. Alex Hattie, the engineer in charge, provided us with dry clothes, a drink of rum and a hot meal.

Bell asked me to made some pencil drawing of the pits and surroundings. I could not use my oil colours, as the mosquitoes got all mixed up with the paint. In any case there was not much to see, only a little clearing in the bush and some holes in the ground.

Back in Resolution, where we did some sketching, we stayed in a house belonging to Mr. Murdoff, who was in charge of the Northern Transportation Company's post. He was an elderly bachelor, and a most amusing man, though somewhat crippled with arthritis. He seemed most to enjoy getting the better of the Hudson's Bay Company. He had an attachment for a young widow in Edmonton and the R.C.M.P. men were constantly urging him to marry her. Murdoff's response was, "With all you handsome boys around, I would be nothing but a referee."

The settlement was overrun with starving dogs. It was too much trouble for the Indians to go out on the lake and get a supply of fish for them.

Bell had a crew working across the lake at Yellowknife: in 1928

gold had not yet been discovered there. We crossed the lake in a small scow with an engine in it, towing two canoes. The first night out we camped on a small treeless island. The next morning we woke to find it blowing so hard we had to spend the day there. In the afternoon another boat put in to the island for shelter. It was owned by a Syrian fur trader, who, when he found we had a doctor in the party, told us that he had a sick wife with him, and he was very worried about her. He brought her over to see Banting; she was a handsome young Syrian woman who was very ill with 'flu. Banting gave her some medicine and they went off much cheered up.

On their way back from Great Bear Lake in 1900 Mackintosh Bell and Dr. Camsell had been picked up by some Indians crossing the lake in a York boat. Camping one night on an island they had found some pieces of hematite ore but, being pressed for time, they had not fixed the location of the island. Bell hoped on this journey to find the island again. The next day we had to take shelter again from a storm, and we found ourselves on the island where Camsell and Bell had camped twenty-eight years earlier. This time it was staked and named Housser Island, and many samples of ore were taken along. Banting fancied himself as an amateur geologist. He left me to do the sketching while he went about banging away with a hammer, getting only little chips of ore. I was sketching on a projecting ledge near him; underneath I saw something shining. I borrowed Banting's hammer and knocked off a piece of ore-bearing rock the size of his head. Banting decided to go back to painting.

We went up the Yellowknife River and made a portage over to Walsh Lake, where we found Smythe, Wallingford and James, members of Bell's party. This was good, clean country of open rock with patches of spruce, and fewer mosquitoes, so we were able to sketch. I made studies for a canvas of the shore line, which is now owned by the Rt. Hon. Vincent Massey.

On our return journey, crossing Great Slave Lake, we travelled all night, though night is not the proper word, as it just got dark enough to see a pale aurora play across the northern sky.

[104]

XIII
Second Arctic Voyage

WHEN AN invitation came for Lawren Harris and myself to visit the Arctic in 1930 we accepted immediately. We were happy to get away from all the pessimism that came with the great depression. Since this was my second voyage, I felt like an old-timer. I had painted a number of canvases and produced a book of drawings as a result of the 1927 expedition, and Harris and I planned to do much sketching on this voyage. Harris' daughter, Peggy, looking over all our preparations, asked him if he was going to take a camera.

"Why?" he asked.

"Well if you don't," she answered, "how are we going to know what the country looks like?"

We left Sydney on 1st August on the same old *Beothic* on which I had travelled with Banting in 1927. Captain Falke was still in command, and our itinerary was pretty much the same as in that year. This time, however, we had a larger cargo, including sixteen hundred tons of coal, lumber for a hospital at Pangnirtung, a big motorboat for Chesterfield Inlet, old library books for the police posts, and necklaces and chewing gum for the Eskimos, these last being provided through the kindness of two artists.

We took with us two young Americans from Ann Arbor University who were going to spend a year in Greenland. They proposed to build their own shack near Upernavik and make geological and meteorological observations. A Dr. Heinbecker of St. Louis was aboard, going to do medical research work with the Eskimos. Aboard, too, was my old friend, Sgt.—now Inspector—Joy. Another distinguished passenger was Dr. Porsild, the noted Danish scientist, who had been in Ottawa

for some time classifying Arctic flora for the Government. He was returning now to his home in Godhavn, accompanied by his little granddaughter. One evening he gave us a talk about the Eskimos in Greenland. Their government, he told us, faced many difficulties. The recent decision to shut out foreign traders had killed enterprise. The people had no ambition, yet they were very egotistical; they all wanted to give orders or to be the captain of the boat. Communication was the biggest problem since it was all by sea. In the south, which was more fertile, the land was suitable for growing potatoes and raising sheep, but too often it was shut off by ice. At Godhavn they raised a few vegetables under glass. The real future should lie in fishing, but this the Eskimos were too indolent to do seriously.

Godhavn, our first stop, was the last place we could send mail from. I could not miss the opportunity of sending a letter to a lady friend in India, "from Greenland's icy mountains to India's coral strand." Steam trawlers of French, Spanish and British registry were all over the place, fishing for cod. This was a new fishing ground. Capt. Falke said it had many advantages over the Grand Banks; there were fewer storms, less fog and none of the constant fear of being run down. The Greenlanders did not like the presence of foreigners in such large numbers, but could do nothing about it.

The evening before our arrival at Godhavn we had rum punch and toasts to our departing guests, Dr. Porsild and the American students, Carlson and Dumerest. Inspector Joy, who seldom spoke of his experiences, on this occasion told us about a trip he had made to Melville Island in 1929 when he ran out of supplies and looked up an old cache put down for Franklin in 1852. There he found raisins, canned mutton and carrots, in prime condition, and some woollen goods, which he was still wearing.

As usual on the arrival of a Canadian Government steamer at Godhavn, the Governor declared a public holiday, and while Harris and I hurried along the shore to paint some stranded icebergs, the whole town became a scene of gaiety.

Then we steamed northward again. The weather was unpredictable; the day would begin with glorious sunshine, then an hour later we would be enveloped in a cold fog bank. There were other difficulties to bedevil the navigator. The sea would be free of ice as far as we could see, then suddenly an ice field would appear from nowhere and we would be stuck in it for hours. We went into Robertson Bay on the

Greenland side to try to find an Eskimo to go with us to Bache, but we had no luck. Rasmussen's schooner was at anchor in the Bay; his men were busy building a trading post.

The Bache post was our destination. At one time it looked as though we would not make it, for big ice packs held us up. Then the pack seemed to open up in the middle, and we steamed right through to Ellesmere Island. We did not get to the Bache post, but Inspector Joy got through in a motorboat.

Harris and I went ashore on Pim Island, climbed up several hundred feet and made sketches. The Island was a desolate spot, mostly boulders and debris, with an occasional patch of moss or lichen clinging to the rocks. Earlier there had been many flowers.

Here we took aboard several more husky dogs and four pups. Our stay there was not of much benefit to us, for sketching was curtailed by fog. Eventually the *Beothic* gave up trying to get to Bache and unloaded the supplies for the post at Framhavn. The R.C.M.P. officers would get them later by boat or, after the freeze-up, by dog train.

It is strange nowadays to read accounts by earlier explorers of this country—men like Greely, Kane and Hayes. With them it was the usual thing for members of the party to starve or freeze to death and to endure dreadful hardships. By 1930 familiarity had robbed the Arctic of much of its terrors. The men of the R.C.M.P. went on long patrols, usually two police and an Eskimo, and their hardships were merely reported as routine. Joy casually mentioned that polar bears had tried on three or four occasions to break into a snow house occupied by R.C.M.P. constables who had to crawl out and shoot them. He told us of another constable who upset his kayak after shooting a seal. He got the seal, saved his kayak and made his way back to camp three miles away, believing that he had endured nothing to make a fuss about.

Harris had brought along a supply of Roman Meal. On this journey the excellent comestible probably got as close to the North Pole as it had ever been. Capt. Falke was run down, so Harris persuaded *him* to use it. Later, Inspector Joy also became an addict.

Falke declared that he felt a year younger when he headed for the open sea. Following the Greenland coast, we saw a noble range of big reddish-violet hills covered by glaciers standing in relief against warm grey skies. We called at Nerck to get some specimens that a German geologist, Krueger, had left there. It was an old settlement of stone igloos; there were bones, dogs, guts all over the place, and about forty

[107]

happy Eskimos. We gave them cigarettes and candy, and Joy got a grand husky dog in a trade for 180 cartridges. We parted with expressions of mutual esteem; a chorus of husky dogs howled from the shore and was answered by those on board. The Eskimos gave the equivalent of their college yell, we tooted the whistle and headed for Lancaster Sound.

After leaving Nerck we ran into some filthy weather. The decks were awash, spray swept clear over the bridge, the old ship rolled and plunged and most of us were off colour. This included the dogs which were having a miserable time huddled in a motorboat on the forward hatch; sheets of spray blew over them continuously. On the after hatch a husky bitch was almost crazy with fear as the water swirled all around her, and she tried madly to escape from the hatch. Finally she made a frantic leap to the steps of the second deck, fell in the water and was swept off her feet. One of the police ran out and grabbed her by the tail just as she was about to go overboard.

The next day the weather was worse than ever, with winds up to seventy miles an hour. One of our pigs was washed overboard. In such conditions it was impossible to sketch but Harris, who was immune to sea sickness, got some fine shots with his movie camera. Towards evening we got in the lee of Coburg Island and things became more cheerful. The Captain said it was the worst storm he had ever encountered in Baffin Bay.

Since our time at any of our stopping places was, of necessity, limited, we got into the habit of making notes while ashore. When we were at sea again we made paintings from these notes in our cabin.

Lancaster Sound, between Devon and Baffin Islands, was long considered the North-West Passage through to the Pacific. Parry went through the Sound to Melville Island in 1819 and wintered there. Franklin journeyed in the same direction in 1845. On this voyage we were to make another attempt to restore the cache Bernier had left on Melville Island in 1910. In 1927 we had been held up by ice just south of Cornwallis Island and were prevented from performing this duty.

A few days later, on 22nd August, we were four miles off Bathurst Island. It was snowing. Just before we rounded Cape Cockburn we ran for several miles alongside a floe of polar ice which we followed as though it were a canal bank. It was the largest ice floe Falke had ever seen. It was old, worn, and full of hollows filled with pools of fresh water which looked blue-green. We dubbed it the Harris ice pan. Up

[108]

to that time we had not found anything named "Harris" in the Arctic. We got about halfway between Bathurst and Byam Martin Islands, where we were brought to a halt as there appeared to be no more open water. At midnight the landscape looked like an endless prairie covered with snow. Little pools of water here and there reflected the sun glow; to the east, the coast of Bathurst was blotted out by an approaching snow squall.

Next morning we woke to find the decks covered with snow. The ice had opened up a little and we steamed north, but were soon stopped by heavy ice. The Captain said he was getting sick of barrel work, by which he meant looking for open water from the crow's nest. This country was explored by Parry in 1819 and by McClintock in 1853-54, both of them most resourceful travellers.

It was now late in the season. On 25th August, soon after we got under way at six a.m., we heard loud shouting. We emerged from our cabin to find the Captain in the barrel and the men heaving the lead; we had almost run aground. The bottom was clearly visible. A short distance away the ice was piled up as though it were on a shoal. Parry had reported encountering shoals in this area. The difficulties confronting our further progress were all too obvious and it was decided to give up the attempt to reach Melville. We turned eastward and, rounding Cape Cockburn, we saw a herd of muskox grazing. We also saw that the big Harris ice pan, pushing all the loose ice ahead of it, was moving shoreward towards Bathurst Island to cut off our retreat. We had to force our way through it for several hours, the Captain remaining in the crow's nest during the entire period until finally the pressure eased. He was most concerned for the safety of his ship. Harris disowned the ice pan after this experience.

The imperturbable Inspector Joy's chief preoccupation at this time was to find card No. 17 for Turret's cigarette premium. His set was otherwise complete.

It was quiet on Lancaster Sound, wrapped in a dense fog, the silence broken only by the monotonous low wailing of a pump or the yelp of a husky dog. We were held up all day there. It was impossible to keep a straight course as the sea was full of the wrecks of old ice floes, worn into all kinds of fantastic forms and unbelievably blue in colour. We made sketches of them. The Captain by this time was completely fed up with the whole venture. He swore that in the Arctic everything is against you: God, the Devil, Satan, the whole lot of them. As for the

magnetic pole, he wished the Russians owned it and kept it in the middle of Siberia.

All next day we moved slowly eastward along Lancaster Sound. We had to find Navy Board Inlet between Baffin and Bylot Islands, and we could see nothing through the fog; the whistle was blown occasionally as the navigator tried to pick up an echo.

We turned south still in heavy fog. Suddenly it lifted and we saw some big cliffs appear; we had come fifteen miles down the narrow inlet without seeing either shore. To the east Bylot Island looked like an exciting place to paint, but we did not land there. By the time we anchored off Pond Inlet it was dark and a heavy sea was running, so we did not go ashore.

In the morning we got ashore with some difficulty. Since I had last visited Pond, two churches had gone up. The thirty-odd Eskimos who comprised the native population were well looked after; the police administered the law, the Hudson's Bay Company looked after their material needs and the Anglican and Catholic missions provided spiritual consolation. It seemed to me that the Eskimos, who lived in hovels, were just about as well off when they looked after themselves.

I dropped in to see Father Girard of the Catholic Mission, a cultured and intelligent man. His was no life of luxury; coal cost one hundred and fifty dollars a ton and he had to make four tons last a year.

On 30th August we could see the stars for the first time. The next day we left Pond. Following the rugged coast of Baffin Island for six hundred miles, we turned into Cumberland Sound. We arrived at Pangnirtung just after lunch and started unloading supplies for the hospital to be erected there by the Anglicans. The settlement consisted of the usual white painted wooden buildings and the colourful Eskimo igloos and tents made of skins and old sails stuck anywhere. There were husky dogs and boulders all over the place. It would have made a fine setting for a play at Hart House if anyone had ever written one with such a background.

I climbed to the top of a high hill and made drawings of the mountains on Pangnirtung Fiord. What a country it was! Lakes, hills, upper grassy meadows, snow-capped mountains. The last time I visited it, fog obscured it all. I had to ford a river going home; cold and swift, it nearly swept me off my feet.

We left Pangnirtung at noon. It was a lively departure. The sun

blazed down on us, our whistle blew, the Hudson's Bay cannon roared, the hundreds of husky dogs howled and the whole population waved and cheered. We left behind Constables Margetts, Fisher and Bolsted, Nicholson, the missionary, and Peter, a husky dog from Ottawa, much to that city's relief. Among other supplies we left a pig, materials for the hospital, and a lot of discarded library books. There were some literary standards in Pangnirtung too. I overheard a remark from one of the Mounties who was looking the books over: "All these books by these blooming women; gosh, they *are* rotten!"

We sailed down Cumberland Sound and into Hudson Strait, to Lake Harbour. Lovely as ever, the settlement lay in a silvery country, gently undulating with small lakes everywhere, and surrounded by grass-covered hills. Here we took aboard Oscar, a snowy owl going to the University of Toronto, who made a noise like the air going out of a tire. I made a sketch and later a canvas of the Anglican Mission erected at Lake Harbour by Bishop Fleming. Harris got material for some fine canvases.

There was not a sign of life on shore as we slipped out in the early morning down the long inlet to the sea and turned west on Hudson Strait. Oscar got so frantic he had to be put into the empty hold.

On this leg of our journey, tragedy struck us. One morning the cook announced that the Roman Meal was all used up. We were consequently run down and listless when we got to Chesterfield, where we arrived early in the morning of a windy and drizzly day. There was not a sign of life on the low shores against which the surf beat monotonously. The settlement was a long unsociable line of buildings: Hudson's Bay Company post, Roman Catholic Mission, an unfinished hospital, the doctor's shack, the R.C.M.P. post and the wireless station. Several of us went ashore on a barge. While unloading was in progress we went to the Hudson's Bay store, where Harris, not very hopefully, asked if the store kept Roman Meal. The clerk had never heard of it. Looking about the shelves, Harris spied something familiar on a top shelf and called the clerk, who got a ladder. It was Roman Meal, four packages of it. We were saved! The clerk said he had been there only six years and it must have been brought in before his time. Harris bought the lot, which lasted us right through to Sydney.

The Eskimos at Chesterfield seemed a nondescript lot, the descendants of anybody who had ever visited these parts.

After leaving Chesterfield we anchored in a little bay off Coats

Island. Dr. Porsild, son of the Danish scientist whom we had left at Godhavn in Greenland on the outward journey, had joined the ship at Chesterfield. He was making a survey of the territory to see if there was enough pasturage for reindeer, and he left the ship to explore the island but found hardly enough feed to support a rabbit. Harris and I went ashore later and explored the country. It was desolate and barren, with not a sign of life. Everything was soggy, and there was nothing to make a fire with. We found a little dead spruce tree; it had died of loneliness, the nearest of its kin being over three hundred miles away. Eskimos had lived on the island once, there were the remains of old igloos, bones and rubble.

Four days later we made our last stop of the voyage at Burwell, a forbidding country with big rounded hills, and little lakes all over the place. We made some sketches there, but it was a dreary land and we were glad to leave.

We had hoped to make drawings of Cape Chidley, but alas there was a thick fog and we saw nothing at all of it. It was time that we were homeward bound; we were running out of reading matter, cigarettes and liquor, and the last of our green vegetables, cabbage. We were rolling home, and with nothing in the hold but Oscar, we bobbed around like a cork through the heavy fog and drizzle. Once we passed close to a large dead whale. It looked like an island; resting on it and flying about it were hundreds of gulls. An edible island must be a gull's idea of paradise.

The passage home was uncomfortable. The *Beothic* creaked and groaned; in the crowded cabin everything rattled and banged. Smash! what was that? It was only Harris's hair tonic, but it was followed by an avalanche of clothes, boxes, books, trunks, all shooting back and forth across the cabin in hopeless confusion. In the bunk above, Harris lay, choking with laughter. He looked down to see me reach out to stop a runaway suitcase; a stool rushing at me gave me a whack on the head. I probably seemed very funny seen from above. However, after two months we could stand a lot of tosssing about.

Rolling south to Belle Isle we passed a two-masted schooner, the *Clara B*. She crossed our bows and, allowing us to pass close, asked us to report her by wireless. She kept alongside of us for half an hour. In the big seas running, her whole hull would disappear from view, then she would rise up on a mountain of wave. Her crew were all in yellow oilskins.

[112]

Disdaining the pilot boat that met us, we steamed into Sydney at dusk on 27th September, with the *Beothic's* fifth voyage to the Arctic completed. She was to leave almost immediaely for the Mediterranean with a cargo of codfish. Oscar was put ashore cussing in his cage. Dr. Heinbecker left for St. Louis to analyze his blood tests; Dr. Porsild for Ottawa to classify his plants. The Mounties got three months' leave. We, with all our notes and sketches, hoped to give Canadians some idea of the strange beauty of our northern possessions. Harris had made enough studies to keep himself busy painting canvases for the next two years.

Nowadays this country has become as remote as Wall Street. If a Canadian wishes to visit the Canadian Arctic, he has to get permission from Washington.

XIV
The Group Dissolved

IN 1933 we decided that the Group of Seven should be dissolved.

The personnel of the Group had changed in the years since we had founded it. Frank Johnston had left us and MacDonald was dead. We had taken on three new members, A. J. Casson, Edwin Holgate and Lemoine Fitzgerald. But the original impetus that had spurred the formation of the Group was gone, and the members themselves were scattered and engaged in many activities. By the 1930's, when the Group held an exhibition, the work of invited contributors outnumbered that of the members.

In 1927 MacDonald had become Principal of the Ontario College of Art and thereafter had little time to paint. Financial problems had always dogged him. For some years he had had four elderly people to care for, at a time when there was no old-age pension. He was never robust. Under these circumstances, it was difficult for him to keep on painting, which brought him almost no revenue, and he welcomed the appointment to the College of Art. He had a whimsical sense of humour which never deserted him. I remember an occasion when the Editor of *Maclean's*, Napier Moore, was telling us about his company's new magazine, *Chatelaine*.

"There is such a demand for it that it's taxing our printing capacity, and we want to cut down the circulation," he said.

"That's easy, Napier," said MacDonald, "just improve the quality."

When the critics of his work disturbed him, he used to soothe his feelings by having his students draw, as an exercise in lettering, the wise saw, "Against stupidity even the gods are powerless."

Though he painted less, he found solace in writing verse, some of

ISLANDS,
GEORGIAN BAY
1954
In the collection of
Mr. N. D. Young,
Toronto

MOUNT AGARD,
BAFFIN ISLAND
1965
In the collection of
Mrs. Geneva Petrie,
Montreal

which appeared in the *Canadian Forum* and in a small book *West by East and Other Poems*. Among others, there was an amusing poem entitled "My High Horse." For MacDonald, to ride a horse up to Lake O'Hara Camp must have been an ordeal. Here are a few lines:

> *And then our boss, the guide,*
> *Bade me to mount, and showed me where to put,*
> *According to the rule, my tender foot,*
> *Let down the stirrup, tightened strap and band,*
> *For symbol of command*
> *He gave an alder switch into my hand,*
> *He flung a careless arm to show the trail,*
> *And slapped my cayuse just above the tail,*
> *And off we swung as though we bore the mail.*

And the conclusion:

> *That evening when the sunset lit the trees,*
> *I stiffly strolled to see my horse at ease.*
> *I had a private word or two to speak*
> *About my language further down the creek.*
> *It seemed unnecessary when I saw*
> *How placidly he looked and worked his jaw,*
> *Oblivious to all troubles of the day,*
> *And standing undisturbed, he munched his hay.*

In his last years MacDonald went to the Rockies every summer and found a strange contentment in the camps high up in the mountains at Lake O'Hara and Lake MacArthur. The little sketches he made there were beautiful. The usual problem in painting mountains is that the viewer's eye immediately goes to the top of the composition. By stressing the decorative quality of the foregrounds, moss on rocks, mountain flowers, little trees such as tamarac, MacDonald overcame this difficulty. The mountains in his sketches were more like a background. The canvases he painted from these sketches lacked the vigour of his Algoma period.

He died in 1932.

Lismer, also, was heavily involved in teaching. In 1927 he had resigned from the Ontario College of Art; he had wanted to introduce new methods of teaching and his theories continually clashed with those of the authorities. He continued his instructional work at the Summer School for Teachers, and became Educational Supervisor at the Art Gallery of Toronto where Carnegie Foundation funds were

[115]

provided to organize children's Saturday morning classes. This was one of the most successful ventures ever conducted in Canada.

Varley had moved to Vancouver, where his experience of painting was stimulating to artists and public alike; but he could no longer contribute much to our exhibitions in Toronto.

Frank Carmichael was the youngest member of the original Group, a lyrical painter of great ability and a fine craftsman. He was never free to devote all his time to painting, and for many years he worked as a designer with the Sampson Matthews Company. He left there to take a teaching post at the Ontario College of Art. His earlier work, in which he designed intricate patterns of tree forms and foliage, is more appreciated to-day than his later work.

Of the new members, Casson, one of our foremost painters, gave much of his time to rejuvenating our art societies. He was active in improving the quality of graphic arts and in giving advice and encouragement in all kinds of art activities. When he was elected President of the Academy it was clear there was no more ill will towards the Group of Seven.

Under all the circumstances, then, it seemed wise to disband the Group. We had never had any particular intention of founding an art society. The Group had no formal organization; we had no officers, and as we had no money we did not need a treasurer. Along general lines we were in accord in the principles we followed. We had come together because we felt that art in Canada was mild and ineffective and obsessed with traditions which in Europe had long been discarded. In the ensuing conflict the Group had been the shock troops, taking all the jibes and jeers, the denunciations and the ignorant abuse. But now the battle was all but won. The old wail about there being nothing to paint in Canada was no longer heard.

There was a last flare-up in 1932 when the National Gallery sent a number of our paintings to Vancouver. It was shocking to read the Vancouver papers, all trying to outdo each other in condemning the exhibition, and the letters to the press that were almost venomous. One of the last letters was by Mortimer Lamb, who wrote to *The Province* rebuking that paper for its bigotry.

Our laughter is somewhat late [he wrote]; it is merely an echo of the cachinnations, now stilled, in Toronto and Montreal of nearly a quarter of a century ago. Nevertheless the interest that has been created is a healthy sign. In time perhaps Vancouver may even become an art centre.

Prophetic words! Vancouver has since become a centre of the most radical art in Canada, and one of the men largely responsible for it was a member of the reviled Group of Seven, Lawren Harris.

In 1934, Harris left Toronto to live in the United States. When later he returned to Canada, he settled in Vancouver. We were bereft. While we rather prided ourselves that the Group had no leader, without Harris there would have been no Group of Seven. He provided the stimulus; it was he who encouraged us always to take the bolder course, to find new trails.

Through his efforts the International Exhibition of Modern Art was brought to Toronto in 1927, and Katherine Dreier came from New York to lecture about it. There was much work in that show that departed from the representation of nature. It made our paintings, by contrast, seem quite conservative.

As early as 1928 when he painted "Mountain Form," which some-one re-christened "Mount Jello," Harris became interested in the idea of abstract art. He believed that it was the beginning of an era in which there was complete freedom for the creative spirit. Later, he abandoned completely painting from nature, and devoted himself to non-objective art.

There were other changes among the friends with whom I had painted, and who had supported the principles of the Group. Shortly before this time, Albert Robinson became ill and had to give up painting altogether; then Hewton had to take over the management of the family business in Trenton.

Lismer kept going farther and farther afield; he travelled all over the United States, to Europe and finally to South Africa, where the Carnegie Foundation sent him for a year to organize a system of art training for children. It fell to my lot to make a speech on his departure, and this, in part, is what I said:

Just at the time when the retrospective exhibition of the Group of Seven was announced [1936] which indicated that we were passing into history, or oblivion as H.G. contends [H.G. was one of our most persistant detractors], we find the old group surging into life again into another and wider field. One of the old originals is going to carry the light into Africa. I won't say darkest Africa, nor is he going to tell the Africans about sin.

I have read that in the old days in a perfectly balanced state the chief interests were science, philosophy, art and religion. In Canada science is at everybody's service; it is amazing the amount we use without knowing anything about it. We have a kind of natural philosophy, too, which we

[117]

use in excusing ourselves for doing nothing, or for making a mess of the things we do. Religion we have lots of; it is one of our chief exports to China, Africa, Borneo and other places. But art has never taken the place it should have in our lives. The first artist who came to Canada noticed a kind of instinctive antagonism. He was a French portrait painter, who, making a drawing of an Indian in profile, was nearly scalped by the indignant sitter for making him only half a man. Criticism is more enlightened to-day, but not much.

I don't suppose anyone realized our deficiencies in this respect as A.L. has, nor has anyone done more to rectify them. From the days of the little art school at Halifax right up to to-day it has been an epic struggle. While the rest of us were immersed in the problem of painting, A.L. took on the job of making over art education, the whole backward system, with such good results that the Carnegie Foundation are now sending him to do the same job for Africa.

I had been using Cobalt violet and Isabel McLaughlin called my attention to the fact that I was getting it into everything I painted. I used to think of South Africa as a purple land, so I gave all my Cobalt violet to Lismer. I have never used it since.

Lismer's first visit to South Africa was extended to Australia and New Zealand. He created such a favourable impression in South Africa that he was invited back for a year to establish a system of art training for children. This work was followed up by his assistant, Norah McCullough, who carried on the training programme in Africa for five years.

Lismer's next move was to Columbia University, where he was a lecturer for a year. Finally he moved to Montreal and took over educational work at the Montreal Museum of Fine Arts. With no studio and little time to spare from teaching, his painting has since been confined to small canvases and sketches.

Largely as a result of the death of MacDonald and the departure of Harris and Lismer, Toronto has lost its pre-eminence as the art centre of Canada. Both Montreal and Vancouver are today considered more active centres.

In the same year that we disbanded the Group I decided to sever my connection with the Royal Canadian Academy. While I was on good terms with most of the members personally, I was not in sympathy with the Academy's policies. I felt that too much authority was vested in the hands of the older members. My letter of resignation read in part:

[118]

Dear Mr. Dyonnet:

You have probably realized that for some years past my position in the Academy has been difficult. My sympathies have been frankly with the younger and more modern painters of Canada. I have tried to conceive of an Academy as a nationally recognized and official art body whose function it was to encourage art in all its various manifestations all over Canada and to uphold any achievement by an individual, a group, or smaller society, whether members of the Academy or not, as something redounding to the prestige of Canadian art; a society in which its own members realized that their privileges also inferred responsibility to Canadian art generally. I suppose such a society is impossible, unless all its members are idealists.

A number of the younger painters were quite distressed when the Group of Seven was dissolved, and it was suggested that a new group be formed with the old as a nucleus. Its membership was to extend across Canada, and a charter was applied for under the name, "Canadian Group of Painters." We have been scolded for calling ourselves The Canadian Group, which we were careful to avoid doing. The Group's intention was to stress the progressive side of the arts and to encourage experiment or research in every way.

The new Group started under a handicap; the depression still lay heavily on the land. We were just emerging from that when the second World War came along, and many of our members went overseas. In the beginning, at least, there were very few sales. However, the Canadian Group of Painters, with no assistance from the Government, has made a notable contribution to the arts in Canada. People used to say of the Group of Seven, "You will see, it will not last." If they expected art to go back to the mild form we departed from when the old Group was formed, they were very far off the mark. They did not foresee what would take its place.

The distaff side of the new Group was never overawed by the male members. They were not only able painters with subtle intuitions, they could be critical and outspoken, and at times there were fireworks. Paraskeva Clark, with a Russian and French background, was not too much impressed with our cultural standards, and said so. Yvonne McKague Housser, constrained by twenty years' teaching in the Ontario College of Art, when she was at last free to devote all her time to painting brought to her work a keen mind and an urgent desire to experiment; and Rody Kenny Courtice, perhaps with less technical ability, paints with a gay abandon subjects largely found on a farm she and Roy, her husband, own on the Rouge River. Isabel McLaughlin,

[119]

reserved, shy of acclaim, paints a naturalist's world of flowers, weeds, sea shells, and marine denizens. She has been a moving spirit in keeping the Group alive, and we are much devoted to her.

Lilias Newton, another member, I have known since she first started to paint. Her early work was done for her own pleasure, then circumstances made it necessary for her to depend on painting for a living and she turned to portraiture with such good results that she was recently commissioned by the Canadian Government to go to London and paint a portrait of the Queen.

I have been away on sketching trips with Peter and Bobs Haworth to Cape Breton, Georgian Bay and other places. I have memories of happy days in their company.

For a number of years after the Group of Seven was dissolved, I went every September to the Heward's summer home in Brockville on the St. Lawrence River. It is a country settled largely by people who took up land after the American Revolution and later by immigrants from Ulster. The place names there are interesting: Tin Cap, Ballycanoe, Mallorytown, Irish Creek, and so on.

We used to motor all around the district on sketching trips; the Eliots—Charlie, Ruth and their mother, Prudence Heward, and often Sarah Robertson, who would come from Montreal. On the back roads we would find a creek or an old farm and all go to work. There would be a short break for lunch, hot soup in a thermos and sandwiches, then to work again. The country was flat, underlaid with rock which outcropped frequently. It was homely stuff to paint, with ripening corn, pumpkins, sunflowers, pasture fields covered with blue bugloss. What gay parties these sketching trips were!

Then young Charlie Eliot, who was studying physics in New York, died suddenly. I started teaching at the Summer School in Banff; and after that there were no more picnics. Prudence died in 1947, and Sarah, her inseparable friend, a little over a year later. Prudence, who was never robust, was forced to stop painting for weeks at a time. Then she would gather up her energy and produce rich, sombre and powerfully-organized canvases. Paul Duval wrote, on the Memorial Exhibition of her work:

Enchanting is a much misused word, but one which may be fairly applied to this artist's most characteristic works. She has created a world of visual enchantment which is both singular and memorable, such portrayals

[120]

as "Rosaire," "Dark Girl," "Little Girl with an Apple," "Rollande," "Farm House Window," and "Barbara Heward" which take their place among the small number of important paintings of people by Canadian Artists.

How unobtrusively she took her place as one of the finest painters in Canada! While Prudence's work was sombre and rather sad, her friend Sarah's work was gay and colourful, and full of sunshine and movement.

In 1936 my niece, Naomi Jackson, won the University Women's Scholarship for a year's study in Europe. She 'phoned me from Montreal four days before she was to leave and asked me to go with her. I said I would if she could book me a passage. She did. The Lismers were on the same boat on their way to South Africa and the crossing was a merry one.

I had not been in Paris since my student days. The year 1936 was a bad one in France; people were depressed, rude and greedy, and their discontent was evidenced by the great number of sit-down strikes. I felt disillusioned and unhappy about a country I had greatly loved. From France we went on to Germany where my niece was to study. People were friendlier there than in either France or England, but one did not need to be very observant to see the sinister side of things. We stopped at a tavern in a little village for lunch. My niece, who spoke German fluently, fell into conversation with an old man, the proprietor's uncle, a friendly old fellow. They talked about the weather and conditions in general. The old man said, "There is a lot going on in this country we know nothing about." His nephew, listening, hurried over with a frightened look, and told his uncle someone wanted to see him in the kitchen.

I spent some time in Berlin with a young German I had known in Toronto. He was very concerned over what was going on in Germany.

In England it rained. I found no interest in Canada at all among the English. I looked up some old friends: Frederick Porter and his wife; Baker-Clack, my old Australian pal; and Arthur Jackson of the 60th Battalion. Arthur had come out to Canada after the war, found a good job in Perth and then sent for his wife. She loathed Canada so intensely that he had to go back to England to a miserable job, with lower pay and ugly surroundings.

Now all these old friends in England have passed on.

My niece and I had booked tourist as she wanted her funds to last. Coming home I picked an outside cabin on the *Montcalm*. On board,

[121]

I was put instead into an inner cabin with two young prigs, one English, the other Canadian, who spent their time telling lies to impress each other with their social importance. Between meals they sneaked up to the second deck. I think they thought I was a night watchman and ignored me completely.

XV
Painting in the West

IN 1937, I went to Alberta to paint. I had been there previously to visit my brother Ernest, who has lived in Lethbridge since 1906, but although I found the country intriguing, I had never made any serious effort to paint it.

The West presents a considerable challenge to the artist. Over a hundred years ago Paul Kane made a brave effort to inform his fellow-countrymen about it. In his historic journey to the west coast, he made many studies of Indians, buffalo hunts and camp life. These furnish a valuable record of the country and the people but as works of art they are not very important. The illustrator, Henri Julien, made a number of notable drawings for the Montreal *Star* at the time of the North-West Rebellion, and Charles Jefferys painted canvases of the West that make one regret that he had to work most of his life as an illustrator. In later years Lemoine Fitzgerald found inspiration in Manitoba for drawings and water colours of great distinction; when others were making strident efforts to call attention to themselves, his quiet, re-strained work showed no desire for acclaim at all. The artist whose work has appealed most to Westerners and who spent considerable time in Alberta was Charles Russell from Montana. His work was done in the days of the cowboy. He was one himself, and a very colourful figure.

In recent years the cowboy has almost disappeared and the West has become completely mechanized. However, the foothills of Alberta, with the mountains as a background, afford the artist endless material. The foregrounds are a problem, because so often there is nothing but a few weeds, scrub or stubble to get hold of. In one painting I made

[123]

there was a loose strand of wire from a fence that formed a nice spiral, and this helped my foreground. I showed the painting to a rancher, who said, "Do you carry a pair of nippers along when you go sketching?" In Northern Ontario the foregrounds are so crowded it is usually a matter of eliminating or simplifying much of the material.

Frederick Cross, who was an engineer and an enthusiastic amateur painter, motored me about the country. It was in his company that I made the sketch for "Blood Indian Reserve," now in the Art Gallery of Toronto. I scouted around and decided that Cowley was the place to work, so I went there early in November by train, arriving on a dark night with a howling wind blowing. I was the only person to get off the train which stopped at Cowley only for a minute. I saw a light disappear in the station. As there was not a light anywhere else in the village, I knocked at the station door and, when the agent appeared, I asked him about a hotel. He said he would take me to it. He woke up the hotel keeper and got me a room. The next day I went sketching. When I returned to the hotel I was told that I was invited to the station agent's for dinner that night. On meeting him again I told the station agent that my name was Jackson; he introduced me to his wife and she said, "Are you A. Y.?" I was taken aback. She continued, "You're one of the Group of Seven." I said, "How do you know?" "Well," she said, "we have a radio and we can read."

Nowadays, when I go West, I always stay with them. The Bundys are now at Pincher Creek. Mrs. Bundy is soloist in the church choir, she writes for the Calgary and Lethbridge papers, she paints, makes pottery, teaches school, and is the local historian for the district. I once told Mrs. Bundy about staying in a village where there seemed to be nothing to paint. Laid out on a flat plain, its one street was so wide that I could not get both sides in a composition. It was hot; the colour was all bleached out of the sky; and it was a case of trying to make something out of nothing. I walked around the town and viewed it from all directions. About three miles away I found a cemetery; there was not a tree, a flower, or even a blade of grass. "Bury me not on the lone prairie," I thought, as I turned away. The village was not only bleak, it had no character at all. I could do nothing with the place; it needed a chinook or a cloudburst to liven it up.

Mrs. Bundy had a similar story to tell. She had graduated from Acadia University, and had accepted a job as a teacher in a little Western town. When she got off the train at her destination, she looked

around and nearly jumped on board again. She asked a big husky chap on the platform to carry her trunk to the hotel. He put it on his shoulder and walked off. When she tried to give him a quarter, he just laughed; she found out afterwards he was one of the richest farmers in the district. Teaching in that village was a trying business; indeed, she said, looking at her husband, if it had not been for the station agent, she would have cleared out and gone back East.

I said, "What was the name of the burg you struck?"

"New Dayton," she replied. It was the same village I had found so unpaintable.

I have visited Pincher many times and also the Harland ranch farther south. Here, a range of mountains rises right out of the foothills which form a wonderful grazing land for cattle. Recently, on a ridge just east of Harland's, drillers put down a well twelve thousand feet and tapped a field of eighty million cubic feet of gas a day.

Harland, my host, had gone overseas in the first World War with the Canadian Mounted Rifles. In a hospital near Boulogne he had met a nurse working with a Harvard Unit. Her father was W. H. Pickering, Professor of Astronomy at Harvard. Harland and his nurse got married and she went from Boston to live on a ranch in the foothills of Alberta. They lived in an old log house, but inside it was full of museum pieces, china, glassware and other treasures.

In the early thirties Alberta was beset by the years of drought; one could drive for miles and miles across the land without seeing a blade of grass. Russian thistle and dwarf cactus seemed to be all that would grow there. Underneath the burned-up land was wealth untold, which only a few people then visualized. Hills rose from the prairies, range after range of them, and then the mountains rose abruptly out of the hills. Valleys with shallow streams at the bottom cut through the hills. The countryside offered all kinds of motifs for composition.

Another kind of wealth was discovered farther north when Gilbert La Bine made his dramatic find of pitchblende on the shores of Great Bear Lake. In 1938 he asked me if I would like to visit his Eldorado Mine. Ten years earlier I had been as far as Yellowknife and I always had a yearning to see what kind of country lay beyond. I accepted his invitation to travel on the Company's plane from Edmonton to the mine. When I got on the plane at Cooking Lake, it was loaded with groceries, steel pipe and other kinds of supplies for the mine, and several Finnish miners. We flew low enough to study all the country

below which, at first, was mostly wheat fields and mixed farms. At one place I saw a farmer looking for his cattle and as, from my elevation, I could see them clearly I wanted to tell him where they were. Lakes and bush followed the wheat fields; the farms got fewer; here and there could be seen a little shack at the end of a long trail; then there was nothing but bush and lakes for hundreds of miles. We stopped for the night at Fort Smith, then followed the Slave River to Great Slave Lake. From Great Slave Lake to Great Bear Lake the land seemed to be half water; there were lakes of every shape and size as far as the eye could see. One wonders where all the water comes from, as there is not very much rain in that country.

We arrived at the radium mine, a little centre of industry in a great empty wilderness. Emil Walli, a Queen's University man, was the manager. I spent six weeks at Eldorado, from August into October. The weather was lovely. I wandered over the rocky hills, which were easy to traverse. There were patches of spruce and small birch, and muskeg lakes, but mostly open rock. Walli's little Scotch terrier took a shine to me and accompanied me on my rambles. The ravens were attracted by her; sometimes while I was sketching, a number of them would come around and stand watching her. She did not mind and they seemed merely curious. There were many old caribou horns sticking out of the moss, but I saw no living caribou.

The miners, who were of many races, were not much interested in the country. They got good pay and gambled it all away. On week-ends they went over to Cameron Bay where the bootleggers took their money. Only three or four of them showed any interest in what I was doing.

J. B. Tyrell, the famous geologist, arrived by plane one day while I was there; he was going on to Coppermine to celebrate his eightieth birthday. In his wanderings all over Canada he had missed this part of the country and he had decided not to put off visiting it any longer.

On of the first questions put to me at the mine was, "Is this the farthest north you have ever been?" I told my questioners I had been eight hundred miles north of Eldorado. I had sneaked round by boat, I told them, nearly as far as Melville Island.

By mid-September the trees were bare of leaves, and winter seemed ready to start in, but it held off until I left, early in October. Before I departed, we were getting, over the short-wave radio, midnight broadcasts telling the miserable story of Munich.

The days were getting short and rather grey and colourless when I climbed on the plane for Edmonton. We landed on Cooking Lake; there was not a soul in sight, but a bus had been left standing on the dock. We all got in and the pilot of the plane drove us to Edmonton.

On another western journey, one of my students at Banff, Mrs. Vivien Cowan, who owned a ranch in the Cariboo, invited me to visit there. This was a large area of Canada that I knew nothing about, although it had been first opened up in the gold rush a hundred years ago. The Fraser River, running westward from the Rockies, swings south at Prince George and cuts its way in a great gorge through hills and mountains as far south as Vancouver. From Ashcroft on the main line of the C.P.R., the ranch was north, at 150 Mile House. A number of the bus stops are still called after the old stage-coach hostels.

My idea of ranches had been mostly derived from motion pictures and I expected to see at Mrs. Cowan's wild cowboys driving herds of cattle all over the place. There were none of these, nor was the country very wild. It was pastoral, a wide valley with wooded hills in the background. Irrigation ditches ran all through the valley, for it is a dry country, but there was not a steer in sight. Inside the old frame house, in the big living room, there were shelves full of books and when I arrived Mrs. Cowan's mother, Mrs. Tully, a bright old lady in her eighties, was playing the piano. There were paintings around by an old aunt, Sidney Strickland Tully. The first friends to drop in were Violet and Arnold Long; he was a surveyor who loved to go out sketching and in his spare time conducted a choir at Williams Lake. Other friends were Roger Fry's son, Julian, who was secretary for the Beef Growers Association, and Lord Martin Cecil, who owned a ranch down the line. My ideas of the Wild West had to be quickly revised. Mrs. Cowan, herself, made me adjust my ideas of ranching. Tall and handsome, and a person of distinguished mind, she had been a widow for some years. She had two charming daughters, and was head of the local art society.

I found the intimate stuff more paintable, the creeks and the little lakes, the patches of small poplar or aspen growing in circular groups. The big panoramas of the Fraser River were a problem, probably better left alone. Across the Fraser, in the Chilcotin district, a great plateau of open country was most impressive.

I happened to mention to my hosts that Stanley McLean was one of the big collectors of Canadian art. They looked rather shocked.

[127]

"You know that man?" they asked. They did not approve of him; he was too shrewd a cattle buyer, they said, and they seemed to hold him responsible for all the buying of Canada Packers. The other companies were anonymous. I told Stanley McLean about this, when next I saw him, and he was much amused, and said he would like to meet Mrs. Cowan. Some time later, flying back from Vancouver, he went round by Williams Lake, and from there to Onward Ranch. The next time I went out there, my hosts told me he was one of the most delightful persons they had ever known.

At Williams Lake there was an art society; farther north at Quesnel there was another. I talked to the Quesnel group during my stay. Some time before there had been a celebration in the town and all the merchants had arranged floats on trucks. The art society's float was a large copy of Picasso's "Les Demoiselles d'Avignon." From Quesnel there is a lovely drive to Barkerville, the famous old mining town built at the time of the gold rush a hundred years ago. It must have been an exciting place in its day, but apart from the little church there is not much of it left now. The whole place should have been preserved as a memorial to the pioneers of British Columbia. There are still a few old-timers who make a living washing for gold in the creeks.

Another place I visited, which many years ago had a population of several thousand, largely Chinese, was Dog Creek. The old ditches and sluices are still there, but now it is cattle country. I stayed at Place's Ranch, where I had a large bedroom, painted white and immaculately clean. The Place family kept open house; during my visit the war was still on, and from an Air Training Station close by the boys would drop in for coffee and to borrow books. Mrs. Place told me that at one time there was too much drinking going on, so she persuaded them to stop and put the money into books. A big library resulted.

I made a sketch of the little school house close by. Mrs. Place regretted that there were not enough children to have a teacher, and she spoke about one teacher whom they had all adored. He had left for Vancouver to study medicine, and afterwards had joined the Air Force. She had had a card from him at Christmas time from Cairo. I said, "I think I had a card from him too. Is his name Parnell?" It was. He is now a well-known doctor in Vancouver.

I tried to paint around Kamloops on the Thompson River. In the dry belt where it was not irrigated, the country was a desert, with only cactus and thistle and such things growing. Across the road where the

land was under irrigation, trees were so loaded with fruit that the branches had to be held up with props.

I stayed with the Mayor of Kamloops, whose wife, Dorothy Williams, was one of my Banff students. She was an art teacher who kept abreast of all the advanced ideas in art training. They have since moved to Victoria.

I wanted to paint an Indian village near by. Most of the inhabitants were friendly but one surly individual was so threatening I decided to clear out.

I remember only one place in the West where I found no hospitality. I arrived at Penticton at 1 a.m. The train had been late, it was raining hard, and the outlook was wretched. I took a taxi to the hotel and asked for a room. The clerk asked me if I had a reservation; when I said that I had not he replied, "We have nothing for you." I inquired if there was another hotel; there was, farther down the street. When I arrived there it did not look prepossessing, and the clerk said they were full up, but if I liked I could stay in the Lounge Room, or there was a room with two beds, one of them occupied. I chose the latter. I did not sleep well. There was no lock on the door, but fortunately the hall light was on, for some time in the night a little sliver of light appeared on the wall. Someone was cautiously opening the door; then a man's head appeared in the opening. I jumped up quickly and he disappeared. Who he was, I do not know; probably he was a sneak-thief and I might have been left stranded with no money.

I left Penticton on the first bus north.

XVI
Some Visitors at the Studio

THE VISITOR said his name was Eugene Savage and that he came from New York. I said, "I remember you; you were one of the most brilliant students at the Chicago Art Institute." He laughed and we had a talk about old times. He had been sent to Canada by the American Federation of Artists to choose an exhibition of Canadian paintings. First he had gone to Ottawa to see Eric Brown. Eric, remembering Wembley and the fury that followed that exhibition, was cagey and gave him a list of all the members of the Academy and the Ontario Society of Artists. I asked him, "What are you going to do with this list; are you going to visit all the artists on it? And what if you don't like their work?" He admitted it would be embarrassing.

At this moment Lawren Harris came along. I introduced them, and Harris said, "I have just been down to New York and I saw a fine big mural of yours there." We took our visitor to the Art Gallery, where he could see all kinds of Canadian painting, then to Hart House to see the more modern aspects of art in Canada. He was surprised to find work of such vigour and freshness; he had known nothing at all about art in Canada and was quite enthusiastic about what he saw. The day he spent with us was a very happy one for all of us. At its close he said, "There is just one thing more; there is a famous doctor in Toronto by the name of Banting. Would it be possible for me to meet him?" I 'phoned Fred Banting who said, "Bring him along." We had a delightful evening together. As a result of his visit to us, Savage was able to organize a very good exhibition of Canadian art to tour the U.S.A.

From Toronto, Savage went down to Montreal to see what there

[130]

TAMARAC AND
SPRUCE,
LAKE SUPERIOR
1924
In the collection of
Mr. Walter Stewart,
Toronto

FIRST SNOW,
GEORGIAN BAY
1922
In the collection of
Canada Packers Limited,
Toronto

was to see in that city. He met Anne Savage there; his daughter was also named Anne so he bought a sketch for her.

There was a knock at the door of the studio and when I opened it I found a very pleasant-looking man standing there who said his name was Percy Grainger. He was pleased when I replied, "I know who you are; come in." I was working on a Quebec canvas at the time, "Winter St. Tite des Caps," a big sweep of country, all rhythmic movement. He looked at it for a while, then he said, "I am working on a composition with just that kind of movement in it."

Mrs. Vincent Massey called one day. She said, "Vincent and I are having a wedding anniversary next week. I want to get him some sketches." She looked over a lot of work, picked out several and said, "Now if you see Vincent, don't let him know." The next day, Vincent Massey dropped in and said, "We are having a wedding anniversary next week; I want to buy Alice a canvas of yours which is in the Art Gallery. If you see her, say nothing about it."

When I opened the door one day, Robinson walked right in without looking at me and started striding in long paces back and forth the length of the studio as though he were on the deck of a steamer. I did likewise, and for about five minutes we paced back and forth without speaking to each other. Then Robinson shouted, "You big fathead."

A Salvation Army officer called at my studio collecting funds. I was working on a winter canvas, and he wanted to know how I went about making winter pictures. I told him I began with the outdoor sketch, sometimes made under harsh conditions. "You can't paint with gloves on," I told him, "and when your hand gets numb, you shove it under your coat to warm it." I added, "You can comfort yourself with that old text, 'Many are cold, but few are frozen.' " He said, "I see you know your scriptures."

Wyndham Lewis spent several years in Toronto during the second World War; he was an exile and they were not very happy years. In Toronto only a few people realized what an important figure he was in both art and literary circles. He dropped into the studio occasionally for a chat with me. I admired very much the big canvas he had painted

[131]

in 1918, called "Canadian Gunpit," but that, he told me, was a phase he had passed through, and was of no more interest to him. While in Toronto, Lewis painted a portrait of Stanley McLean for the staff of Canada Packers. In the background he brought in, as a note of colour, a canvas I had painted of Cobalt.

One evening Lewis and his wife came to dinner with MacIver in Tom Tomson's shack. Mellowed with some good Scotch, he fell into a reminiscent mood and talked of Augustus John, James Joyce, Ezra Pound, and other noted people of his acquaintance. It was a memorable evening.

An occasional visitor to the Studio was Malcolm MacDonald, then British High Commissioner to Canada. He loved the Canadian country and got to know it as few Canadians do. He was a keen naturalist; one of his most charming books, *The Birds of Brewery Creek*, is a record of a year's bird-watching in the environs of Ottawa when he was stationed there during the war. My sketches from all over the country pleased him, so when he came to Toronto he generally dropped in to the studio and often went away with a couple of them. Queen Elizabeth saw one of these and liked it so much he gave it to her. I heard about this in an amusing way. I was in Pincher Creek, Alberta, when I met a pretty little school teacher who asked me if I would speak about art to her class. I could not refuse, so I ended by addressing the whole school. Every child in town knew me after that. One evening I went to a movie; before the principal film began there was a news broadcast and suddenly I was startled to hear blaring out the words, "Her Majesty the Queen has acquired her first Canadian picture; it is a study of winter in Quebec by A. Y. Jackson." Two little girls in the row in front of me turned around and started to giggle at me.

He telephoned me to say he was from Vancouver and an admirer of the Group of Seven. Could he see me? He came and we had a friendly chat in which he showed he was well informed about the Group. He told me he was in the publishing business, and was undertaking a big educational project in which his company needed the endorsement of well-known artists; he named several of our celebrities who were interested. The company, he told me, wanted to present me with a set of these books; he was careful not to mention the word "encyclopedia." I said I thought it was very generous of the company and he

[132]

replied they were honoured. If I signed a little paper the books would be sent along. They came the next day with a bill for forty-two dollars. It was a very second-rate encyclopedia.

I went to see my lawyer-cousin, Erichsen Brown, who laughed and said there was not much to do about it. If I went to court I would probably only add to my expenses.

I wrote the publishers that I would be responsible for the account on condition they took the books away. I did not, I told them, want them around as a constant reminder I had been a simpleton.

It was settled, the books were collected and I had to pay only the agent's commission of nine dollars.

One rainy morning during the war, there was a knock at my door, and there stood Melinda, a wistful, pretty little soul, who had come to Toronto to get work in munitions. She was under age and no factory would employ her. I had happy memories of meeting Melinda on the S.S. *Montcalm* some years earlier. She was a little Ukrainian girl, at that time nine years of age, on her way to Canada with her mother, who was coming to join her husband.

Several of us helped in teaching Melinda English words. She was a very bright youngster and an apt pupil. I wrote the postmistress in the village she had gone to, got her address, and sent her toys at Christmas.

Later, I sent her books. Her letters to me, written in English, kept improving every year. After the war she returned to Toronto, where she worked in a restaurant and spent her nights at school to improve her English. Then she attended business college in the daytime and worked after school from six till midnight. When she left school she got a job in a bank; her father died and she had to support her mother and a younger brother. Her evenings she spent at lectures at the University of Toronto. Melinda, who is now happily married, was a wonderful example of pluck and perseverance.

Two opulent-looking ladies opened the door one day and started walking round looking at everything on the walls. Then they walked out again without taking the slightest notice of me. They must have thought the studio was a shop.

He was in the studio before I knew who he was. "You have some

[133]

shares of Wylie Dominion?" he began. I admitted I had acquired a few in a weak moment. "Well," he said, "you scrape up every cent you can lay your hand on and buy more." I told him I had no money; this did not stop him. "Have you any stocks?" he asked. I said I had a few shares of McIntyre. "What's McIntyre?" he sneered; "fifteen-dollar ore, two thousand tons a day. Get rid of it! Do you realize that Wylie Dominion is going to run forty-dollar ore and will not have one measly little two-thousand-ton mill but four three-thousand-ton mills. Just think of it!"

"Yes," I said, "it sounds wonderful but I still have no money."

"Now, look!" he said, "I'll tell you a secret. A French syndicate is going to take over Wylie Dominion; in a few days there won't be a share to be bought on the market. You can buy it to-day for fifty cents and it's your last chance."

I 'phoned my broker, who told me there was lots of the stock available at twenty cents. Later the company put in a hundred-ton mill and ran out of its ten-dollar ore a few months later.

Just back from their war service overseas, Bruno and Molly Bobak called on me one hot day. They were house-hunting and were tired and discouraged. We chatted for a while and as they started downstairs, I said casually, "I am going out West. How about parking here for the next four months?" They almost wept.

I had many friends in Toronto, from a whole generation of youngsters who called me Uncle Alex to an old lady, Mrs. Christina Bertram, who for twenty-five years was a mother to me. Never a week passed while I was in Toronto that I did not have tea or supper with her. She knew Thomson, MacDonald and many other artists, and she was one of our most loyal supporters. Even when she was over eighty she would go to our exhibitions. Her grandchildren, the N. D. Youngs and the Hamiltons, are among my very close friends to-day. I feel almost embarrassed by the number of Jackson paintings they have acquired for their homes.

There was a knock at my studio door one day, and a young student introduced himself. He was Walter Stewart, and he wanted to interview me about an article he was writing on art for *Varsity*, a paper published by the students of the University of Toronto. He asked

intelligent questions and produced a good article. I met him later at Hart House where he was having an interview with W. B. Yeats, the poet, who was very friendly and gave Stewart more time than he gave the professionals. After he got married our acquaintance continued; his wife, Jane, was also interested in art and literature. As the family came along I was Uncle Alex to all of them. Three of them are married now. The Stewart home is a kind of private gallery, with Jackson paintings in every room.

There were many distinguished people who dropped in to the studio in the years that I lived there: Lady Byng, John Buchan, Raymond Massey, Rockwell Kent, Dr. and Mrs. Charles Camsell, as well as many people I knew more intimately. Rockwell Kent just about took Toronto by storm. He packed the Eaton Auditorium to the doors and talked two hours to a spellbound audience. Painter, illustrator, and writer with an urge for adventure that has taken him to Patagonia, Greenland, and other far places, it was a worthwhile experience meeting him.

Probably no one knows more about northern Canada than Dr. Charles Camsell, geologist, explorer, and for many years Deputy Minister of Mines in the Federal Government. He had flown over a great part of it, but in the early days he made many difficult journeys by dog team and canoe. His autobiography, *Son of the North*, is a thrilling story.

My studio was never like a lady's boudoir. It was a workroom, with a big window facing north and a gallery at one end where I could throw things out of sight. There was a small bedroom but no kitchen. I made tea occasionally; I had breakfast in the shack and other meals at restaurants. MacDonald, who had rented this studio before the first World War, had painted along the base of the gallery an old Chinese text: "With the breath of the four seasons in one's breast one can create on paper. The five colours well applied enlighten the world." I am not sure what it was all about, but the lettering was beautiful.

I had a big easel which was supposed to have belonged to Thomson. A pair of West Coast snowshoes, an Indian mask and prints of paintings by Cézanne and Van Gogh served as decorations. The rent, as long as Harris owned the building, was twenty-five dollars a month. Compared with most of the studios I occupied in Europe, it was palatial.

XVII
Artists at War

THE SECOND World War followed the first one too closely; it was heart-breaking that the job had to be done all over again. Thousands of those who fought in it were sons of the men who fought in the first war.

The arts were not as adversely affected as they had been in the earlier war. There was much publicity in the way of drawings for the press and of posters to encourage recruiting and war loans, Red Cross and other activities, and these provided one form of employment for the artist. There were others.

It was with considerable reluctance that the Canadian authorities decided to send artists overseas to record the activities in the war of Canada's fighting men. This reluctance is easy enough to understand when one remembers that the large collection of paintings of World War I had been cluttering up the store rooms of the National Gallery for nearly twenty-five years. The original intention of building a memorial gallery to contain them was never given much consideration. Instead, the national war memorial at Ottawa took the form of a monument, designed by the March brothers, of troops crowding through an archway. Now, with the fine collection of paintings of the second World War completed, it is to be hoped that something will be done to build a memorial gallery where the outstanding work of both collections may be permanently hung. This should make for some interesting comparisons between the art of nearly forty years ago and that of to-day, all the more so since the work of the first war was predominantly British, while the work of the second is all Canadian.

There was another reason for the reluctance of the authorities at Ottawa to commission artists to make a record of the activities of the Services. During the first month of the second World War it seemed

as though more war records would be merely duplicated what had been done in the first war, for the armies were massed in the same areas that had been fought over in 1914-18, the same place names were in evidence, and the war was one of position. After the break-through of the Maginot Line, the scene changed; the war became one of movement, the artist was constantly on the move, so there are fewer of the old conventional battle pictures in the second war records.

It is logical that artists should be a part of the organization for total war, whether to provide inspiration, information or comment on the glory or the stupidity of war. Knights in armour, bowmen and spearmen, the clash of arms, men and horses in a swirl of movement, this was the stuff that battle paintings were made of in the early days. With the introduction of gunpowder and the increasing range of guns, the space between combatants grew wider with every war. In Napoleonic times, however, a battle could still be visualized, and the artist, from an imaginary observation post, could paint panoramas of moving masses of men in action.

When the War Records of the first war were organized, the artists started off thinking in terms of the kind of war art made popular by the *Graphic* and the *Illustrated London News*. One had the feeling of something left over from previous wars, when one observed the old stock poses, the same old debris lying around like still life, and the smoke drifting around whenever the composition gave trouble.

The machine gun destroyed the old death and glory picture which depended on a mass of cavalry or infantry hurtling forward, with the shot-riddled flag clutched in the stricken hero's hand. Such pictures were mostly painted by artists who had no first-hand information of war, and who drew for their subjects upon their own lively imaginations. It was not long before we realized how ineffective this kind of picture was. Such paintings as D. Y. Cameron's "Flanders from Kemmel Hill," Paul Nash's "Void," Wyndham Lewis's "Canadian Gunpit," and Varley's "For What?" give a much truer picture of war.

In the second World War the battle picture as such was no longer possible. The fighting often spread over a front of two hundred miles and the mass movement and close order which, up to the time of the Franco-Prussian War, was the common property of the war artists, gave way to extended order, with men crawling or dashing forward in little groups. The artist had to use the incidental to illustrate what was going on in endless repetition beyond his vision.

Although Canada was the first to employ artists in the making of

[137]

war records in 1917, in the second World War both Britain and the United States were a long way ahead of us. But when we finally did decide to make use of our artists, the scheme for their employment was worked out very thoroughly, and so far as possible the most capable artists in the country were given the opportunity to participate. The names of professional artists already in the armed forces were given first consideration. There were many applications and while there was much goodwill on the part of the selection committee to give everyone a chance, the number of appointments was limited and it was not possible to gamble on the mere promise of potentialities. Artists were commissioned to the three services, Navy, Army and Air Force, given official rank and attached to various units overseas.

As a result of art competitions held by the Army and Air Force, several young painters who had had little previous recognition were brought to light and were given commissions as war artists, among them Bruno Bobak, Pat Cowley-Brown, Aba Bayefsky and Molly Lamb.

While we were late in getting started, our artists were in time to take part in the invasions of Sicily and Italy, and a great amount of first-hand material was accumulated in these and later campaigns. Most of the work is the direct statement of the eye witness, war seen through the eyes of an individual, some of it coldly factual, some reflecting, in varying degrees, how the artist felt about what he saw. The Italian campaign in particular abounded in colourful material for the painter: hill towns, rolling country, old architecture—much of it reduced to rubble—snow and cold, heat and blazing sunlight, these made the background to the Canadian army in action.

Outstanding of the work done during the Italian campaign was the series of water colours painted by Major Charles Comfort. They showed keen observation and a dramatic presentation of an invaded country. The mellowed old landscape as a background for the vigorous tough army of a younger race, the men and machines, the old towns, the devastation and the landscape of serene beauty provided Comfort with a variety of material for these remarkable field sketches. No less satisfying was the work of his fellow artist, Major Will Ogilvie. Less realistic than Comfort's paintings, there was a feeling of leisurely movement, good colour and sensitive drawing in Ogilvie's many and varied compositions.

In an early exhibition there appeared a number of small studies signed by a name famous in Canadian art, Captain Lawren Harris,

gifted son of a distinguished father. One had the impression, regarding his sombre and dignified "Battleground before Ortona," of things remote from the struggle as though they had happened far away and long ago.

One can imagine the difficulties facing the artists who took part in the invasion of France. What were they to paint out of all these vast movements of men and machines? What could one do with a pencil when even a hundred movie cameras could give but a glimmer of what was going on?

The Canadian artist rose magnificently to the challenge. After ten years I still remember the Aleutian Island paintings of Ed Hughes, with the helmeted figures in greatcoats, who looked like invaders from another planet; Carl Schaefer's records of the vast movements of aircraft and activities about the air fields; and the very notable canvases of Jack Nichols, with their groups of sailors crowded into corvettes and destroyers.

In general, the War Records produced a collection of paintings by our younger artists, impressions of things seen or their interpretations of things experienced. There were no paintings which expressed the glory of war; that seems to have died out with Napoleon. There are miles of canvas and tons of sculpture glorifying his victories, but Goya's little etchings showing the horror of war are worth all of them today.

The paintings of the second World War are probably the last records of war that will be made by artists. With atom bombs, and rocket guns that throw shells thousands of miles, the day of the war artists has come to an end. Even the moving picture people will not do much with that kind of war and if we cannot make movies, it hardly seems worth while going on with wars.

There is a feeling of honesty and sincerity in these records of Canada's participation in the second World War, and little that is sentimental or melodramatic. The real value of our War Records programme was that our artists, through their experiences, gained a deeper understanding and a fresher vision with which in later days they were to stir up the rather sluggish stream of Canadian art. As to the paintings the war artists produced, in time their importance as works of art will mean more than their value as mere records.

There arrived at my studio one day Pte. Molly Lamb of the C.W.A.C. I knew nothing about this young lady except that she was the daughter of my old friend, Mortimer Lamb of Vancouver. She

showed me her drawings of army life, which mostly concerned the mis-adventures of Pte. Lamb; they were very graphic and also amusing. I sent her down to see the Editor of *New World* who gave her a commission to make a series of drawings, "A Day in the Life of a C.W.A.C." These were reproduced in the magazine and later the originals were acquired by the National and the Toronto Galleries. They were not, however, popular with her superior officers. Indeed, Molly's artistic temperament kept her in hot water much of the time.

In the exhibition of the work of the Armed Forces held in Ottawa, the first prize went to Sapper Bruno Bobak and the second to Pte. Molly Lamb. One result of this was that Bobak was transferred to the War Records. Women, however, were not wanted in Records and this seemed manifestly unfair to Molly, so she and I together composed a letter to her O.C. pointing out that though women were taking a very active part in the war no one was officially recording their activities. It was strictly against army regulations to send such a letter. Very properly it was not answered, but not long afterward Pte. Lamb got orders to proceed to St. Anne's to take the training course for officers.

In London, some time later, Lieut. Bobak was advised that his limited studio space was to be partitioned down the middle, to make room for Lieut. Lamb. He was sufficiently irked by the loss of space, and even more so when he found that Lieut. Lamb was a woman. Indeed he was so annoyed that for a long time he refused to have any dealings with the newcomer, or even to speak to her. Then one day, interested in what she might be doing, Bobak peeped around the partition and Molly caught him at it. It was impossible after that for him to maintain an aloof attitude; and that was how Molly Lamb eventually became Mrs. Bobak.

The artist in Canada endured some minor embarrassments in the pursuit of his craft during the war years.

I took on the job of illustrating a book, *The St. Lawrence*, one of the Rivers of America Series. I had read a number of the volumes in the series, and liked some of them very much. If I had known all the difficulties that were in the way of completing it I would not have undertaken the commission. I planned on having my friend, MacIver, drive me right down the river while I made sketches, and I thought I could get a general permit to sketch anywhere. That proved impossible. I finally received permission to work on the waterfront in Mont-

real and Quebec. My work there was very much interrupted; about every ten minutes a Veterans' Guard or a harbour security guard would step over and I had to explain to each of them what I was doing. I wanted to get a wide view of the port from the Jacques Cartier bridge for a double-page spread. I showed the guard on the bridge my pass; he took it to someone higher up and on his return said the pass was in order but I would have to get a letter of confirmation from some port official. It would have taken a week to get it and my permit expired the next day, so that was the end of that.

Later, in Quebec, I was making a drawing from the Lévis shore when an army truck drove up with four men in it. They bore down on me and took me to headquarters. Under such conditions I got fed up and had to do what I could from my old notes. I was not happy about the project at all, and my unhappiness was increased when I found the book uninteresting.

These were not my only brushes with the authorities. I was sketching some barns in a little village on the south shore below Quebec when someone came trudging through the snow and wanted to know what I was doing. I showed him. Did I have permission? he asked. Yes, but my permit was at the hotel. Well, I would have to show it to him. So I had to quit work and go back to the village to get my permit. My interlocutor got a good ragging at the hotel.

I knew an artist who was rushed by the police when he was making a sketch of a haystack!

People have stupid ideas about what a drawing can convey. If a spy wanted factual information, all he would have to do would be memorize the details and put them down in note form later. When I was making war records in 1918 I had to report to the British Intelligence at Montreuil with my drawings. The officer said that all I needed to consider was not to put in my drawings a gun emplacement or an ammunition dump in its relative position to a recognizable landmark.

The art societies were called upon to send exhibitions of paintings to the various camps. The artists were very generous in lending their paintings but, as more and more camps were formed, it became impossible to find enough pictures to fill all the requests. The Y.M.C.A. devised a unique system of travelling exhibitions, whereby paintings, prints and photographs were packed in cases in which each picture was

[141]

slipped into an individual slot; but these were useful only for small works. I remembered how dingy our billets and messrooms were in the first war, with not a note of colour to brighten them, and I thought that this situation should be remedied in the second war. The possibility occurred to me of using silk screen prints for this purpose and I went to discuss it with C. A. G. Matthews and A. J. Casson at Sampson Matthews Limited, in Toronto. They believed it could be done.

The silk screen is a stencil process, but instead of using cut-out stencils the design is outlined on a silk screen stretched tight in a steel frame; the colour is squeezed through the silk on to stiff cards. After the first colour is applied every trace of it is painted over on the screen with a stop-out varnish; each successive colour is then pushed through the screen and stopped out. When the last colour is applied, it goes through the only part of the screen not stopped out. By this process up to a thousand impressions can be made. We had never thought of using silk screens as a means of producing pictures of over three feet in length. If it could be done there were many advantages. No printing plates were required; the plates alone would have cost more than five hundred silk screen prints. Being on heavy card, the reproductions could be put on the walls with a strip of wood around them; frames or glass were not necessary; and they could be washed without damage. Charles Comfort and I made the first two designs; they were reproduced so well that ten feet away we could not tell the print from the original.

The first step was to get the National Gallery to endorse the scheme and to pass on all the designs: the Director, H. O. McCurry, agreed wholeheartedly. We then got in touch with Joseph W. G. Clark, the Chief of Information, Armed Forces, who gave the project his full approval but who feared that if there was a request for funds for the project the Government would turn it down. Matthews had considered that possibility and said he believed the whole project could be sponsored by private companies. Clark agreed to this, providing the liquor interests took no part in it; he said some people would raise a howl if they did.

Finally, there was an appeal to the artists for designs. There was no money to pay them; this was to be their contribution to the war effort. The response was gratifying. Some of the designs submitted were unsuitable for silk screen reproduction, but after due consideration thirty designs were accepted. There was no lack of sponsors; banks, insurance companies and industrialists got behind the plan.

[142]

The work was done without profit by Sampson Matthews Limited. The Department of National Defence agreed to take charge of distribution. There were many problems to work out, to which Casson and the staff of Sampson Matthews applied themselves.

A step forward was made when Sydney Hallam undertook to reproduce James Wilson Morrice's "Quebec Ferry." It seemed impossible to do this by silk screen, but it was most successful.

The prints were sent out in packages with five different reproductions in each, and soon every camp in the country was demanding them. They were sent to camps in England and later, when the war was over, to the army of occupation in Germany.

That the plan was successful, and popular with the men in the services, is shown by the excerpt from a letter, written by J. Burgon Bickersteth to J. R. Gilley, acting-Warden of Hart House in the University of Toronto.

You can imagine how excited I was when 2,000 coloured reproductions of Canadian pictures arrived about three weeks ago. It must be just a year since I had noticed the announcement of this imaginative plan in the Canadian Liaison Letter and had immediately cabled and written to Canada requesting an additional supply for the use of the British Army. There must have been many difficulties about arranging this and it is only now after twelve months that they have arrived and we are tremendously grateful to the great generosity of Stanley McLean for having had the idea in the first place, to the Director of the National Gallery at Ottawa for his co-operation, to N.D.H.Q. for giving it their blessing, to the firms who put up the money and to Sampson Matthews for their admirable work in actually making the reproductions. I shall now have enough prints to make up some twenty-five exhibitions each of twenty-three prints and I am sending out eight exhibitions to each Command except to A. A. Command, who are having fourteen as it covers so large an area. I have had the notes about the artists mimeographed, as also a short statement about the way the plan originated and about the Group of Seven. These notes, with a printed slip saying that the exhibition has been made possible by the generosity of a Canadian donor, are being sent out with each exhibition.

The exhibitions did more to familiarize young Canadians with the names of their artists than all the publicity we had ever had previously. Something like seventeen thousand four hundred prints in all were distributed free of charge. When the war was over there was such a demand for them for the decoration of schools, hospitals and offices, that it was decided to go on producing them. They were thus the source of considerable revenue for the National Gallery.

[143]

George Pepper had been going to teach at the Banff Summer School when he joined the army and went overseas. He and his wife, Kay Daly, were very old friends of mine and tenants of the Studio Building for many years. George worked with the War Records overseas and in the line of duty with Records he was for a time reported missing. He and the historical officer were given wrong directions and got inside the German lines. George's companion was killed, but George escaped; he hid in a culvert for ten days. It is not an experience that George talks about.

I took his place at the school. I have never considered myself a teacher, but I did my best. I would take out about two dozen students every day and try to show them how to mix up colours and paint with big brushes. Many of them were school teachers from Alberta and Saskatchewan who had never painted before. They brought tin boxes and dried-up tubes of colours that had been about the house for years. At that time there was little money in the West; some students told me that if they arrived home with a dollar they would do well.

That same year H. G. Glyde and I went to Edmonton to make studies of the Alaska Highway for the National Gallery of Canada. We had letters to the American Public Relations Office and to the R.C.A.F.; the former offered us every assistance, the latter showed not the slightest interest in us. Apart from Fort Nelson and Fort St. John, we were the guests of the Americans.

It took considerable time to arrange for permits and for authority to sketch along the Alaska Military Highway. There was an elaborate exchange of telegrams and air mail letters between myself in southern Alberta and the National Gallery at Ottawa before it was accomplished; so it was not until the 14th of October that Glyde and I landed at Whitehorse in a big transport plane.

From the plane we had looked down on a vast dun-coloured landscape traversed by many rivers. With a map it was easy to recognize them. To the west lay a jumble of mountains; below, bush, muskeg and lakes, the smaller ones frozen over. Occasionally we got a glimpse of the highway, winding its way through valleys or climbing over the hills, but the kit bags and pack sacks piled up in the body of the plane made sight-seeing difficult.

In Edmonton we had seen the U.S. Army Public Relations Officer, Major Vann Kenney, who had received instructions from Washington to give us every possible assistance. His courtesy and good will and the

information he provided made our way very easy. In these war days, transportation and accommodation were vital problems on the highway. We had to have a military permit to enter the country, and we had to show it at every camp we visited.

At Whitehorse, the Public Roads Administration had one of its men meet us at the airport. The P.R.A. also provided us with a room in one of the barracks, complete with electric light and a private bathroom. We had remarkably good meals too. If artists do their best work under adverse conditions, we must have been badly handicapped!

It had been suggested from Ottawa that we should make paintings of the highway, the Canol project and of R.C.A.F. activities. We soon realized that the highway alone would require all the limited time at our disposal. We could have devoted months to sketching the construction work along the road or the endless vistas of country through a thousand miles of ever-changing scenery. In many places we got out of the car to make a fifteen-minute drawing and found enough paintable subjects to make us want to camp right on the spot for a week.

The P.R.A. provided us with a car and a young engineer to look after us. We motored west from Whitehorse to Kluane Lake not far from the Alaska border. For a hundred and fifty miles the road runs through a high open country with mountain ranges on either side. The timber line gets lower in the north so that the mountains rise from the wooded plains with hardly a tree on them. Mile after mile of sharp pointed peaks covered with snow form a background, while the road follows the long swinging undulations of open, wooded country— stretches of spruce and poplar, grassland or burnt-over country, lands of little sticks. There was no snow in the valleys, but the ground was rich with hoar frost where the sun could not find it.

There was so much to see that we could not take the time to paint in oils, but made innumerable pencil notes, using abbreviations for colour and numbering the tones. Later when we returned to our comfortable quarters in Whitehorse, we worked our sketches up in colour.

In Whitehorse the glamour of early days still lingers; but that year the northern lights looked down on stranger sights than ever Robert Service dreamed of. Indians, doughboys, airmen, prospectors; the husky dogs dodging caterpillar tractors; bulldozers and other monsters which roared through the old settlement. The little narrow gauge railroad from Skagway was busy day and night. Planes circled over-

[145]

head and military and engineering camps were everywhere. It was a most picturesque jumble and we could have sketched there happily for a month, but there were eight hundred and fifty miles of highway to be looked over between Whitehorse and Dawson Creek, where the new highway joins the old road from Edmonton. The U. S. Public Relations Officer arranged to motor us the whole way. Two young American soldiers took turns at driving the car, and we spent nearly a week on the road.

We had heard stories about this part of the country, that it was just a great stretch of monotonous bush. Perhaps it was the crisp October weather with the low sun, the sombre richness of the colour, the frost and patches of snow, the ice along the edge of the rivers, but whatever the reason, we found it fascinating.

Having passports and credentials from Ottawa and Washington, we got beds and meals at the military camps; the meals cost twenty-eight cents and they were very good too. We carried sleeping bags, which were necessary when travelling on the highway. There was still a great deal of work going on—grading, putting in permanent bridges, eliminating bad curves, crushing gravel for surfacing, and so on. The country was mostly wooded, the common trees being spruce, jack pine and poplar, with occasional patches of birch and tamarac. One of the interesting sketching motifs was the way the bulldozers had shoved the trees aside so that they leaned away from the highway. About every hundred miles we found a military camp with a big sign at the roadside saying "Stop." We stopped: for identification, also for meals and sleeping quarters.

We saw little of the air activities at Fort Nelson, although we did stay overnight with the R.C.A.F. Here we found a number of the boys interested in art, some of them doing quite good sketches. We made some drawings round the airport too. This was the only place our activities were questioned. On several occasions an officer would come along and say, "Sorry, but you will have to tear that up." We handed him our authority from Washington advising all units of the American army to give every assistance to Mr. X who was working for the National Gallery of Canada. There would follow profuse apologies and best wishes, and the question, "Anything we can do for you?" Glyde and I felt that at last artists were coming into their own.

We ended our tour at the Peace River Bridge. We had about twenty minutes' time to make a drawing of this beautiful suspension bridge, then we had to turn back to wait at Fort St. John for a plane

out. The settler had pushed up into this part of the country, coming into it from the vast lone land to the north made us appreciate the stuff the pioneer is made of.

We were held up for some hours at Fort St. John, very pleasantly delayed at the R.C.A.F. officers' mess. A party there was just breaking up at 1 a.m. when a man shoved his head in the door, and asked, "Mr. Glyde and Mr. Jackson here? Plane leaving in five minutes." We climbed into the big transport plane and in a few minutes we could see the Peace River below reflecting a pale aurora, then the lights of Edmonton. The big plane glided quietly over the sleeping city at 3 a.m.

The man at the desk in the office of the airfield said, "Have you arranged for accommodation? No? Well we have officers' quarters where you can be put up for a dollar." During the last leg of our journey Glyde had remarked that with all our experiences on the highway we had not been in a jeep; we emerged from the office to find one waiting to take us on the last two minutes of our journey. I remember the driver saying, "The old gentleman had better sit in front," meaning me. A short while later we were lost in sleep, between white sheets, in perfect comfort.

In 1944 I was back at Banff and H. O. McCurry made arrangements for Glyde and me to go up the Alaska Highway again, this time with the R.C.A.F. We reported at Edmonton and were told to see a Flight Lieutenant who, patently, had been instructed to give us the brush-off. They would fly us in according to instructions, he informed us, but there would be neither accommodation nor transportation for us at the camps. I said to Glyde, "To hell with them, let's go to Rosebud." Sixteen years before, returning from the West with Banting, I stood beside him on the rear platform of the train. It was rolling country all cut up with coulees; the little village we saw from our perch was named Rosebud. Banting said, "We will have to come back here and paint some day." Glyde and I spent two weeks there, two weeks of lovely weather, wandering about the hills, painting farms and ranches. We stayed at a pleasant little hotel run by a Dutchman and his French-Canadian wife; settlers, who came to the hotel from everywhere around, seemed most friendly people. How Banting would have loved being there! But Banting was dead, killed in Newfoundland three years before, in the crash of the plane which was taking him to England.

[147]

XVIII
Art Appreciation and Otherwise

PAINTING IN Canada has always been a precarious way of making a living. Not half of the artists in this country depend on the sale of their paintings for income; they are either teachers or commercial artists. This was so forty years ago, and while the number of artists has greatly increased since then, there are still comparatively few of them— and these mostly portrait painters and of recent years mural painters —who make a living from their art.

While I was a student in Paris, many Americans studied there on scholarships, but no Canadians. After the first World War, through the efforts of the Royal Canadian Academy, a few scholarships were awarded to artists for study abroad, but these soon ceased for lack of funds. Of late years the Canadian Government has been awarding a number of fellowships for study in France and Holland, and several Guggenheim fellowships have been granted to Canadian artists to study in the United States; Carl Schaefer, Jack Nichols and Roloff Beny have so far received them.

Since the financial rewards of painting are so few, it might well be asked why anyone should devote his life to art. The answer is simple; the true artist cannot help himself.

Artists would continue to paint even if they had no sales at all; a creative urge impels them. Lismer used to boast that he possessed the largest collection of Lismers in the country, and Emily Carr's work piled up with only occasional sales at ridiculously low prices. There were times when she could not afford canvas, and painted on wrapping

[148]

paper. In spite of such impressive evidence of the lack of public interest in their work, both continued to paint, undaunted by it and by the knowledge that in Canada only the poets rank lower than the painters in the financial scale. Someone once remarked that wealthy Canadians would as soon keep a boa constrictor as support a poet.

Apart from the artists whom circumstances forced to become teachers or to do commercial work, there were others who aspired to be artists who never had a chance. Art in a cold country does not flourish naturally, as it did in the Mediterranean Basin, which has been regarded as the cradle of the arts. In Canada, art was something that could wait until all other needs were satisfied. As one wanders about the country, one sees records of people of much promise that never came to fruition. Paul Duval showed me once some water colours by an Alberta coal miner, paintings of fairy tales that were quite delightful. In an Alberta tavern some local sign painter had made decorations on the walls; they were crude and unconventional, but with something vital about them.

Years ago I met Bill Wood, who worked in the shipyards at Midland. He had always wanted to be an artist, and he had managed to put in a few months' training in Toronto in the wintertime when he was a Great Lakes sailor. Then he got married and raised a family. When he took up etching, he made his own press and prints. His efforts at etching and painting were all made after the day's work or at weekends.

Hart House purchased one of Wood's paintings of a girl playing a violin. His own letter regarding the painting appeared in *Canadian Paintings in Hart House*. "It represents," he wrote, "more to me than a 'Woman with a Violin'. The woman whom it recalls is a lassie playing by ear the songs and hymns of Auld Scotland, the homeland of my father. I painted 'Memory's Melodies' when the Grants visited us in the evening and Mrs. Grant played her violin . . . after I had ten hours in the auto-body works in Penetang. The mellow colour of the canvas is due no doubt to its being done at night by the usual electric light. The paint is home brew from dry colours. Do I love a violin? Do I? It's as beautiful as a bark canoe I once bought off an Indian at Byng Inlet and lost the next day as belonging to another Indian. My attitude towards the arts is that where your heart is, there your art is also."

In their modest little home at Midland, where his wife helped out by sewing and other work, Bill, painting signs, making etchings, talking like a philosopher, was a most cheerful soul. The Art Gallery

of Toronto has one of his canvases, "On the Beach." Whenever I see it I can't help feeling that if he had had only a quarter of the opportunities some of the young artists have today, he would have proved to be a genius.

One wonders whether Tom Thomson could have continued painting if Dr. MacCallum had not come to his aid. The Doctor could have made a small fortune out of the Thomson paintings he owned. Instead he decided to leave them to the Art Gallery of Toronto; but when he made inquiries, he found the Gallery was not interested, so the collection was bequeathed to the National Gallery of Canada.

There are other artists who, with a little encouragement, might have shed lustre on our drab civilization, but they were not encouraged. We were busy making money and there would be plenty of time for art in the sweet by and by.

My brother Harry had the ambition to be a painter, but he got married and had to labour at commercial art until he retired ten years ago. The urge persisted in the family, however; his daughter, Naomi, after doing relief work in Finland and West Germany for three years for the Friends' Service, now works with the Department of Fine Arts at McMaster University; his second daughter, Geneva, was until recently in charge of the art classes at the Montreal West High School.

While there are drawbacks to being an artist, it is seldom that you hear of one who abandons art for a more lucrative career. I can think of only one and he did not completely sever himself from the arts. He sells pencils.

It seems unlikely that art will ever become one of Canada's exports, beyond the sale of an occasional sketch to a tourist. We shall have to provide a home market for it. For some years the home market has been expanding and many people are collecting the work of Canadian artists. The little art societies and sketch clubs all over the country have had much to do with making the public familiar with the names of our painters.

One of our serious problems in Canada has always been transportation. The art societies have not the funds to send exhibitions to places that cannot pay the expenses. Probably half the population of our country has never seen a good original painting.

The Canada Council might well consider financing the circulation of exhibitions. Since it is difficult, also, to find suitable accommodation for exhibits, it might be worth while if the Council were to undertake projects which would meet this need: an extension to a public library,

[150]

proper lighting in a community centre, the remodelling of a school-room. It is important, if encouragement is to be given to young artists, that when their student days are over there will be a reasonable chance that they can earn a living. This is far from being the case at present.

Among the artists who have struggled cheerfully and defiantly against adversity are Florence Wyle and Frances Loring. At the time of the first World War, they made some bronzes of "Women's Work in the War." With the proceeds they bought a farm near the Rouge River. It was not much of a farm, but it produced a few helpings of asparagus each year, and boasted a tree that yielded half a dozen quinces annually. There were some sumac trees on it that Miss Wyle used for wood-carving, and the farm also supplied logs for the big fireplace in their Toronto studio. Most of the land was gravel and that was their salvation, for gravel became of value in the second World War; they sold first a few acres, then some more, and finally the whole farm. I would not say they lived in affluence ever after, but they were able to modernize their old studio and make it very comfortable.

In some ways the Loring-Wyle studio on Glenrose Avenue has been the art centre of Toronto. Originally a church, with additions tagged on to it from time to time, it was a most colourful place. The owners, both born in the United States, came to Toronto over forty years ago and have made their living as sculptors, a form of art that fluctuates between an occasional big commission and long periods when medallions or busts or other odd jobs help to keep the fires burning. What wonderful parties they put on! Artists, musicians, architects and writers were proud to be invited to a Loring-Wyle party.

Frances Loring for years has been lecturing and broadcasting about the arts. On one lecture tour I accompanied her to the Peace River country. We addressed gatherings in schools and in community halls; I never in my life did so much talking. Miss Loring had done much more lecturing than I had and her talks on sculpture were very popular.

The conductor of our tour forgot to lock the trunk of his car on one occasion, and my suitcase dropped out, leaving me with only the clothes I was wearing. In Peace River it can drop to zero in October, but fortunately that year it stayed mild and sunny. I was going to wire H. O. McCurry about the mishap and thought I would add "the wind is tempered to the shorn lamb." Miss Loring suggested I should wire "book, chapter and verse, etc.," so we called up a United Church minister and asked him where to find this text in the Bible. He asked if we were sure it was biblical. We tried other ministers, but they

[151]

were puzzled too, and it was not until we returned to Edmonton that we found the quotation came from Laurence Sterne.

During recent years help has come to the artist from a most unexpected quarter. The big corporations in Canada have undertaken projects that have given the artists opportunities they never had in the early days. The Pulp and Paper Association commissioned a series of paintings on paper making and the various types of trees used in the process. The Imperial Oil Company has used work of quite a radical nature for murals and printed publicity; the recently completed mural by York Wilson for the new Toronto offices is a great achievement.

The big "Cities of Canada" project by Seagram's was another ambitious undertaking. The painting of the pictures for this series could have been better planned. With the very considerable costs of reproductions, exhibitions and travelling expenses, which were all very generously financed, it would have been a small matter to have more paintings made and the best ones selected. Two or three artists could have made paintings of the same city, or one artist might have painted several cities and, by a process of selection, the finest canvases could have been accepted for the collection. Some of the cities just about defied the artist.

Among the many murals being commissioned is one by Charles Comfort for the Toronto-Dominion Bank in Vancouver portraying the history of British Columbia. It is outstanding, boldly conceived, and effectively painted.

The Canadian Pacific project of having Canadian artists decorate the new observation cars with murals of the National and Provincial Parks across Canada was most successful. The artists were given an almost free hand, providing that they did not throw nature overboard in the cause of art. One of our young artists declared that you have to "strangle nature to produce art." Some enthusiasts believe that art only commences after the last trace of nature has been eliminated. This project, apart from decorating the cars, was to make people aware of the large number of recreation grounds all over Canada, and also of the need of creating many more, of setting aside large tracts of at present uninhabited country and preserving them against exploitation for all time.

Such murals as these, the Seagram exhibition, and silk screens in the schools, do much to make us appreciate the beauty of our own country. The possibilities of pictorial design are scarcely realized as yet.

XIX
The Studio Closes

IN 1949, Dr. Keenleyside invited me to do some work in the Yellow-knife country north of Edmonton for the Department of Resources and Development of which he was Deputy Minister. I was only too happy to get back there. I was to travel in one of the Eldorado Mine planes, and Mr. Bennett, the Director, suggested I go through to Port Radium and work at Yellowknife on my way back. The mine had been shut down at the beginning of the war, and reopened as a uranium mine under control of the Government when the atom bomb programme made that material very important. Little of the old place was left, and I think only one of the employees of 1938, the date of my previous visit, remained. It was a happy little community now, of young engineers and their wives, a school with twenty children in attendance, a comfortable guest house, a modern hospital, and recreation rooms.

My friend, Dr. Maurice Haycock, who is a mineralogist, had been working at Beaver Lodge, Saskatchewan and he joined me to do some sketching. It was a very colourful autumn and we found much to paint as we wandered over the big hills. We had an exhibition of our sketches in the schoolhouse before we left.

We flew south to Yellowknife. After a few days Haycock had to leave for Ottawa, but the mining recorder there, Geddes Webster, was another person who went about with a sketch box, and he showed me much of the country. I went by plane to one of the gold mines, the North Inca, sixty miles north of Yellowknife. While there was much spruce in the vicinity, the mine used oil for cooking and heating. I asked the manager why, as the oil had to be flown in, and he said it cost less to fly oil in than to cut wood half a mile away. Going out on the

return flight the plane was loaded up with boxes. The pilot said after we got away, "I hope you don't mind travelling with dynamite." There was a thousand pounds of it on the plane. Yellowknife was one of the friendliest towns I have ever been in—a real pioneer settlement. The flowers were still blooming in the gardens when I left early in October while at Edmonton, six hundred miles south, everything was frozen up.

Next year Haycock had work to do at Port Radium, so I timed myself to get there when his work was completed. I had always wanted to get into the Barren Lands, and Mr. Bennett had promised he would get me there. There were three of us in the party, Haycock, myself and Bob Jenkins, a permanent employee, who came along to hunt and explore. Picking out a sketching ground from the air offers several difficulties. You must find a lake big enough for the plane to get in and out of; a lake you can walk around is preferable since a large body of water cuts the sketching ground in half. A country with much diversity is preferable, and you must remember that what you see from a plane in four minutes will be a two hours' hike from your base. On the map we had picked out a nameless lake that looked like a perfect spot and proved even better than we visualized. There was a sand beach on the corner we hoped to land on. We put up our tents, one to sleep in and the other for supplies; we called the second tent the A & P since we had all our groceries on display in it. The pilot left us saying, "I will be back in a week, boys." It was near the end of August and chilly; a sharp east wind hardly ever let up but at least it kept the flies away. We had a Coleman stove, and by hunting under the little scrub willows, we could find enough dry twigs to boil a kettle of water; this saved gas. Snow flurries swept over the hills known as the Teshierpi Mountains which protected us from the north. From these hills we could see the Dismal Lakes in the distance. A prospector told me that never were lakes so appropriately named. It was an exciting country; with its moss and lichen and small plants turning red and orange, it looked like a rich tapestry; and big boulders were strewn about everywhere. We could nearly always find one to crouch behind as protection from the east wind when we were sketching. There was not much wild life. Once we saw a few caribou a long way off; and once I scared up a wolverine without seeing him. He circled around and almost ran into Haycock, who was sketching in the shelter of a boulder. Jenkins had used up all his ammunition by this time and had only one cartridge left. We speculated about what we should do

[154]

if a Barren Lands grizzly came along. I was under the impression that these animals were a myth but in the Museum at Ottawa I had been shown enough hides and skulls to prove that they did exist. We kept a tin of gasoline outside the tent to wash our brushes in and our plan for dealing with the bears hinged on this. If a grizzly came along, I was to throw the gasoline over him, Jenkins was to follow with some lighted matches and Haycock was to record whatever transpired with his movie camera. Fortunately we were never called upon to translate our plan into action. I imagine the Barren Lands grizzlies are rare. How they survive in such a country is a mystery.

We told Dr. Charles Camsell about our trip some time later, and he said, "You must have been within five miles of where Mackintosh Bell and I turned back in August 1900." This was the occasion of their attempt to reach the Coppermine overland. Theirs was an arduous and heart-breaking journey, and we felt almost ashamed of the effortless ways that we can reach such places today.

The Barren Lands country was so fascinating that I returned there the following year. John Rennie of the Giant Yellowknife Mines went with me. We flew farther east over the Coppermine River and came down on a lake near September Mountains, sixty miles south of the Coppermine settlement on the Arctic Ocean. It was a lovely country to walk over, with short grass and moss like a carpet, gently rolling hills with occasional rock outcrops and many little lakes. It appeared tree-less, but in sheltered spots we found a few stunted spruce trees. The trees that die last for years and these provided us with excellent firewood.

The plane picked us up after a week, and we flew west to Hunter Bay, close to Great Bear Lake, a much rougher country, with bold escarpments back from the shore. From the plane it looked like easy country to travel over; there appeared to be long stretches of gravel resembling highways. When we actually got on them, they turned out to be miles of large sharp stones covered with lichen.

The weather, which had been mild and sunny in the Coppermine country, turned grey and colder. Fortunately this country was well wooded, so we could sit around a roaring fire. Close to camp there were lots of blueberries; by the time we left a couple of whiskey jacks were getting friendly. Rennie, who had spent several years in the north, knew how to make himself very comfortable in the bush. He was also an enthusiastic painter.

[155]

Before leaving, I spent a couple of days at the Hudson's Bay post on the west end of Great Bear Lake. Father Brown, a handsome young priest, looked after the spiritual life there, and Réal Gravel, a cultured French Canadian, had charge of the school. He had prints of the works of the Group of Seven on the walls of the classrooms.

The Hudson's Bay factor had a winter supply of wood in his stockade; the Indians had none. I asked him why, and he said he had urged them to put in wood as they were doing nothing. A few of them wanted to, but they were deterred because, they said, it would be used by everybody, so what was the use of their working at it.

I went down the Bear River on one of the Company's boats; the ore from the mine was loaded in bags on a barge which was attached to the bow of the steamer. It was an exciting trip, for the Bear River is very swift, full of shoals and boulders, and it takes great skill to pilot the boats down. I was on the deck making drawings all the way down. Later I painted up several canvases from notes I made on that trip. At one point the ore had to be carried several miles by trucks to get around a series of shallow rapids. There is a camp at the foot of the rapids where I stayed several days; then I flew from there to Yellowknife over another strange lake-studded country.

The National Film Board suggested to me that it would like to make a colour film of me at my work. I did not like being singled out for such attention, and advised them to call the film "Canadian Landscape," to which they agreed. The script was written by Graham McInnes.

I was planning a trip to Grace Lake near Espanola with MacIver at the time, and it was arranged that McInnes and Budge Crawley, who was to make the picture, should come to our camp when the autumn colour reached its height, early in October. The weather was fine, and for several days McInnes and Crawley followed me around taking shots, some that were arranged and others I was quite unaware of. In Toronto the work was continued in my studio; then in April, Crawley came down to St. Tite des Caps where I was sketching with Randolph Hewton. There was still plenty of snow but the weather was sunny and mild, and Crawley, who was indefatigable, took shots not only of me, but of the life of the village generally, which were delightful. It would probably have made a better movie if this part alone had been used, with me coming into it, not as the chief figure, but merely as an artist who happened to be there.

[156]

However, the film was most successful and has been shown all over Canada and in many other countries as well. When I was sketching on the Bear River there were a few Indians also camping there. A truck driver told me of speaking to one of them who said, referring to me, "Sure, I know who that old fellow is. I seen him in a movie at Norman Wells last winter."

Since this first one, films have been made of Emily Carr, Tom Thomson, Arthur Lismer and others. I am in favour of such projects. They provide a most effective way of making people in out-of-the-way places aware of what is going on in Canadian art.

The Art Gallery of Toronto arranged one-man exhibitions of the paintings of Harris and Lismer, retrospective shows, embracing their work right from their earliest efforts. The Harris exhibition was held in 1948 and Lismer's in 1949. The success of the shows was very gratifying for artists who had been regarded as radicals in their younger days and who remained unrepentant radicals too. It was the public that had moved on and now loved the canvases that once they had hated. An early experiment of Harris' of pulling his brush through blobs of red, yellow and blue paint and on to the canvas, known among us as "Tomato Soup," was exhibited nearly forty years after it was painted; it did not shock anyone. In fact, the public was now shock-proof, having become familiar with the work of Picasso, Léger, Braque, Miro, Jackson Pollock, and others; it is doubtful if any combination of shapes or colours would bring out any worse comment than, "Isn't this odd." Whether the cautious Canadian will invest his money in abstract art is another question.

My exhibition followed in 1953, covering a longer period and showing less change or development; it too was very popular. General Bruce Matthews invited the Governor-General, Vincent Massey, myself, my niece, Naomi, and the Directors of the Art Gallery, to a dinner, and the Governor-General opened the exhibition with a brief and gracious address. To be the centre of such a demonstration seemed the happy culmination of my life's work. The same night the Canadian Group had a party in my studio for the Governor-General and suite. A full-length article appeared in *Mayfair*, and there was so much publicity that I began to feel embarrassed. In a catalogue of a Canadian exhibition held at Andover, Mass., Mr. Alfred Deschenes of Cap à l'Aigle, a self-taught contributor, expressed the fear that I might "gain

[157]

a bigger reputation than [my] talents warrant," and that I "would be unable to paint pictures which will come up to the expectation raised by the publicity." That expressed my feelings too.

In the spring of 1954 I was invited to go to Vancouver to open a retrospective exhibition of the Group of Seven. It was, I think, the finest show of the Group that I have ever seen. Each artist had a space to himself and his work, most effectively hung, created much enthusiasm. I remembered with a certain wry amusement that the last show we had had in Vancouver, in 1932, was received with more abuse than any of our exhibitions had sustained anywhere in Canada. At the time I wrote a letter to the *Mail & Empire*, which I called "Wild Art in the Mild West." To-day, Vancouver has become the centre for some of the most abstract painting produced in Canada.

In the fall of 1948, the Studio Building was sold. For years Harris had run it for the benefit of the tenants; it was conceived as a workshop for artists, and all that he asked was that the revenue should cover expenses. It had been an art centre since its construction, and pictures painted in the Studio Building were in every public collection in Canada. After the change-over, whatever glamour it had left departed. Admonitory notes began to appear, advising tenants that hammering, slamming doors, and other similar misdemeanors were forbidden. Thoreau MacDonald, the son of J. E. H., one of Canada's most outstanding illustrators left; he had been there thirty years. George Pepper and his wife, Kay Daly, also departed. My turn came when I was informed that I must wear felt shoes while in the studio and that when I stretched canvases I had to go down to the basement. I spent some restless nights wondering what I was going to do, then suddenly thought of Manotick. I had a niece who lived there and I could build a place next to hers. I called up my old friend Haycock in Ottawa and asked him to look over the ground. He reported most favourably; I bought a strip of land, got plans made and, when the construction was started, I gave my notice.

Before I moved to Manotick I had become familiar with the Gatineau country north of Ottawa where I had sketched with Maurice Haycock and Ralph Burton. I had found some interesting places to paint, rocky hills rising out of the farmlands, rivers, lakes and old settlements all quite close to Ottawa. So I left the Studio Building with few regrets. I had lived there for thirty-five years and it was time to move. Before I departed I received a testimonial from the original owner.

Vancouver, B.C.

14th January, 1955

Dear Alex,

Given the conditions of 25 Severn Street, I am very glad you are going to move. I think your idea of your own place next your niece's property in Manotick is a grand idea. You will be out in the country and yet near enough to a city to keep in touch with the goings-on in the world. Your moving from the Studio Building marks the end of an era, the one era of creative art that has the greatest significance for Canada, and you were the real force and inspiration that led all of us into a modern conception which suited this country, and the last to leave the home base of its operations. Well, best wishes for a new life, zest and happy days of work in your new base of operations.

Yours,

Lawren

XX
Tying up the Ends

I SETTLED easily into my new home. It was a two-bedroom bungalow, comfortable, and a good place to work. I painted in a bright, spacious studio; the big window afforded enough light so that I could work in all weathers.

Manotick is a pretty little town on the Rideau River, not far from Ottawa. It had some importance in the nineteenth century as a port of call for the river traffic to and from Ottawa, and as a milling and small manufacturing centre. But now the old grist mill is a museum, and a large part of Manotick's population is composed of people who work in the capital but prefer to live in a smaller, quieter place. I built my house on two lots adjacent to my niece's property, on the edge of the town. I made a well-meaning effort to landscape the grounds with trees, chiefly poplar, spruce and mountain ash; but since I was away sketching the following summer, and all the summers while I lived in Manotick, the saplings didn't fare too well. Only a few of them still survive.

I found that, as time went on, I was being asked more and more to do paintings on commission. One of the larger ones was a mural requested by the Class of 1909 of the Ontario Agricultural College at Guelph. They wanted something to present to the college on their fiftieth anniversary, in 1959; they assured me that they had chosen me because they didn't want an abstract.

I went down to Guelph one day and hunted all around for something to paint. It was difficult, because the landscape was flat and the college buildings scattered all over the campus. Finally I found three

buildings that were close enough together to make a composition. There was the old library, which was a kind of freak red-brick thing, but which provided a solid base for the painting; then the chemistry building (although I had to move the trees around so you could see it); and at the far end, the administration building. The administration building was modern and I couldn't make much of it, so I just had a corner of it in. When the mural was finished, I had to go down to Guelph for the unveiling. There were forty-two members of the Class of 1909 present, farmers mostly, and very nice fellows. They had come from all over North America for the occasion. I pointed out to them the liberties I'd taken in the painting, how I'd had to push it all together so it would fit in. They didn't mind, however. They seemed pleased with it. Nowadays I find that I have about six months' work in commissions ahead of me at any given time.

Although I was going sketching around Georgian Bay and Lake Superior during the summers, I didn't make another really ambitious trip until 1961. That year, and the following year as well, Maurice Haycock and I flew up to the iron mines in Labrador. We found it a thrilling country; there was still plenty of snow, even though it was June. Haycock and I were treated like princes. On the first trip we did a lot of painting around Schefferville, and as a special honour I slept in the room Maurice Duplessis had died in. I don't think he objected to artists. On the second trip I was commissioned to do a painting of the first big body of iron ore they had opened up at Labrador City. The mine was opened officially by Joey Smallwood, and he was presented with the canvas.

Two years later Haycock, Ralph Burton and I flew to Whitehorse, rented a station wagon and covered the country as far as Eagle, Alaska, then east to Dawson. We had a grand time with the old-timers we met, people who had lived up there for many years. We took a side-trip to the Ogilvie Mountains, then to the Keno Hill Mines, and finally back to Whitehorse, where we were given a great welcome.

I made my last extensive trip in 1965, to Baffin Island. I accompanied a group of mountain climbers, mostly members of the McGill Alpine Club, under the leadership of Pat Baird. When I had been to Baffin Island thirty-five years before I had gone by boat and it took several days, but this time we flew up on a Nordair plane and arrived in a few hours. Our destination was a group of interesting mountains, one of which was 7,000 feet high. Since some of them had never been

[161]

scaled before, they were quite a challenge for the climbers. We landed on a long stretch of silt along the shore of the lake. Normally we would have put down on the lake itself. But this was July; the lake was still frozen, although the ice wasn't firm enough to land on.

Supplies had been flown in the week before. Among other things, we were to have four hundred pounds of sugar and four hundred pounds of powdered milk. We opened the packages containing the four hundred pounds of sugar, but when we came to open the packages of powdered milk, they turned out to contain sugar also. So we had eight hundred pounds of sugar and no powdered milk, which was no help to me because I'm not allowed to eat sugar. We had no way of getting other supplies, since we were cut off by distance from any radio contact. But we got along all right. We had plenty to eat, and my niece Geneva and a friend of hers had come along to do the cooking.

While the others climbed mountains, I painted them. It's good country. There are no trees to get in your way, as there are in the Rockies. We found it a good place in other ways too: coolish, but once we got inside our sleeping bags we were all right. It was only in the early evenings, when we didn't feel like going to bed yet, that we had to walk around to keep warm. Of course it was light all the time, except for a little duskiness around midnight. I made about twenty-two sketches, of which I painted up a dozen when I got home. The Alpinists bought up all the sketches.

On the way back we stopped off at Pangnirtung. I had been there thirty years before and one old Eskimo remembered me. It was interesting to see how the Eskimo way of life had changed since my first visit. Then the Eskimos lived in igloos and skin tents and even, occasionally, in caves. Now many of them lived in bungalows and wore white man's clothing. The Eskimos seem to adapt to civilization much better than the Indians do. They are quite handy around the airport, and I have heard that they can take an automobile engine apart and put it together again the first time they see it. Down at Frobisher Bay, the Eskimos have their own automobile repair shop, bakery, stores, and a little hot dog stand. Eventually they may live just like other Canadians.

In 1963 I left Manotick and moved right into Ottawa, where I live today. I had enjoyed Manotick's peacefulness, but the town came to have its disadvantages after a while. There were no friends there of

my own age. The buses did not run often, and whenever I wanted to go into Ottawa for some colours it took all day. Finally, because so many people in Manotick came to have cars, the bus service to Ottawa was curtailed, and I knew I would have to move.

I'm happy in Ottawa. It's a nice-sized town; it has most of the advantages of a city, yet you know every tenth person you meet on the street. I have a fairly active social life. Often there are two or three parties a week, frequently at the home of my friends, the Firestones. They have a large modern house full of paintings, and their parties are attended by diplomats from the various embassies. The embassies themselves occasionally hold open house, so that I've made the acquaintances of a good many Russians, Yugoslavians, Brazilians, New Zealanders and Venezuelans during the past four years. My niece Naomi and her family live in Ottawa, as do Charles Comfort, Maurice Haycock and Ralph Burton.

My apartment is in a big old house on MacLaren Street that once belonged to the Booths, the old Ottawa lumbering family. The house is a great brick jumble of a place; it's not great architecture, but it has plenty of character. Other homes like it are gradually disappearing in Ottawa, being replaced by big, faceless apartment buildings of glass and steel, and the entire neighbourhood will probably consist of nothing but these apartment buildings by the time the speculators are through.

Although I don't have a proper studio in my apartment, I still paint as much as ever. I do mainly small canvases now. I make short trips into the interesting country around the city, up the Ottawa Valley to Eganville and down it to Grenville, and up the Lièvre River to an old settlement called Poltimore. But exciting scenery is no longer as necessary to me as it once was. Although my subject matter is much the same as it has been for fifty years, I find that if I can paint something out of my head, I feel more creative.

Since I came to Ottawa I've done a good deal of talking in public; too much talking, I suppose. I speak in the high schools occasionally, and at the Ottawa Teachers' College every year. I also had to say something when I received honorary LL.D.'s from the Universities of Saskatchewan and British Columbia and from McMaster and Carleton Universities. Generally my audiences like to hear about the Group of Seven.

[163]

Perhaps the most important recent development involving the Group is the McMichael Conservation Collection of Art. Robert and Signe McMichael have assembled the largest existing collection of work by the Group of Seven and artists associated with the Group, Tom Thomson for example. It has been beautifully hung in the McMichaels' home at Kleinburg, a few miles north of Toronto, and it's open to the public on weekends from April to November. The setting is perfect for our work: a spacious, well-lighted house built from beams that were originally hand-hewn by pioneers of the area. The interior walls against which the paintings hang are made of weathered boards that were once a part of local barns, and large windows look out on fields and rolling hills like those in many of the paintings. The McMichaels, who plan to enlarge the collection, have given it to the Ontario Government.

There are four of us from the original Group still living: Harris, Varley, Lismer, and myself. I still communicate with the others off and on. Harris is living in Vancouver, Varley in Unionville, Ontario, and Lismer in Montreal. Lismer, who is eighty-two, teaches over five hundred students at the Montreal Museum of Fine Arts. I've tried to persuade him to retire to some small town and paint for the rest of his life, but I think he'd rather teach.

I am not as agile as I used to be, but I get about. I'm eighty-four now, and still painting. I imagine I'll go on working as long as I'm physically able. I wouldn't know what to do if I stopped; painting has been my life.

XXI
Conclusions

WHILE I have wandered about Canada all my life, I do not contend that it is necessary or even advisable for the artist to cover the whole of a country looking for subject matter. I enjoy moving about and seeing strange places but, though that has been the function of some painters in the past, I am not interested in views or in providing information. Some artists find continuous inspiration in limited areas, as Cézanne did around Aix-en-Provence and Van Gogh around Arles, Constable in Suffolk and Tom Thomson in Algonquin Park. French painters in particular tend to stay close to home. While thousands of artists have gone to France to study and to paint, the French, with few exceptions, have been content to work and find inspiration in their own country. The exceptions were some of the old masters who travelled widely, mostly on commissions for their royal patrons. Other artists have stimulated their inspiration by journeying far afield. Turner and Bonington wandered about Europe; Gauguin started in Peru and ended up in Tahiti. Another much travelled artist whose work was almost sensational forty years ago was the Russian Nicholas Roerich. There was austerity and a spiritual fervour about his paintings that impressed many people. Lawren Harris greatly admired his work. It is strange that today his name is seldom mentioned.

In Canada, Paul Kane was the first artist to penetrate the wilds, going right through to the Pacific coast in 1846-48. Later artists worked in the Rocky Mountains after the Canadian Pacific went through. I was camping on the Skeena River once, when an old fellow asked me if I knew Tom Martin, an artist who had been there years before. Verner lived and painted in the West for a few years, then continued

[165]

painting Indians or buffalo in England for the rest of his life. Only occasionally does one feel that he painted something he had actually seen. I met Verner when I was a student in Montreal; he advised me not to take up art as a career.

In more recent years artists have been to the Canadian North by boat and plane. Any place in Canada can now be reached with no effort or discomfort if the artist can afford to travel by plane, but these advantages of travel also mark the end of much of the picturesque and colourful life of the northern people. Paddling is now a lost art; probably the husky dog will disappear and the caribou, along with the teepee and the igloo; and Eskimos and Indians are wearing the same store clothes as everyone else. Most of the picturesqueness had departed before artists came in contact with it, and now that many of the younger artists have gone abstract, there is the possibility that this way of life will never be recorded. It is strange to recall that one of the criticisms hurled at the Group was that we did not paint the life around us; not the inhabitants but only the setting. Now neither the inhabitants nor the background is considered of any importance.

Is all this vast and lovely country to be turned over to the Koda-chrome operators? Will there be no place in it for artists like Tom Thomson, Maurice Cullen, Emily Carr or David Milne, with their intimate interpretation of the part of the country they lived in?

In the catalogue of a Canadian exhibition sent to the United States in 1943, Marion Scott, the Montreal painter, wrote:

The Group of Seven in discovering the Canadian landscape adjusted their technique to this new vision and produced a new style of Canadian painting, but to-day when ideologies not countries claim our first loyalty, geographical uniqueness seems to lose significance. There seems to be another reason for the dwindling importance of the piece of ground you are born on; to-day we are more likely to be influenced by ideas and painting coming from outside our country than by those from within.

This sums up the inevitable changes that are taking place in the world of art. It took more than twenty years for the influence of the French Impressionists to reach Canada. To-day the influences of the world outside reach us very quickly. They reach other countries equally fast, so that we have paintings from all over the world which resemble one another because all are derived from the same sources.

In Canada where the art centres are so far apart, where there are few personal contacts among the artists and the changes in environment

are so decided, it seems that we are likely in the future to have some kind of regional art. Vancouver will have much in common with California, the Martimes with New England; Quebec will look to France for inspiration but to New York for markets, and Ontario will become more American in its inspiration as time goes by. Some people tell us that economic domination will have no noticeable effect on us, so long as we preserve our own culture, but Canadian non-objective art is unlikely to be very different from American. For many years we had a country with little or no art, now it seems we are to have art without a country.

While some of the small countries like Greece and Holland have produced much of the world's greatest art, and while Mexico has created art that is definitely its own, it seems that Canada, with its population so closely akin and bordering on the United States, will not create an art recognizably different from the work in that country.

I went once with Harry McCurry to New York to arrange an exhibition of Canadian paintings that was put on at the Canadian Club in the Waldorf-Astoria. The Club wanted to purchase some Canadian paintings to adorn its walls. It was not what one would call a modern show in Canada, although the members seemed to consider it rather radical. Later they purchased a Cullen and a Fred Hutchison. I spoke to a number of newspaper men who dropped in to the show. One of them said he had never seen any Canadian painting before. He had expected to find the influence very British, he said, but could find none; he found instead much French influence and some American, and something he could not quite place. I said, "Perhaps it's something Canadian."

One of the last efforts to stem the tide of modernism was a letter written in 1944 by J. O'Connor Lynch at Montreal, and signed by twenty artists headed by Richard Jack. Probably a majority of our intelligent citizens at that date agreed with the letter, of which the following paragraphs express the trend:

It is surely time that the Art Gallery of Montreal realize its responsible position in the community and endeavour to maintain a high standard in Art. Certainly its present policy of drifting has allowed it to succumb to the baneful influence of the exponents of the isms. Such drifting is not the freedom of Democracy; it is the freedom that breeds Anarchy in Art.

To sit back quietly and wait for this nonsense to die out is quite insufficient. In the meantime, the crack-pot theorists who advocate and

[167]

promote this sort of drivel are insinuating themselves into positions of influence in art galleries, art schools and in newspapers across the country and in typical fifth column style are boring from within to tear down all standards of art appreciation.

If our great industrialists and intellectuals bring with them into the art world the same common sense that they apply to their affairs in everyday life, they will never be duped by the honeyed phrases of false prophets in art, and our children will no longer follow some Pied Piper who leads them into a fog of incipient imbecility.

At the time this letter was written, the art objected to was only the first mild intimation of the revolution going on in many countries. The better informed critics were wary about committing themselves. Most of our modern work is derived from Kandinsky, Paul Klee, Mondrian, Picasso, and other artists of established reputations, and that is probably the chief reason that extreme forms of art expression have invaded our exhibitions with practically no opposition at all. A few months ago an exhibition of Canadian non-objective art was arranged by our National Gallery to go on tour in the United States, and no one raised any objections. This kind of art has now official recognition. Whether all other forms of art are obsolete, as many of the exponents of non-objective art believe, it seems quite obvious that the kind of art Mr. J. O'Connor Lynch approved has lost its authority. The artist with convictions will paint to please himself and not be concerned with any classification.

The neglect from which the arts have suffered in Canada is nothing to be proud of. Banting liked to repeat the precept, "No country can afford to neglect its creative minds." The long neglect has made us, as a people, ready to accept second-rate standards in all kinds of productions. We have depended mostly on other nations for our literature, music, drama and all the other arts. An English journalist, who travelled across Canada, once described it as a land of unredeemable mediocrity. Now in many fields we are beginning, with considerable success, to find we can do things for ourselves and can take pride in our own achievements. It is remarkable that with such little encouragement Canadian artists have accomplished so much. Someone said to William Brymner that if artists had more business ability they could make a decent living, to which he retorted, "In Canada an artist has to be a financial genius merely to stay alive."

The second half of this century holds much promise for Canadians.

We have great wealth and resources; we are respected as a nation; all over the Western world there is a feeling of goodwill toward us. If we are to uphold this reputation we must bear in mind that all countries that have made their mark in history have left a record of themselves through their sculptors and architects, their painters, poets and composers, and others endowed with the creative spirit. Up to the present we have not created much that will hold posterity spell-bound. Perhaps through international art, we may impress other nations, but since half the world is communist and sceptical of modern trends in art, it might be as well to find sources of inspiration and sympathetic understanding of our efforts in our own country. We do not strive to produce a national art. But if we have the will and the vision and the courage to work out our own national destiny we may create a climate in which the arts will flourish.

Index

Thérèse, 67
Thompson River, 128
Thomson, Norah (Mrs. H. P. De-Pencier), 86
Thomson, Tom, 25, 26-27, 28, 29, 30, 31, 32, 33, 34, 38, 48, 54, 71, 72, 73, 76, 134, 150, 157, 160, 161, 164
Thornton, Sir Henry, 90
Times, The, London, 79, 80, 83
Tobin, Quebec, 63
Tonquin country, 89, 90
Toronto, art in, 23, 32-33, 47, 117-20
Toronto Art League, 23
Toronto Ladies Club, 26
Torrance, Lilias, *See* Newton, Lilias Torrance
Totem poles, 91
Tovell, Dr. Harold, 46
Tremblay families, 62-63, 64-65, 66
Trépied, France, 20
Tully, Mrs., 127
Tully, Sidney Strickland, 127
Turner, Joseph M. W., 160
Tyrrell, J. B., 126

Upernavik, 105
Usk, B. C., 92

Valcartier, Quebec, 35, 36
Vancouver, B.C., 91, 116, 117, 118, 158
Vancouver exhibitions, 81, 116, 158
Van Gogh, Vincent, 16, 83, 135, 160
Varley, Fred, 22, 24, 26, 44, 54, 72, 116, 137, 164
Vaughan, J. J., 86
Venice, Italy, 9, 20
Verner, 160, 161
Vimy-Lens sector, 40

Wakeham Bay, 101
Walker, Sir Edmund, 28
Walker, Horatio, 17, 67, 79
Walli, Emil, 126

Wallingford, 104
Walsh Lake, 104
Walter, 46
War Records, Canadian, 7, 38-43, 137-41
Waterways, Alberta, 102
Watkins, Adjutant, 39, 41
Watson, William, 69
Webster, Geddes, 153
Week, The, 23
Weeks, a geologist, 100
Wembley Exhibition, 43, 46, 79-81, 83, 84, 85, 95
Westengard, 70-71
Whistler, James A. M., 10
Whitehorse, N.W.T., 145-46, 161
Williams, Mayor and Mrs., 129
Williams family, 15, 25, 52
Williams Lake, B.C., 127, 128
Williamson, Curtis, 27, 28, 44, 71, 85
Wilson, Bert, 31
Wilson, York, 152
"Winter St. Tite des Caps," 131
Women's Art Association of Toronto, 61
Wood, Bill, 149
Wood, Derwent, 43
Woolgar, 36, 37
World War I, 31, 35-43
World War II, 136-47
Wright, Orville, 52
Wright, Miss, 52
Wyle, Florence, 45, 79, 151

Yasui, 8
Yellowhead Pass, 30
Yellowknife, N.W.T., 103, 125, 154, 156
Yellowknife River, 104
Young, Alexander, 1, 75
Young, N. D., and family, 134
Y.M.C.A. travelling art exhibits, 141-42
Ypres, 36